# Reading the Art in
# Caldecott Award Books

# Reading the Art in Caldecott Award Books

## A Guide to the Illustrations

Heidi K. Hammond
Gail D. Nordstrom

ROWMAN & LITTLEFIELD
Lanham • Boulder • New York • London

Published by Rowman & Littlefield
A wholly owned subsidiary of The Rowman & Littlefield Publishing Group, Inc.
4501 Forbes Boulevard, Suite 200, Lanham, Maryland 20706
www.rowman.com

16 Carlisle Street, London W1D 3BT, United Kingdom

British Library Cataloguing in Publication Information Available

**Library of Congress Cataloging-in-Publication Data**

Hammond, Heidi K., 1953–
Reading the art in Caldecott Award books : a guide to the illustrations / Heidi K. Hammond and Gail D. Nordstrom.
pages cm
Includes bibliographical references and indexes.
ISBN 978-1-4422-3922-7 (cloth : alk. paper) – ISBN 978-1-4422-3923-4 (pbk. : alk. paper) – ISBN 978-1-4422-3924-1 (ebook)
1. Caldecott Medal–Bibliography. 2. Picture books for children–Awards. 3. Children's litera-ture–Illustrations. 4. Illustration of books. I. Nordstrom, Gail D., 1959– II. Title.
Z1037.A2H36 2014
011.62'079–dc23
2014016188

♾™ The paper used in this publication meets the minimum requirements of American National Standard for Information Sciences Permanence of Paper for Printed Library Materials, ANSI/NISO Z39.48-1992.

Printed in the United States of America

This book is dedicated to the 2011 Randolph Caldecott Award Committee who taught us how to look, and look again, and to the Association for Library Service to Children for the opportunity to serve.

# Contents

# Acknowledgments

We would like to express gratitude to the following:

- St. Catherine University professor emeritus Mary Wagner for introducing us to each other as new adjuncts;
- the teachers and librarians attending our presentations at Minnesota Educational Media Organization and Minnesota Library Association conferences who wished for a book such as this which prompted us to write it;
- the respondents to our survey on PUBYAC, LM_NET, child_lit, and MEMOList;
- Vicki and Steve Palmquist, linchpins of the children's literature community;
- Aimée Bissonette of Little Buffalo Law & Consulting;
- our graduate assistants Lacey Rotier for her initial research and Emily Nisius for her continued research and writing support; and
- St. Catherine University for the Faculty Research and Scholarly Activities Grant and for the opportunity to work together at their Scholars' Retreat.

We are especially grateful to our family, friends, and colleagues who supported and encouraged us throughout the project. And, finally, we thank the illustrators of the Caldecott Award books, whose work inspires us.

# Introduction

You have probably introduced many Caldecott Award Medal and Honor books to children. Like us, you may have pointed out the shiny gold or silver seal on the front cover and told your audience that the illustrator of the book you held in your hands had won an award for the "most distinguished American picture book for children." You may have exclaimed over the cover illustration. Then, like us, you read the book and discussed the story, neglecting to mention ever again the art for which the book won the award. This, we believe, is quite common and very natural. Many of us are comfortable analyzing text but less comfortable analyzing art. Perhaps we don't feel we know enough about art to discuss it. It could be that we ourselves wonder why this book even won the award. What set this book apart from all the others in a given year?

Without an educational background in art, people sometimes feel inadequate talking about it. We know what we like, but we can't always articulate just what it is we like about it. Until the two of us served on a Caldecott Award Committee, we didn't feel confident about our knowledge of children's book illustration. To prepare for our service, each committee member read several books and articles that we have listed in the bibliography in Appendix A. Then we learned a great deal more through discussions with the members of our award committee. We have continued to learn as we have written this book, and we are sure we have much more to learn as we continue to enjoy award-winning children's literature.

In the entries following this chapter, we analyze and discuss the illustrations in selected Caldecott Award Medal and Honor books and explain why we think these books meet the criteria for the award. We hope that you will find our book useful when you share Caldecott Award books with children. What follows is the story of our experience serving on the 2011 Randolph

Caldecott Award Committee, including committee member responsibilities and the process of selecting the medal winner. Then we explain why we wrote this book and how you might use it.

## OUR CALDECOTT STORY

It is time-consuming and hard work but such a privilege to serve on the Caldecott Award Committee. As librarians, it ranks high on our list of professional accomplishments. To begin, we would like to share with you our paths to serving the American Library Association (ALA) and its division, the Association for Library Service to Children (ALSC), as book award committee members.

### Gail's Story

My election to the Caldecott Award Committee began with an appointment to the 2002 Newbery Committee. A mentor had recommended me to the ALSC president, who was making appointments. My work in establishing Newbery and Caldecott "mock" discussions in the state on behalf of the Minnesota Library Association was mentioned in the phone conversation when I was offered the position. As a youth services librarian in a public library, I had been active in the Minnesota library community but had not served on any ALSC committees at that point in my career.

After serving on the Newbery Committee, I was appointed to the ALSC Kids! @ your library Campaign Task Force (now the ALSC Public Awareness Committee), followed by the International Relations Committee (now dissolved). In the summer of 2008, I received a call from a member of the ALSC nominating committee asking if I would consider running in the spring 2009 election for the 2011 Caldecott Committee. While trying to maintain my composure, I was reviewing the timeline in my head: the election would take place the following spring; those elected would begin work the following January. Eighteen months felt like enough time to clear the decks to prepare for the task. However, I fully realized that being elected was a long shot, with sixteen candidates for eight open positions. Stunned and flattered, I agreed to run with little hope of garnering enough votes to win.

While I did no campaigning, I knew that my Newbery cohorts were supporting my run. My more recent committee work in ALSC had introduced me to more division members. And while I am not related to Ursula Nordstrom, the children's book editor and publisher, I wondered if my famous last name might win me a few votes. When the election results were announced in May, I was among the eight candidates who won seats on the committee. Once again I was stunned and flattered. I remember returning to the web page with the ALSC election results several times before believing

the news and allowing myself to get excited. In fact, I waited a few weeks to reveal the news to my family, friends, and colleagues. In the next eight months, the full committee would take shape with the appointment of the chair and six other members.

## Heidi's Story

Gail was one of the elected Caldecott Award Committee members; I was one of the seven appointed members. Unlike Gail, I had no experience in ALA or ALSC, but I did have a desire to serve. So I filled out the committee volunteer form and indicated my committee preferences, as directed. I checked the "Awards" box, but I did not choose an award committee, such as the Batchelder Award, Newbery Award, or Caldecott Award. I would have been happy to serve on any award committee.

The committee volunteer form is not long, only two pages, but there are several boxes to check and lines to fill in. One section asks you to check other divisions of ALA of which you are a current member. I checked AASL (American Association of School Librarians) and YALSA (Young Adult Library Services Association). The final section asks for a listing of relevant background experience for committee assignment. I wrote that I had been a school librarian at the elementary, middle, and high school levels and that I had served on a state children's book award committee. I also stated that I completed a PhD degree in education/curriculum and instruction with an emphasis on children's literature and that I taught children's literature and young adult literature courses in a master of library and information science program.

One day in early December 2009, I received an e-mail letter from ALSC asking if I would be willing to accept an appointment to the 2011 Randolph Caldecott Award Committee. Willing? Are you kidding? Of course I was willing! I was thrilled! I was so excited I hopped out of my chair and jigged around the room. Then, because I couldn't believe I had actually been appointed, I reread the letter. It certainly looked official. It was on ALSC stationery. I determined that this was not a hoax, did some more jigging, and then called all my friends with the good news. I couldn't celebrate for too long, though. I had hotel and plane reservations to make. Committee work would begin at the ALA midwinter meeting in Boston in January 2010, just a few short weeks away.

## Committee Member Responsibilities

Committee members are encouraged to attend the first ALA midwinter meeting, and so we did. We knew the names and workplaces of the other committee members from correspondence with our chair, but here we would get to

meet them in person. Our chair distributed a calendar for the year's work that included deadlines for book suggestions and nominations. This was also our opportunity to ask any questions we might have after reading the *Randolph Caldecott Medal Committee Manual*, located on the ALSC website.

After completing committee business, our chair introduced Nell Colburn, the 2009 Caldecott Committee chair, who read a letter from her committee to us. She addressed the requirement of confidentiality and pointed out that it was necessary to keep committee work private in order to maintain the integrity and authority of the award. She also offered suggestions about shelving all the books we would soon be receiving from the publishers and developing a note-taking system for our reading. She advised us to "reread, reread, and reread." The letter was very helpful and gave an accurate portrayal of the committee work. It was published in *School Library Journal* in February 2010 as "Caldecott Confidential: What's Next Year's Best Picture Book for Kids? Please, Don't Ask."

While attendance at the first midwinter meeting is optional, Caldecott committee members are required to attend the ALA annual conference in June of the year under consideration, in our case 2010. They are also required to attend the ALA midwinter meeting of the next year, where the winner is chosen. During the 2011 ALA annual conference the following summer, winners of the Newbery, Caldecott, and Wilder Awards give acceptance speeches, and they are awarded their medals at a gala banquet. Committee members are not required to attend, but few would want to miss that.

In addition to attendance at one annual conference and one midwinter meeting of ALA, committee members must have access to the majority of children's books under consideration. All picture books that meet eligibility requirements can be considered for the Caldecott Medal. Though most publishers send eligible books to committee members, some publishers cannot afford this expense. Whether publishers send the committee books or not, members are expected to suggest titles and to seek out and read all books suggested and nominated by other committee members. They are also encouraged to engage colleagues and children in book discussions without breaching committee confidentiality.

## The Committee Process

After the initial midwinter meeting, we were eager to start reading and evaluating picture books. We had to wait patiently because the first books didn't arrive until sometime in February. We were not idle, though. In the *Caldecott Manual* is a list of suggested reading about the art of picture book illustration, and we busied ourselves reading to better prepare for the work that lay ahead. This helped us become familiar with the language of critical art evalu-

ation so that we would be better able to articulate our thoughts about picture books concisely and effectively.

Once books arrived and we began reading, it was important to take notes for each book. Even if we thought a book didn't merit consideration, it was useful to record that. Committee members develop their own methods of note taking, and the *Caldecott Manual* provides a sample note-taking form that allows space for bibliographic information, a short summary, and information about characters. It also provides space to list the strengths and weaknesses of the book. No matter what method each individual used for recording information, we needed to be mindful to critically evaluate the book with regard to the Caldecott criteria:

- Excellence of execution in the artistic technique employed;
- Excellence of pictorial interpretation of story, theme, or concept;
- Appropriateness of style of illustration to the story, theme, or concept;
- Delineation of plot, theme, characters, setting, mood, or information through pictures;
- Excellence of presentation in recognition of a child audience. (ALSC 2009, 11)

Each month, March through December, we emailed the committee chair with eligible titles of books we felt were worthy of consideration by the whole committee. We could suggest many, few, or even no titles each month, but each title we suggested should be a strong contender, in our estimation. Suggestions did not require justification, only bibliographic information. The chair compiled the lists monthly and tallied the number of suggestions for each title. We eagerly awaited these lists because they offered insight about what other committee members were thinking and appreciating. Sometimes these lists caused us to go back to reread and reevaluate a book or seek out a book we hadn't yet received from a publisher. We didn't know which committee members had suggested which titles, but the lists were cumulative. As the months went by, some books accrued more suggestions because we could recommend titles even if they had been previously suggested. This helped us gauge support for a title and prepared us for the practice discussions at the ALA annual conference in Washington, DC, in June 2010.

At the ALA annual conference, a preconference session was offered by ALSC, titled "Drawn to Delight: How Picturebooks Work (and Play) Today." Along with many members of our committee, we learned from children's literature experts and Caldecott Award and Honor winners such as Brian Selznick, Jerry Pinkney, David Small, and Kadir Nelson. For part of the day, we divided into small groups to see studio demonstrations of illustrators at work and to have hands-on opportunities to learn about art.

When the Caldecott Committee held its meeting, our main item of business was to have each member introduce a picture book he or she had sug-

gested during the previous months. Our committee chair assigned one title to each member. Like a trial lawyer representing a client, we felt we needed to make the best case possible for our assigned book, whether we believed it should continue on in the process or not. We took turns introducing our titles, allowing the committee member about three minutes to point out the merits of the book. Then our chair would open the discussion for input from other committee members. First we would discuss everything positive about the book, and then our chair would ask if anyone had any concerns. These discussions followed the guidelines listed in the *Randolph Caldecott Medal Committee Manual* (ALSC 2009) and provided practice for the selection process to come at the following midwinter meeting.

Before the midwinter meeting, every committee member nominates a total of seven titles. In addition to the suggestion procedure, which continued through December, each person nominated three titles in October, two in November, and two in December. Nominations required bibliographic information as well as written justifications for each title. Each month our chair compiled a list of nominated titles with their justifications and the name of the person or persons nominating the title and then distributed the list to us. This list focused our attention on the books that would require close scrutiny. These, and only these, books would be considered at the midwinter meeting, with the exception of any titles that qualified as late suggestions. Everyone kept a shelf of suggested books separate from the rest of our books. Now we pulled books from our suggested bookshelf for a smaller shelf of the nominated books, or "the contenders."

We mulled over our nominations. The first three were relatively easy. It was more difficult to nominate the next two titles. In subsequent rounds we could nominate books previously nominated by others. With fifteen members of the committee, there was a possibility that we might be considering 105 books in January, but multiple nominations of titles could reduce the total. The most difficult nomination was the last. The seriousness of our work was not lost upon us. Winning the medal would immensely impact an illustrator's career for the rest of his or her life and become a part of Caldecott Award history.

Finally, January came and we arrived in sunny San Diego only to spend two full days locked in a conference room with our committee for deliberations. Did we mind? Not at all! After a year spent poring over hundreds of picture books, we were ready. What took place were intense and exhilarating discussions about books and art that left us with a deep appreciation of the committee process and great respect for our fellow committee members.

We followed the same procedure and guidelines for discussions that we used at the annual conference, keeping the Caldecott criteria foremost in mind. However, instead of presenting just one book, members had multiple books to introduce as assigned by our chair. We sat at a large table filled with

two copies of each nominated book, one set provided by ALSC and matching copies provided by the people introducing those books. We agreed to proceed in order around the table with each person presenting one book and continue until all the books had been introduced. After each discussion, we decided by consensus whether to keep the book or remove it from consideration. If we decided to remove a book, it was taken off the table, never to return, even as a possible honor book.

We kept the discussion moving under the competent leadership of our chair using the following *Caldecott Manual* tips:

- Use good critical analysis, no vague words (cute, nice, good, etc.).
- Be cooperative—listen to each other, no side conversations.
- Refer back to the criteria to keep the discussion focused.
- Make comparisons only to books that were published in the year under consideration.
- Clarity—be clear in what you say. Think through the point you are making, and speak loudly enough to be heard by everyone.
- Be concise—be sure that what you have to say adds to the discussion; try not to repeat what others have said.
- Do not book talk or summarize the plot.
- Refrain from relating personal anecdotes. (ALSC 2009, 36)

More than once our chair reminded us, "There is no perfect book." By the end of the first day, we were comfortable with the books that had been eliminated and pleased with the books that remained. The next day was going to be more difficult.

When we met the next morning, we began in the same way as the first day. Once again, we presented in order around the table with each person introducing one book, and we continued until all the books had been introduced. However, because this was a book's second introduction, we had to find additional information to present. Eliminating a book now was painful, sometimes excruciatingly so, because all of the remaining books were award worthy. But it was our job to narrow the titles down to a reasonable number for balloting.

Since all committee work must be kept confidential, we cannot divulge how many or what titles were considered for balloting or how many ballots it took the committee to determine a winner. Three tellers were selected to tabulate votes, and balloting proceeded according to the *Caldecott Manual*.

*Balloting*
When there is consensus that all the books on the discussion list are fully discussed, the committee proceeds to a selection ballot. Certain procedures apply:

- Committee members list first, second, and third place votes for the award on a selection ballot.
- In tabulating ballot results, the tellers assign four points to each first place vote, three points to each second place vote, and two points to each third place vote.
- There is a formula to determine the winner. A book must receive at least 8 first choices at four points per vote for a total of at least 32 points, and it must have an 8 point lead over the book receiving the next highest number of points.

*Tally*

Once balloting is complete, the tellers tabulate the results. The tabulations are double-checked, and the Chair reads the results aloud to the committee. Depending on the results, certain steps are taken:

- If there is a winner, the committee proceeds to considering whether or not to select honor books.
- If the first ballot does not produce a winner, the committee follows procedures for re-balloting.

*Re-Balloting*

The committee may not proceed to another ballot without a second round of book discussion. At this point, certain choices present themselves, and certain procedures apply:

- By consensus the committee may choose to withdraw from the discussion list all titles that receive no votes on the first ballot.
- By consensus the committee may choose to withdraw additional titles that received minimal support on the first ballot.
- Once withdrawn from the discussion list, a book is permanently eliminated from consideration for the award.
- Once a second round is complete, the committee proceeds to a second ballot.
- On a second ballot (and, if necessary, all subsequent ballots), votes are tabulated by the tellers who use the same point system and formula as in the first round to determine a winner.
- If after a second ballot, there is still no winner, the committee is required to re-open discussion and then re-ballot, alternating between discussion and re-balloting until a winner is selected. (ALSC 2009, 36–37)

After two days of intense work, cheers rang out! *A Sick Day for Amos McGee*, written by Philip Stead and illustrated by Erin Stead, was the 2011 Randolph Caldecott Medal winner.

Our work wasn't done yet. We still had to decide if we wanted to award Caldecott Honors. Here again, we must maintain confidentiality. We did select two honor books, and we followed the procedure listed in the *Calde-*

*cott Manual*. It is important to note that honor books are not ranked, no matter in what order they appear on a list. The honors are equal.

*Selection of Honor Books*
Immediately following determination of the winner of the Caldecott Medal, and following appropriate discussion, the committee will entertain the following:

- Whether honor books will be named.
- Whether the committee wishes to choose as honor books the next highest books on the original winning ballot or to ballot again.
- If the committee votes to use the award-winning ballot, they must then determine how many honor books to name.
- If the committee chooses to ballot for honor books, only books that received points on the award winning ballot may be included. The same voting procedure is followed as for the award winner.
- If the committee has chosen to ballot for honor books, following that ballot, the committee will vote how many books of those receiving the highest number of points are to be named honor books. (ALSC 2009, 37)

We chose *Interrupting Chicken* by David Ezra Stein and *Dave the Potter: Artist, Poet, Slave*, written by Laban Carrick Hill and illustrated by Bryan Collier, as the 2011 Randolph Caldecott Honor books.

Still, our work wasn't done. We gathered around to decide where to place the award stickers on the book jackets. Several members of the committee and our chair wrote the press releases for each book. While we could tell anyone and everyone that we had chosen the Caldecott Award, we couldn't name the winner or even tell whether we had selected honor books. We had to maintain strict confidentiality until the winners were announced the morning of the press conference. And we still had to notify the winners.

Before the press conference, the committee convened to make phone calls to the winners. We crowded into a tiny room in the ALA press information office. Our chair called the Caldecott Award winner, Erin Stead, first, and then the Caldecott Honor recipients. Amid much committee jubilation, they were informed of their awards, but we couldn't hear their reactions because the speakerphone didn't operate very well. Our chair had to relay their responses back to us. That, however, did not dampen the thrill of making "the call."

After having several committee photos taken by an ALA photographer, the committee attended the Youth Media Awards press conference. Each award committee sat at a designated table. We waited through several award announcements, as the Caldecott Award is the second to last announced, followed by the Newbery Award. It was very gratifying to hear all the cheers and applause when Erin Stead was announced as the 2011 Randolph Caldecott Medal winner for *A Sick Day for Amos McGee*.

Other than promoting the awards and affirming the importance of good books for children, our intense year of work was done. It was a little bittersweet bidding farewell to committee members after the press conference, but we knew we would see them again at the ALA conference in New Orleans, when the recipients would receive their awards at the Newbery/Caldecott/Wilder banquet.

Summer in New Orleans is hot, but the heat didn't deter us from celebrating. The publishers of the 2011 Caldecott Award Medal and Honor books hosted dinners and invited us to meet with them and the illustrators. It was very exciting to meet Erin Stead, Bryan Collier, and David Ezra Stein. We were also invited to sit with the publishers and illustrators during the Newbery/Caldecott/Wilder banquet. It was lovely to be seated up close to the podium and to listen to the acceptance speeches. Erin Stead spoke first, followed by Clare Vanderpool, author of *Moon over Manifest* and winner of the 2011 John Newbery Medal, given to an American author for the most distinguished contribution to children's literature. The Laura Ingalls Wilder Award is given every other year to an author who has made a substantial and lasting contribution to children's literature, and that year Tomie dePaola won. When he finished speaking and the evening ended, our Caldecott experience concluded. We walked away that night with memories to last a lifetime.

## The Books: What Did You Do with All Those Books?

Our story would not be finished without telling you what happened to all the books the publishers sent us. Each of our committee members received more than five hundred books. We are often asked, "Do you get to keep all those books?" The answer is "Yes!"

Committee members determine individually what to do with the books they acquire. We kept a few of our favorites because they had become like old friends. Many were donated to libraries or charities, and some were given to friends, students, coworkers, and children. Because we believe that books should be shared with children, not collect dust on shelves, we found ways to place these books in children's hands.

## WHY WE WROTE THIS BOOK

Caldecott Committee members are encouraged to engage colleagues and children in book discussions during the year they serve on the committee. It is quite useful to receive their feedback about the books, but, because of confidentiality, we cannot reveal which books we are considering. We presented books to children in schools and public libraries, and they were delightfully frank with their opinions.

We also presented books to colleagues at our state library and state school library conferences. We related how we were selected to serve on the Caldecott Committee, described the committee's work, and analyzed the illustrations in picture books. Then we divided the audience into groups, gave them stacks of picture books under consideration, and asked them to discuss the books based on artistic merit, much like committee members do. As we circulated among the groups to listen to their discussions, more than one person informed us that they had never heard picture books described as we had done. They wished for a book that explained picture book art so that they could use it to discuss the illustrations with their child audiences more effectively. We decided to write that book.

## HOW WE WROTE THIS BOOK

As we conceived this project, we wondered if there really was an audience for the book. It is true that librarians at our presentations had asked for it, but were enough people interested? To determine this and also gather titles to include in our book, we constructed a survey and distributed it to several library and children's literature listservs. We received more than five hundred responses, and more than eighty respondents wrote additional comments such as, "Often I have wished for a resource such as the one you propose," and "I would love to use a book that told me succinctly what to tell students about each book's illustrations." They confirmed a need and an audience for this book, and they provided a list of titles to include. In addition to the titles from the survey, we included all medal and honor books beginning with the 2010 awards.

Then we needed to decide what to include about each title we selected for the book and how we would present that information. We wanted to keep our entries short and easily accessible. We decided to arrange the titles in alphabetical order and include information about the illustrator's style and chosen medium. We usually discuss the visual elements of at least one illustration in depth but point out other interesting visual and design elements throughout the book. We include biographical information about the illustrator only as it reflects upon the art.

## WHO THIS BOOK IS FOR

This book is for youth services librarians, school librarians, elementary teachers, art teachers, and parents who share Caldecott Award books with children. In addition, future Caldecott Committee members, children's literature enthusiasts, and instructors of children's literature courses may find this a useful reference. We hope that in reading this book you will learn about

picture book illustrations and that you will feel more knowledgeable and comfortable talking about the illustrations with others. We also hope it will encourage you to seek more information about picture book art.

We know that if anyone else had written this book, they may have chosen different medal and honor books and different illustrations to analyze. They may have discussed different aspects of the illustrations. We cannot tell you what the individual Caldecott committees valued about the art in any given book because their committee's book discussions are confidential. But we can tell you what we think about the art in the books we selected and how we think that art meets the Caldecott criteria, based on our experience. We may even be able to help you discover for yourself why a particular book was considered worthy of the award.

## HOW TO USE THIS BOOK

We see this book as a guidebook, pointing out the unique features of the illustrations, much as if you were touring a Caldecott book. Our book should be used in conjunction with the picture books we are describing, rather than as a stand-alone resource. For example, if you were planning to introduce *Tuesday* by David Wiesner or just wanted to know more about the art in the book, you would read the entry in this book for *Tuesday* while you had the picture book open in front of you. The books would be read side by side. By carefully examining some illustrations, we give readers the tools to transfer their knowledge to other illustrations throughout the Caldecott book and even to other books.

There are multiple resources, including a bibliography of books and articles to help you continue learning about picture book art. There is also a glossary to help you understand the language used to describe the art. The Caldecott terms and criteria are included. The indices allow you to search not only for titles, authors, and illustrators but also for media and styles. This will make it easier to find additional books by the same illustrator and will help you find comparable illustrations in similar media or styles.

We explain how we think each book meets the Caldecott criteria for "the most distinguished American picture book for children." With each entry, we hope our book answers the question, "Why did that book win a Caldecott Award?"

## SOURCES

Association for Library Service to Children (ALSC). 2009. *Randolph Caldecott Medal Committee Manual*. http://www.ala.org/alsc/sites/ala.org.alsc/files/content/caldecott_manual _9Oct2009.pdf.

Colburn, Nell. 2010. "Caldecott Confidential: What's Next Year's Best Picture Book for Kids? Please, Don't Ask." *School Library Journal* 56 (2): 38–40.

# All the World

## 2010 Caldecott Honor

Frazee's small vignettes and sweeping double-page spreads invite readers to share a joyful day with a diverse, multigenerational community. Flowing lines and harmonious colors give vibrant life to Scanlon's poetic text.—2010 Caldecott Award Committee (ALSC 2013, 96)

*Author:* Liz Garton Scanlon
*Illustrator:* Marla Frazee
*Style:* Cartoon
*Media:* Black Prismacolor pencil and watercolors on Strathmore two-ply hotpress paper

## ANALYSIS

In masterful pencil and watercolor images, Marla Frazee breathes life into Liz Garton Scanlon's poem that explores connections, from the ordinary to the profound. The illustrator introduces a cast of characters who play and work in a small seaside community. By following the activities of these townspeople, Frazee successfully interprets the esoteric concept of "all the world" and makes the text accessible for a wide audience. The artist's strong sense of composition and distinctive use of line and color are noteworthy.

In the body of the book, the first lines of each stanza appear on one double-page spread. The handwritten text winds around one, two, or three illustrations on a clean white background. In contrast, dramatic full-bleed illustrations accompany the repeating "All the world" verses. Frazee varies the layout with both symmetrical and asymmetrical compositions.

The symmetrical layout of the farmers' market imparts harmony and stability in the fifth opening. Here, a curved road guides the reader through the scene. A Volkswagen bus enters on the verso while the tandem cyclists ride into the market. Vendors sell their goods to shoppers in four stalls, two on either side of the gutter. Two vehicles on each side of the parking lot are angled outward. Tire tracks loop in and out of the lot, leading to a tractor driving off toward the page turn. Above, the clouds and sky on the verso are balanced by the text on the recto.

Asymmetrical page design catches the reader by surprise in the tree-climbing spread in the seventh opening. The eye moves from a scraggly sapling against an open sky to a sprawling tree that fills two-thirds of the image. Frazee's soft but determined horizontal pencil lines sweep across the image, accentuating the tree leaves and trunk as well as the round hilltop that suggests the curve of the earth. The small mission-style building in the lower right corner gives a clue to the next scene in the park.

Throughout the book, the striking line work and horizontal page layout carry the narrative forward. The lines create a sense of movement to guide the reader to the page turns. The artist changes the direction of the lines in the storm sequence to create excitement: swirling winds and birds in the ninth opening are followed by the diagonal lines of the incoming rain and end with the steady vertical downpour. This visual disturbance marks a turn in the story as characters move from outdoor to indoor activities and order is slowly restored.

The color palette changes throughout the book. Soft blue, green, brown, and yellow dominate the first openings. Grays and blues move in with the storm. Twilight brings stunning blues, violets, and golds. Dramatic dawn colors wrap around the earth in the nineteenth opening to embrace "all the world." Warm light fills the indoor scenes of the café and living room in the twelfth and sixteenth openings.

In the artist's multigenerational community with interconnected relationships, characters reappear throughout the book. Many shoppers at the farmers' market turn up in other scenes. Providing continuity, tandem cyclists pedal in and out of many images before they rest on a porch swing in the eighteenth opening. The book comes full circle on the final page when the girl from the beach admires her shell as a new day dawns and "All the world is all of us."

Marla Frazee's exquisite, energetic line work and sublime colors meet the Caldecott criterion of "excellence of execution in the artistic technique employed." Grounding the abstract poem in a specific setting with interrelating characters demonstrates "excellence of pictorial interpretation of story, theme, or concept." This concrete interpretation is particularly effective "in recognition of a child audience."

## FOR FURTHER CONSIDERATION

- Frazee describes the challenge of illustrating the poem as "daunting" when she pondered how to represent "all the world." She explains that her creative breakthrough came when "I decided that no one—certainly not me—has ever experienced 'all the world,' but we all have the sense that we belong here. On good days, at least. When I personally feel like I belong to the world, it is because I am with people I love in places I love. So I decided that would be my solution" (Schulze 2012).
- The artist notes that the setting is a "fictional stretch of what looks like the central coast of California, one of my all-time favorite places" (Danielson 2009). The grandfather who pulls the wagon with the sapling and sits on the living room ottoman is based on Frazee's grandfather Billy.
- *All the World* is Frazee's second Caldecott Honor. She received her first in 2009 for *A Couple of Boys Have the Best Week Ever*, which she wrote and illustrated.

## ILLUSTRATOR NOTE

Marla Frazee remembers, "I knew I wanted to be a children's book illustrator from the time I was in first or second grade. I loved books, loved to read, and most of all, loved to draw" (Danielson 2009).

The artist recalls two favorite books from childhood, both with Caldecott ties. She liked Maurice Sendak's 1964 Medal book *Where the Wild Things Are*, "primarily when Max's room turns into a forest. It just blew me away when I saw that the first time" (Liu 2011). With Robert McCloskey's 1949 Honor book *Blueberries for Sal*, "I spent countless hours studying those wonderful endpapers of Sal and her mother canning blueberries in their cozy kitchen. I wondered how an illustrator could draw a room that somehow included me, the viewer" (Kumar 2011, 67). Frazee succeeds in doing just that in *All the World*.

## SOURCES CONSULTED

Association for Library Service to Children (ALSC). 2013. *The Newbery & Caldecott Awards: A Guide to the Medal and Honor Books*. Chicago: American Library Association.

Danielson, Julie. September 8, 2009. "Gingerbread Pancakes with Liz Garton Scanlon and Marla Frazee." *Seven Impossible Things before Breakfast*. http://blaine.org/sevenimpossiblethings/?p=1783.

Kumar, Lisa, ed. 2011. "Marla Frazee (1958–)." In *Something about the Author*, vol. 225, 66–72. Detroit: Gale.

Liu, Jonathan H. October 21, 2011. "Wordstock Interview: Marla Frazee." *GeekDad*. http://www.wired.com/geekdad/2011/10/wordstock-interview-marla-frazee/.

Schulze, Bianca. January 30, 2012. "Award-Winning Illustrator Marla Frazee & the Best Interview Ever." *Children's Book Review*. http://www.thechildrensbookreview.com/weblog/2012/01/award-winning-illustrator-marla-frazee-the-best-interview-ever.html.

# A Ball for Daisy

## 2012 Caldecott Medal

Chris Raschka's deceptively simple paintings of watercolor, gouache and ink explore universal themes of love and loss that permit thousands of possible variants.—Steven L. Herb (ALSC 2012)

*Author/Illustrator:* Chris Raschka
*Style:* Impressionistic
*Media:* Ink, watercolor, and gouache

## ANALYSIS

Daisy's wiggly shape and expressive face convey her delight as she frisks about with her red ball. She loves this ball so much that she cuddles contentedly with it when she takes a nap. Her ball is more than a toy; it's her best friend.

With minimal brushstrokes, Raschka masterfully captures motions and emotions. On the day the little girl takes Daisy to the park and her ball bounces behind a fence beyond her reach, Daisy looks worried. Relieved to have her ball safely returned, Daisy becomes concerned and then angry as a brown dog takes her ball away and accidentally pops it. Both Daisy and the brown dog express shock. In the eighth opening, Daisy's shock turns to concern. The brown dog has deflated Daisy's ball and her spirits.

Turning the page to the ninth opening, the reader follows Daisy through a grief cycle in a series of eight panels. Daisy stares at her flattened ball in bewilderment, cocking her head first one way, then another. In denial, she pokes at it hopefully. As she takes the ball in her mouth, she sadly begins to

understand there is no remedy for the situation. She shakes her ball in anger, lifts her head, and howls. Daisy is so agitated at this point that her actions break out of the frame. Then her dark thoughts turn to dejection, and Daisy bows her head in sorrow as she faces away from her ball. Her eyes and her body droop despondently.

Daisy's expressions and body language reveal exactly how she feels. Raschka also employs color to convey emotions. Reading the panels across the two-page spread, the watercolor washes gradually darken from yellow to purple to brown, marking Daisy's journey from disbelief and distress to depression.

Without words, the illustrations carry the narrative completely. Raschka uses several graphic conventions to communicate meaning. Motion lines indicate Daisy's ears flopping up and down and the ball flapping side to side as she shakes her ball and her body shudders. A squiggle above her head indicates her unhappy thoughts. Multiple panels effectively depict action happening in quick succession and are used not only in this opening but also throughout the book. Sometimes horizontal panels are read vertically, as in the couch scenes of Daisy settling in for a nap. In the fifth opening, the horizontal panels are still read vertically, but they stretch across the double-page spread as Daisy and her owner play fetch in the park. Raschka spreads panels across two pages again when Daisy returns home from the park in the eleventh opening. The variety of panels interspersed with single- and double-page illustrations provides interesting contrasts.

Another contrast to consider is the way Daisy jauntily trots to the park and how forlornly she drags herself home. The wavy outline of Daisy napping on the couch with her ball shows a dog full of life compared with the listless Daisy outlined smoothly on the couch after her ball bursts. Instead of cuddling her ball, Daisy is cuddled by the little girl who consoles her.

This is the first time the complete girl is pictured. Prior to this the reader saw her only from the waist down, reflecting Daisy's point of view. Daisy's world is at her eye level. Because her master becomes more important to Daisy, the reader is allowed to see more of her. As Daisy begins to accept her loss, her perspective broadens. She accepts the comfort and friendship of the little girl and later, the new blue ball and the friendship of the brown dog.

Raschka's ability to express maximum emotions through minimal use of line and color qualify as "excellence of execution in the artistic technique employed" and "excellence of pictorial interpretation of story, theme, or concept." Raschka stated, "I try to paint in a manner primarily derived from the essence of the book as a whole, whatever that might mean to me. Somehow, the book itself will dictate the style" (Danielson 2009). The style he chose for the story of Daisy satisfies the Caldecott criterion of "appropriateness of style of illustration to the story, theme or concept." Daisy's routine of going to the park, playing, and napping mimic the routine of a young child,

and this creates a connection between the dog and the reader, demonstrating "excellence of presentation in recognition of a child audience."

## FOR FURTHER CONSIDERATION

- It is sometimes pointed out that dogs and their owners look similar. Daisy has white fur and her young master is a girl with white-blonde hair. The curly brown hair of the girl in the park matches the curly brown hair of her dog.
- Even though Raschka created several dummies before he completed his final illustrations, his gestural art looks quickly sketched. Gestural art is an attempt to capture a moment, a movement, an expression. In describing Raschka's art, Leonard Marcus says, "The whole thing feels—there is no better word for it—alive" (Marcus 2012, 34).
- Daisy is a busy little dog, and the action stretches horizontally across the pages. However, when Daisy stops to rest, she naps on a prominently green striped couch. The bold color and the vertical lines slow the reader's eyes and stop the action.
- Gouache paint is more opaque than watercolor. The ball, painted in red gouache, appears solid against the transparency of the watercolors surrounding it. The red color dominates, draws the reader's attention, and indicates the importance of the ball.
- Raschka won an earlier Caldecott Medal for *The Hello, Goodbye Window* in 2006 and a Caldecott Honor for *Yo! Yes?* in 1994.

## ILLUSTRATOR NOTE

The inspiration for Raschka's story was an event that happened to his son Ingo when he was four years old. A neighbor's dog named Daisy took his son's yellow ball, bit down too hard on it, and broke it. This Daisy was a large black dog, not the Daisy of the book. But his son experienced emotions of disbelief, devastation, and irrevocable loss similar to Daisy. In his Caldecott Medal acceptance speech, Raschka said, "The task of a picture book illustrator, I would say, is to remember a particular emotion, heighten it, and then capture it in some painted vocabulary, so that the same emotion is evoked in the child, in the reader" (Raschka 2012, 22). In *A Ball for Daisy*, Raschka's "painted vocabulary" depicts a wide range of emotions relatable to children.

## SOURCES CONSULTED

Association of Library Service to Children (ALSC). 2012. "2012 Caldecott Medal and Honor Books." http://www.ala.org/alsc/2012-caldecott-medal-and-honor-books.

Danielson, Julie. August 26, 2009. "Seven Impossible Interviews before Breakfast #83: Chris Raschka." *Seven Impossible Things before Breakfast.* http://blaine.org/sevenimpossiblethings/?p=1771.

Marcus, Leonard. 2012. "Chris Raschka Unleashed." *Horn Book Magazine* 88 (4): 32–35.

Raschka, Chris. 2012. "Caldecott Medal Acceptance." *Horn Book Magazine* 88 (4): 17–25.

# *Blackout*

## *2012 Caldecott Honor*

Rocco illuminates details and characters with a playful use of light and shadow in his cartoon-style illustrations. He delivers a terrific camaraderie-filled adventure that continues even when the electricity returns.—2012 Caldecott Award Committee (ALSC 2012)

*Author/Illustrator:* John Rocco
*Style:* Cartoon
*Media:* Graphite pencil on Strathmore Bristol paper and digital color

## ANALYSIS

A nighttime blackout in Brooklyn comes alive through John Rocco's limited yet dramatic palette and skilled play with darkness and light. In the opening pages with electricity in full force, white borders surround single pages and one-and-a-half-page spreads as well as smaller panels. Black text is set against cream. Outdoors, warm hues shine from bridge lights, street lamps, headlights, and windows, softening the street scene in the first spread. Here, four adjoining windows on the recto catch the reader's eye. These rooms, awash in muted tones of green, violet, or gold, show silhouettes of human activity. A page turn reveals a close-up of the windows with four family members busy in their separate rooms. The spreads that follow disclose that sister and parents are too preoccupied to play a board game with the youngest child.

When the lights go out, the illustrations transform to blue and black hues with yellow accents. For the first time, Rocco includes some full-bleed dou-

ble-page spreads, with smaller panels incorporated into the fifth and ninth openings. Any borders are now solid black. The text has transformed to gray or black on gray. Despite his restrained use of color, Rocco creates visual variety through texture, perspective, and lighting.

Especially prominent in the blackout scenes, energetic line work fills both indoor and outdoor surfaces and backgrounds, from tabletops and floors to brick and sky. In contrast, subtle pencil shading and digital paint add softness to expressive faces and glowing light sources. The artist's techniques provide depth and interest.

Rocco changes perspective in the tenth opening, when the reader observes from above as the family contemplates exploring the roof. The next spread provides a transition that commands attention. On the verso, the action moves in a dynamic diagonal line with the text following the family as they climb the stairs. When the door opens on the recto, the reader looks down upon the mother and child from an almost dizzying vantage point as they gaze upwards.

The next two spreads show the rooftop and sky, pulling out to feature the activities on adjoining roofs. In both illustrations, the cat's shadow appears among the neighbors' silhouettes; this calls back to the kitchen where the father creates hand shadows for his bored children and the stairway where the youngest makes a rabbit. The dazzling sky is reminiscent of Vincent van Gogh's painting *Starry Night*.

When the family moves to the street, muted colors return in the gleam of headlights, candles, flashlights, and lantern. Children play at the fire hydrant, a woman hands out ice cream, and neighbors sing on the steps. The sixteenth opening is a turning point in the story. Framed in black, the verso shows the children eating ice cream on the stoop with their parents. When electricity returns on the recto, the borders surrounding the two panels revert to white. A subdued hallway light shines through the door, and then the candles disappear as the family moves indoors. However, the closing scenes disclose that they are not quite ready to go "back to normal."

Rocco points out that "in *Blackout* the page is more of a stage, like in theatre, where the characters come and go and we are the stationary audience" (Danielson 2011). On this stage, the small cast of characters shows a wide range of emotion, from boredom, rejection, and fear to comfort, curiosity, and delight, through facial expressions and body language.

John Rocco's imaginative book design and mastery of darkness and light meet the Caldecott criterion of "excellence of pictorial interpretation of story, theme, or concept." The story line and characters' emotions are clearly "[delineated] through the pictures" rather than words. The intriguing subject and friendly cartoon format demonstrate "excellence of presentation in recognition of a child audience."

## FOR FURTHER CONSIDERATION

- Rocco describes his inspiration for the book: "I always knew right from the beginning that it was going to start off with families separated, because that's what electricity does in a lot of ways. Especially today with computers and television, video games—all these distractions. That stuff really separates you as a family" (Salamone 2011).
- The story is based on the historic August 2003 blackout that affected New York City and much of the region. Though he didn't live there at the time, Rocco became intrigued with the subject after talking to many who experienced it.
- The fictional setting is based on the DUMBO (Down Under the Manhattan Bridge Overpass) neighborhood of Brooklyn, where Rocco lived when he wrote and illustrated the book. Marzipan's Ice Cream shop is a tribute to Rocco's daughter, who loves ice cream and whose middle name is Marzipan.
- The cat appears in almost every spread, usually providing comic relief or leading the reader to the next page. In the second opening, the cat leaps out of the frame and off the page. Similarly in the ninth opening, the cat breaks the frame as it springs out of the window toward the reader. On the next page, its tail draws the child's attention to the roof.
- Rocco incorporates graphic novel conventions in the design of the book, breaking down some spreads into multiple panels, incorporating sound effects and musical notes into images, using speech balloons, and choosing an all-uppercase font. Some of the spreads and placement of serif type are reminiscent of Maurice Sendak's *In the Night Kitchen*, a 1971 Caldecott Honor book.

## ILLUSTRATOR NOTE

After illustrating his first picture book in 1992, *Alice* by Whoopi Goldberg, John Rocco began a fifteen-year career as art director in the entertainment industry, working on such projects as video games, films, theme parks, and museums before returning to publishing. He reflects, "I guess the best way I can put it is I tell stories, whether it's with picture or words; whether it's working as an art director or making books. I made the transition back to books because I love books—the form, the medium" (Abrams 2012).

Rocco has also illustrated several works of middle-grade fiction, including the original covers of Rick Riordan's Percy Jackson and the Olympians series.

## SOURCES CONSULTED

Abrams, Dennis. May 16, 2012. "John Rocco: 'Committed to Telling Stories.'" *Publishing Perspectives*.   http://publishingperspectives.com/2012/05/john-rocco-committed-to-telling-stories/.

Association for Library Service to Children (ALSC). 2012. "2012 Caldecott Medal and Honor Books." http://www.ala.org/alsc/2012-caldecott-medal-and-honor-books.

Danielson, Julie. May 31, 2011. "Seven Impossible Interviews before Breakfast with John Rocco." *Seven Impossible Things before Breakfast.* http://blaine.org/sevenimpossiblethings/?p=2143.

Salamone, Gina. July 6, 2011. "Illustrator John Rocco Drew Inspiration from Brooklyn Neighborhood for Children's Book 'Blackout.'" *NYDailyNews.* http://www.nydailynews.com/lifestyle/illustrator-john-rocco-drew-inspiration-brooklyn-neighborhood-children-book-blackout-article-1.156194?pgno=1#ixzz2YJb0XNfv.

# Click, Clack, Moo: Cows That Type

## 2001 Caldecott Honor

Seemingly simple watercolors and fluid, confident black lines supported by careful color choices, dramatic shadows, and dynamic page design combine to create a lighthearted pictorial experience.—2001 Caldecott Award Committee (ALSC 2001)

*Author:* Doreen Cronin
*Illustrator:* Betsy Lewin
*Style:* Cartoon
*Media:* Watercolor

## ANALYSIS

"Farmer Brown has a problem. His cows like to type." On a discarded manual typewriter, the cows in the barn have begun writing notes to the farmer. The first message posted to the barn door is an appeal for electric blankets. After the farmer refuses to comply, a new note declares that the bovines will provide no milk. Upon reading this announcement the irate man leaps in the air, clenching his fists in the fourth opening.

The tension rises in the sixth opening, when Farmer Brown receives yet another note requesting electric blankets for the chickens. This full-bleed spread depicts a showdown of sorts between farmer and livestock: the backlit farmer is poised outdoors in the lower right corner while a cow and chickens stand in a dimly lit barn in the foreground. In a battle of wills, Farmer Brown and the cow stare intently at one another, although their eyes are obscured from the reader.

The unusual perspective creates a comic scene. The reader observes the confrontation from the point of view of a chicken in the shadows behind the cow, whose enormous rump dominates the spread. Its bulk is balanced on the verso by a copy of the note, black text on white paper, framed in black against the muted barn wall planks.

While the cow's backside is prominent, a diagonal line from the top of her tail to the tip of her nose leads directly to a diminutive Farmer Brown in the distance. A small swath of yellow surrounds him. The man has clearly met his match. This pivotal spread reveals the balance of power in the escalating conflict and foreshadows its resolution.

The point of view reverses in the next spread. Here, ten empowered chickens face the reader, holding their proclamation of a work stoppage. The entire background is now bathed in yellow sunshine, backlighting the chickens. An upturned milking stool and buckets reinforce the animals' resolve. A narrow strip of ground holds the shadows of the chickens, stool, and buckets.

Betsy Lewin's shifting perspective throughout the book provides a dynamic element to the presentation. Close-ups of a resolute Farmer Brown in the first, third, and ninth openings contrast with wide views of the frustrated farmer running to and from the barn in the second and eighth openings. A long shot of Duck walking away from the reader to the barn in the tenth opening differs markedly from the extreme close-up of Duck standing before the unseen farmer in the twelfth opening.

The illustrator plays with light and shadow throughout the book. The bright outdoor spreads show yellow-green hills and pale blue and white skies of summer, with a tan path running between the barn and the house. In most of the barn scenes, however, the animals are backlit or in semidarkness with cool purple, grey-green, or blue colors. Farmer Brown's striking shadows upon the barn in the third and fourth openings convey his strong emotion.

Lewin uses loose lines in her cartoon drawings, produced with brush and watercolor in a "gestured form" (Evans 2008, 68), infusing her work with energy and humor. This style "depicts character, emotion, and action in a very direct way" (Evans 2008, 68). Lewin uses a limited but effective palette with broad watercolor washes. For example, in the tenth opening, the green landscape shows few brushstrokes and has little detail; a slight variation near the gutter gives depth to hills. Lewin has applied the watercolors on the path in an informal manner, lending texture and interest. The red paint of the barn spills over the small roof, showing the human touch of the artist. She makes no apparent attempt to add delicate detail or to correct imperfections. Lewin explains, "If I'm working in a humorous style, in pen and watercolor, I try to make the first drawing the finished one, because you can never get that freshness again" (Marrantz and Marrantz 1997).

Betsy Lewin's expressive cartoon illustrations and interesting use of perspective meet the Caldecott criterion of "excellence of pictorial interpreta-

tion" of the humorous story. Her engaging style depicting characters in unlikely situations wearing comical expressions is "[appropriate] to the story" and "[recognizes] a child audience."

## FOR FURTHER CONSIDERATION

- Red endpapers tie into the primary setting of the story, the barn. The color reappears frequently in Farmer Brown's ever-present neckerchief and the chickens' wattles.
- The uneven typeface of the cows' notes reminds the reader that the animals are using an old typewriter, presumably abandoned by Farmer Brown. The typeface of the farmer's note is straight and clear as he is using a new typewriter.
- The eyes of the cows and chickens, simply drawn in cartoon style, communicate great emotion, from curiosity and determination to fear and surprise.
- The spot art on the half-title page shows an old-fashioned typewriter on the ground. This very machine provides the catalyst for the story. On the title page, five cows are gathering to examine the typewriter. One cow stares directly at the reader in an expression of astonishment, promising a humorous tale.
- The text on the final double-page spread seems to conclude the story. However, the visual narrative continues on the single-page illustration of Duck diving into the pond, backside prominently displayed. The image confirms that Farmer Brown has also conceded to the ducks' demands.

## ILLUSTRATOR NOTE

On the publisher information page, Betsy Lewin describes the unique process she used to create the illustrations:

> For this book I did brush drawings using Windsor Newton lamp black watercolor on tracing paper. I then had the drawings photocopied onto one-ply [S]trathmore kid finish watercolor paper and applied watercolor washes to the black drawings. The advantage to this method is that I can get as many copies on the watercolor paper as I want, and I can experiment with the color, choosing the finishes I like best.

Pen or brush with ink and watercolor are Lewin's favorite media, giving her the freedom to "[draw] in a very quick, spontaneous style" (Marrantz and Marrantz 1997). "I love the immediacy and freshness of drawing like this. It's like liquid thought. The images flow through my hand and onto the paper almost before I know they are in my head" (Evans 2008, 70).

## SOURCES CONSULTED

Association for Library Service to Children (ALSC). 2001. "2001 Caldecott Medal and Honor Books." http://www.ala.org/alsc/awardsgrants/bookmedia/caldecottmedal/caldecotthonors/2001caldecott.

Evans, Dilys. 2008. *Show & Tell: Exploring the Fine Art of Children's Book Illustration.* San Francisco: Chronicle.

Marrantz, Sylvia, and Kenneth Marrantz. 1997. "Betsy and Ted Lewin." *Library Talk* 10 (2): 20.

# *Creepy Carrots!*

## *2013 Caldecott Honor*

Pronounced shadows, black borders, and shaded edges enhance this ever so slightly sinister tale with a distinctly cinematic feel. This is one serving of carrots children will eagerly devour.—2013 Caldecott Award Committee (ALSC 2013, 93)

*Author:* Aaron Reynolds
*Illustrator:* Peter Brown
*Style:* Cartoon
*Media:* Pencil on paper, digitally composited and colored

## ANALYSIS

Peter Brown thinks *Creepy Carrots!* is his darkest book, but after reading *The Stinky Cheese Man and Other Fairly Stupid Tales* and meeting Jon Scieszka and Lane Smith, he realized that it was okay to write and illustrate "dark, funny, quirky, off-the-wall books for kids" (Kiriluk-Hill 2013). He transforms Aaron Reynolds's text into a mock horror story for children but makes his characters cartoony because "I like the idea of kids a tad on edge, but the last thing I want is to have kids have nightmares" (Kiriluk-Hill 2013).

Influenced by old movies and television shows, Brown knew he wanted his illustrations to be black and white. He said, "The black and white aesthetic felt both spooky and timeless" (Brown 2013). Old movie posters with strange typefaces inspired the book cover, and the title page was modeled after opening credits of those same old movies. The carrot celebration in the last illustration is reminiscent of choreographed dance scenes from movie

musicals of the 1930s. He even gives a nod to Alfred Hitchcock's *Vertigo* in the twelfth opening.

Each illustration fades to edges with rounded corners to resemble early television screens. The atmospheric palette of black, gray, and white, high-lighted only with spots of orange, make even the most ordinary scenes appear mysterious. In the sixth opening, Jasper is brushing his teeth. He already suspects the carrots are following him and then is horrified to spy them in the bathroom mirror. They are lurking behind the shower curtain in another reference to Hitchcock, this time *Psycho.* He whips around only to find an orange washcloth, bottle, and rubber duck sitting on the side of the bathtub. The perspective is from behind Jasper, and dramatic lighting casts ominous shadows in the style of film noir.

Brown says he wanted to create as much melodrama as possible (Brown 2013). Examination of the eighth opening reveals how he uses perspective and lighting to increase tension. In the upper illustration on the verso, the perspective is from above. The shed's light casts an eerily carrot-shaped shadow of Jasper as he flees to his mother. In the bottom illustration, the lighting and perspective are from below. The house with Jasper's mother framed in the doorway appears at a slant. This diagonal line is unsettling and heightens the suspense. On the recto, even though Jasper and his mother discover that what he thought were carrots were really just tools and orange paint, the tension remains high. Shadows cast by a lone light bulb in the recto are still foreboding.

In two openings, Brown mirrors the recto and verso. In the eleventh opening, paranoid Jasper thinks he sees "creepy carrots creeping EVERY-WHERE." From constantly looking behind him to find nothing, now he sees menacing carrots watching him from the window, the road grate, and the cemetery. The illustrations on the verso show what Jasper imagines, and the illustrations on the recto show what is actually there. But what is reality? Turning the page, the verso shows Jasper is terrified and convinced the creepy carrots are truly coming for him. The illustration on the recto shows Jasper in the same position, but now he is lying in a field of flowers. A raised finger and light bulb above his head, a technique from comics to show what a character is thinking, indicate that Jasper has just gotten an idea. The tension that has been building up to this point now breaks.

The dark palette, cinematic perspectives, and gloomy lighting meet the criteria of "excellence of execution in the artistic technique employed" and "of pictorial interpretation of story, theme, or concept." It also meets the criterion of "appropriateness of style of illustration to the story, theme, or concept." *Creepy Carrots!* is spooky, but not too spooky, to fulfill the criter-ion of "excellence of presentation in recognition of a child audience." Peter Brown provides a way for children to scare themselves safely.

## FOR FURTHER CONSIDERATION

- Rows of carrots on the endpapers are broken by images of the three main carrot characters. The front endpapers depict them as angry and threatening. Relocated on the back endpapers, the carrots are happy as a result of the story's conclusion.
- Interspersing panels between single pages and double-page spreads, Brown effectively paces the story's action. In the second opening, Jasper pulls, yanks, and rips carrots from the ground. In the tenth opening, Jasper and his father search under the bed, look through the closet, and open dresser drawers in search of the carrots. Wordless panels in the thirteenth opening show Jasper sawing, digging, watering, and nailing as he builds a fence around Crackenhopper Field.

## ILLUSTRATOR NOTE

When Brown first read *Creepy Carrots!*, the script reminded him of *The Twilight Zone* television program. He always begins his work with research, so he watched many episodes of the series as well as old black-and-white horror movies and film noir. His creative process includes experimenting with several drawings of a scene and comparing them to determine which he likes best. He often draws details separately because he knows he can combine them later after he scans all his images into Photoshop. Using Photoshop, he can combine elements, reposition and resize them, and compare one page design to another. When he is satisfied, he puts it all together for his dummy. After the sketches are approved, he returns to Photoshop to add color. He drew his final art for *Creepy Carrots!* in pencil, but he never draws the pictures in the order in which they appear in the book. Nor does he do the easiest first and the most difficult last. He decides which illustrations will be the most difficult and which will be the most fun, and then he alternates between them as he makes the final art (Danielson 2012).

## SOURCES CONSULTED

Association for Library Service to Children (ALSC). 2013. *The Newbery & Caldecott Awards: A Guide to the Medal and Honor Books.* Chicago: American Library Association.

Brown, Peter. 2013. "The Creepy Carrots Zone." http://vimeo.com/43773523.

Danielson, Julie. April 20, 2012. "Seven Questions over Breakfast with Peter Brown." *Seven Impossible Things before Breakfast.* http://blaine.org/sevenimpossiblethings/?m=201004.

Kiriluk-Hill, Renée. February 9, 2013. "2013 Caldecott Children's Book Illustrator Peter Brown Inspired by N.J. Childhood." *Hunterdon County Democrat.* http://www.nj.com/hunterdon-county-democrat/index.ssf/2013/02/2013_caldecott_childrens_book.html.

# Dave the Potter: Artist, Poet, Slave

## 2011 Caldecott Honor

The story about Dave the Potter was never meant to be told, yet it showed up two hundred years later hollering like a newborn child. So I wonder.—Bryan Collier (Collier 2011b, 101)

*Author:* Laban Carrick Hill
*Illustrator:* Bryan Collier
*Style:* Realistic and abstract
*Media:* Watercolor/collage on 400-pound Arches watercolor paper

### ANALYSIS

Bryan Collier's remarkable illustrations expand the lyrical narrative of Dave, a nineteenth-century potter who created large stoneware vessels, some adorned with original verse. The fourteenth opening shows Dave in his studio, standing tall in front of a pot that he has just built before he glazes and signs it. The illustration fills the verso and spills over the gutter to cover three-fifths of the double-page spread. The painting meets a block of rich-hued purple paper where the text is placed.

Color and light are important elements in the illustration. Earth tones dominate the artwork, and a triangle of light above Dave suffuses him in its glow. Collier uses this same lighting effect in the seventh opening, where Dave is seen from the rear, working at the potter's wheel, as well as in the spot art on the dedication page. The background directly behind the potter is dark, almost marbled in texture. With collage, Collier incorporates crisp and

glossy photographs of actual pots, in contrast with the more muted painted images.

One of the foremost features of the artwork is texture. In the image, the texture of the watercolor paper appears underneath the paint, especially in the potter's hair, his shirt, and the pot. Collier also creates texture in the painted folds of Dave's shirt and, in other illustrations, clay coils of the pots. Wood grain is prominent in the furniture. The torn paper of the tree canopy creates ragged edges and gives a three-dimensional quality to the artwork. In addition, the strip of regal colored paper on the recto is highly textured.

Dave stands right of center with his pot, the focal point of the page. The man's ambiguous expression is open to interpretation, perhaps triumph, pride, or defiance. In the window on the far left is a view of his owner's home. The blue sky and light façade of the building captures the eye as a sober reminder that Dave is enslaved during the time of the story. In fact, windows and entryways appear in many of the illustrations, providing light, breaking divisions, offering possibilities, and connecting Dave the slave to a larger world.

Also on the verso, light shines on a bench holding a map. The map has symbolic significance, as scholars believe that Dave spent his life in the Edgefield District of South Carolina (Mack 1999). It may represent freedom, opportunity, or Dave's reflections on other people and places as expressed in his poem, "I wonder where is all my relation / friendship to all—and, every nation."

The artwork bleeds off the top, bottom, and left side of the page. However, the internal edge of the illustration is ragged. The outermost edge of the purple paper appears torn from the artwork, tying the text to the illustration to unify the entire spread.

From cover to cover, the illustrations tell a complete story. The spot art on the title page shows unformed clay on a potter's wheel, giving readers a clue to the subject of the book. The first opening shows Dave with "gritty grains" of dry clay in his hands. Throughout the book Collier shows the construction of a pot, ending with Dave writing upon and signing his work of functional art.

Bryan Collier's skilled melding of watercolor and collage is distinctive, meeting the Caldecott criterion of "excellence of execution in the artistic technique employed." The accessible and detailed illustrations "[delineate] plot, theme, characters, setting, mood or information through the pictures." With his effective use of color, light, and texture, the illustrator goes beyond Laban Carrick Hill's text to explore the artistic process and the indomitable human spirit.

## FOR FURTHER CONSIDERATION

- In the Illustrator's Note, Bryan Collier explains, "Since there are no known visual references showing what Dave actually looked like, I based my illustrations on a model who I felt reflected the spirit of Dave."
- The artwork shows reminders of Dave's captivity. In addition to the view of his owner's home, a slave ship crosses the ocean in the third opening, shackles hang on the wall in the seventh opening, and slaves work in the field in the twelfth opening. Collier includes images of hope, however, such as the aforementioned map and the inspiring words "LIVE LIFE" on the shed siding in the fourth opening.
- The illustrator uses two techniques to show an expanding pot under construction: a gatefold in the eighth opening is a series of four paintings of Dave's hands molding clay on a potter's wheel, and cut-paper collage suggests an ever-growing pot in the tenth opening.
- All of the illustrations of the book are placed on the far left or far right of the spread with one exception. In the third opening, the painting is centered on the page where the gutter splits the image of a pot filled with grain. In the background, the sails of a slave ship catch the light. Collier uses the gutter to his advantage to call attention to the journey from freedom to captivity that fractured the lives of the enslaved.
- The spot art of the bibliography shows Dave holding the shoulder and rim of a broken pot. Of the possibly tens of thousands of pots that Dave made, of which more than one hundred were signed and dated, relatively few confirmed pieces exist (Mack 1999).
- Collier won Caldecott Honors in 2002 for *Martin's Big Words: The Life of Dr. Martin Luther King, Jr.*, by Doreen Rappaport, and in 2006 for *Rosa*, which he both wrote and illustrated.

## ILLUSTRATOR NOTE

Bryan Collier's technique of combining watercolor and collage is a recognizable trademark of his book illustration. The artist describes his passion for collage: "Collage is more than just an art style. Collage is all about bringing different elements together. Once you form a sensibility about connection, how different elements relate to each other, you deepen your understanding of yourself and others" (Collier 2011a).

Reading was an important part of his childhood. Collier recalls, "At home and at school, I was encouraged to read. I remember the first books with pictures that I read by myself were *The Snowy Day* by Ezra Jack Keats and *Harold and the Purple Crayon* by Crockett Johnson. I liked the stories, but I

really liked the pictures" (Collier 2011a). Interestingly, Keats also combines paint and collage in many of his picture book illustrations.

## SOURCES CONSULTED

Collier, Bryan. 2011a. "Bryan Collier: Bio." *Bryan Collier.* http://www.bryancollier.com/bio.
     php.
———. 2011b. "CSK Illustrator Award Acceptance." *Horn Book Magazine* 87 (4): 99–101.
Mack, Tom. October 5, 1999. "Dave the Potter." *University of South Carolina–Aiken.* http://
     www.usca.edu/aasc/davepotter.htm.
SCIWAY: South Carolina's Information Highway. 2013. "Dave the Potter—Pottersville, Edge-
     field County, South Carolina." http://www.sciway.net/afam/dave-slave-potter.html.

# Don't Let the Pigeon Drive the Bus!

## 2004 Caldecott Honor

Perfectly paced, every line and blank space in the deceptively simple illustrations are essential to this distinguished work.—2004 Caldecott Award Committee (ALSC 2013, 102)

*Author/Illustrator:* Mo Willems
*Style:* Cartoon and postmodern
*Media:* Calligraphic cartoon drawings in dark marking pencil; scanned, cleaned, and colored in Photoshop

### ANALYSIS

This clever story breaks picture book conventions on the front endpapers, where the visual narrative begins. Here, Pigeon imagines himself behind the wheel of a bus. The text, displayed in speech balloons, begins on the title page. On the verso, a bus driver announces that he is stepping away and directs the reader, "Don't Let the Pigeon Drive the Bus!" which also serves as the title of the book. The copyright and dedication pages show the driver walking off the far left while Pigeon pokes in his head from the far right. A page turn brings the reader to the first opening, where Pigeon walks toward the empty bus, determined to hop behind the wheel.

Mo Willems draws Pigeon with simple lines and colors, making the bird instantly recognizable on every page. The images are flat, with occasional shading where a wing meets the body. The illustrator embraces this style, saying, "I like my characters to be two-dimensional. Just because you can do something in 3-D doesn't make it better. I want my line to be focused, so the

emotions of a character are clear" (Kumar 2011, 208). The bird expresses emotion through his stance, wing position, pupils, and eyelids.

The second opening begins a series of single-page illustrations in which Pigeon tries to convince the reader that he should drive the bus. When the bird makes his first simple request, he stands in a stately manner, sweet and charming. By the time he suggests playing a game he calls "Drive the Bus" in the eighth opening, the bird is animated, flapping his wings on the verso and dashing off the page on the recto.

When the tension escalates, the format changes. In the tenth opening, eight square panels on a double-page spread show a desperate bird trying a variety of tactics to change the reader's mind. A page turn reveals the climax of the story in a frenetic spread. Six views of an exasperated Pigeon show him jumping, flapping, flopping, and screaming. Even the handwritten text conveys emotion with bold, black uppercase letters outlined in yellow, like caution signs on roadways. The warm background hue further energizes the illustration.

When the driver returns and drives off alone, Pigeon is clearly dejected, head bent and wings hanging limply. On the final spread, part of a semi truck dominates the image and bleeds off the page. Rather than feeling intimidated, the small pigeon is inspired. The story concludes on the back endpapers with Pigeon's new dream of driving the truck.

Pigeon changes size and position throughout the book, providing a sense of perspective and adding visual interest. The vantage point varies from the close-up on the "I'll just steer" spread to the long view where he complains, "I never get to do anything!" Willems creates a sense of depth in the few spreads that include the bus. The vehicle is small and usually placed on the upper half of the page, defining the background.

Willems works with minimal elements in the artwork: Pigeon, driver, bus, feathers, and semi truck. The illustrator also uses some graphic novel conventions with speech balloons and a few motion lines. The cool, muted background colors on each spread are flat, with no change in value. These clean, uncluttered pages focus attention on Pigeon, whose motivations are clear. Willems explains, "I want you to see my characters for who they actually are, to expose their core jealousy, anger, love, joy, and silliness. I want you to see yourself in them" (Marcus 2012, 172).

*Don't Let the Pigeon Drive the Bus!* includes qualities of a postmodern picture book. Most apparent is that the story "invite[s] coauthoring—[where] the power of telling the story is shared between the author and the young reader" (Goldstone and Labbo 2004). The entire text of the book is in speech balloons, yet the dialogue is consistently between a character and the reader, not between the characters themselves. The reader engages with a character on almost every page, first promising the bus driver to prevent the pigeon from driving the bus and then reminding Pigeon that he cannot do so.

Mo Willems's spare drawings astutely convey the personality of Pigeon to meet the Caldecott criterion of "excellence of pictorial interpretation of story, theme, or concept." The humorous cartoon illustrations accentuate the playful nature of the book, showing "appropriateness of style of illustration to the story, theme or concept." The clear depictions of the wily and expressive Pigeon exemplify "excellence of presentation in recognition of a child audience."

## FOR FURTHER CONSIDERATION

- Willems's artwork is minimalist and reductive. He explains how for *Pigeon*, "the idea was to make the drawings seem like they were done as quickly as possible, like Japanese calligraphy. It's also important to me that a five-year-old be able to reasonably draw the characters in my stories" (Marcus 2012, 269). "A lot of my design process involves taking things away until I get the simplest, rawest drawings" (Cramer 2005, 153).
- The intrepid Pigeon appears in every book that Willems illustrates.
- Mo Willems received Caldecott Honors in 2005 for *Knuffle Bunny: A Cautionary Tale* and in 2008 for *Knuffle Bunny Too: A Case of Mistaken Identity*.

## ILLUSTRATOR NOTE

In 1993, Mo Willems began printing an annual 'zine, *The Mo Willems Sketchbook*, for friends and clients. An early version of *Don't Let the Pigeon Drive the Bus!* first appeared in one of those publications. He admits, "It didn't even occur to me that children might enjoy the Pigeon's antics until my wife started reading the sketchbook at the elementary school library where she worked part-time. Even so, I was surprised when, a few years later, an agent suggested I . . . start reworking this sketchbook as a picture book" (Willems 2013, 74).

When he began to develop the book, Willems realized that it had no ending. He recalls how in an early draft the story concluded with "Pigeon wanting an airplane for the final reveal, but we finally settled on a semitruck" (Willems 2013, 74).

## SOURCES CONSULTED

Association for Library Service to Children (ALSC). 2013. *The Newbery & Caldecott Awards: A Guide to the Medal and Honor Books*. Chicago: American Library Association.

Cramer, Susan Spencer. February 21, 2005. "Making Failure Funny." *Publishers Weekly* 252 (8): 153.

Goldstone, Bette P., and Linda D. Labbo. 2004. "The Postmodern Picture Book: A New Subgenre." *Language Arts* 81 (3): 196–204.

Kumar, Lisa, ed. 2011. "Mo Willems (1968–)." In *Something about the Author*, vol. 228, 203–10. Detroit: Gale.

Marcus, Leonard S., ed. 2012. *Show Me a Story! Why Picture Books Matter: Conversations with 21 of the World's Most Celebrated Authors*. Somerville, MA: Candlewick.

Willems, Mo. 2013. *Don't Pigeonhole Me! Two Decades of "The Mo Willems Sketchbook."* New York: Disney Editions.

# Extra Yarn

## 2013 Caldecott Honor

Because I knew I wanted Jon to illustrate this book, I was able to sort of write a story in his world, or in the space where our worlds overlap. When I saw his art, it felt just right, like pictures from a book I'd loved as a kid and then forgotten about.—Mac Barnett (Danielson 2012)

*Author:* Mac Barnett
*Illustrator:* Jon Klassen
*Style:* Minimal realism, cartoon
*Media:* Gouache, digital

## ANALYSIS

When Annabelle finds a box of yarn in the first opening, the reader sees her "cold little town" of angular buildings and trees in shades of black, gray, and brown. Snow covers the ground, roofs, and sky, dirtied by soot. Simple line work on buildings and fence posts offers some details and texture to the full-bleed illustration. Absent shadows, minimal shading, and undefined background give the illustration a flat appearance.

Color begins to appear in the single-page illustrations and double-page spreads that follow as the girl knits sweaters for herself and her dog, and then for the people, animals, and objects in her community. The variegated, muted hues are set off against the clean background. Oversized stitches and small fibers sticking out from the pullovers add bulk and texture. In the two consecutive illustrations in the sixth and seventh openings, a continuous strand

of yarn connects the students, teacher, and townspeople modeling their sweaters.

In the tenth opening, Jon Klassen shows in an understated yet dramatic way how "things began to change." The knitted exteriors of the buildings against the white snow and sky are cheerful and droll. Soot no longer dominates the landscape. In the foreground of the verso, Mars the dog runs toward the water, the corners of the buildings creating a diagonal line to the shore. The dark color and sharp angles of the sea portend an ominous turn in the story.

The next opening shows Annabelle and Mars greeting visitors on the verso while the archduke prepares to debark his ship. The dark swath of the ship and sea and the tall, angular figure of the archduke are threatening, juxtaposed with the cheerful town. The tilt of the dignitary's chin and the "A" on the flag and hat suggest that he is haughty and proud. Unlike the round faces of the other characters, the archduke's visage is long and narrow and he wears a sharp mustache.

In the thirteenth to the sixteenth openings, the white background turns to shades of gray and taupe when the archduke arranges for the theft of the yarn box and returns to his castle to open it. A rising and setting full moon shows the passage of time. In this somber, achromatic sequence, only one page is set against white: the box holding needles but no yarn. As the wordless climax of the story, the image alone communicates the unexpected turn of events.

The final double-page spread suggests that the magical yarn has been restored to the box, now back in Annabelle's possession. This light, colorful scene contrasts with the bleak first opening. Branches on the recto extend off the edge to beckon a page turn to the playful illustration on the last page. On knitted branches sit four animals in sweaters, first seen in the ninth opening.

Klassen's artistic style in the book combines elements of cartoon art and minimal realism, in which an artist "capture[s] the essence of . . . subjects with the fewest possible visual elements" (Art Tattler International 2011). Jon Klassen's unadorned illustrations meet the Caldecott criterion of "delineation of plot, theme, characters, setting, mood or information" of the contemplative story. Color, or lack thereof, shows the transformation of a town and the selfish spirit of the antagonist in "excellence of pictorial interpretation of story, theme, or concept." The artist uses line, shape, and color in a retro style "[appropriate] to the story, theme or concept" of this original folktale.

## FOR FURTHER CONSIDERATION

- On the cover, a strand of yarn links the letters of each word in the title. This is expanded on the title page, where the strand joins two trees and then trails off the page to continue on the copyright and dedication pages, where it leads to the open yarn box. This pulls the reader into the story.
- According to the artist, creating the pattern for the sweaters in the book was "tricky." After several tests he found success when he photographed a large swatch of a second-hand sweater over a light table. "It was a big handmade one so it had big chunky stitches in it. After I took the picture, I colored in that black and white photograph . . . so I could get [the] different colors of the sweater I wanted, but we still had the stitch. So all the sweaters in the book are that sweater" (Klassen 2013).
- The spread featuring Mr. Crabtree in the eighth opening is one of Klassen's favorites. Because the character is resistant to a sweater, Annabelle knits him a hat. In the only close-up in the book, "Mr. Crabtree is smiling a small smile wearing his new hat. Nothing is said in the text about his emotional state, and I can't explain exactly why this spread is the most important one, but I know I was more nervous drawing his smile than any other part of the book, which usually means you're onto something good" (Klassen 2012).
- The bear and rabbit in the ninth opening are protagonists from Klassen's book *I Want My Hat Back* (2011).
- Originally from Niagara Falls, Ontario, the artist moved to Los Angeles in 2005 to begin a career in animation, working on such projects as the film *Coraline*, adapted from Neil Gaiman's book, and *Kung Fu Panda 2*. With the publication of his first picture book in 2010, Klassen shifted his focus to book illustration.
- The illustrator also won a Caldecott Medal in 2013 for *This Is Not My Hat*. He is the second illustrator to win both a Medal and Honor in the same year. The first was Leonard Weisgard, who won a Caldecott Medal in 1947 for *The Little Island*, by Golden MacDonald, and an Honor (then called a "runner-up") for *Rain Drop Splash*, by Alvin Tresselt.

## ILLUSTRATOR NOTE

One day, author Mac Barnett was scanning the website of his friend Jon Klassen. Though he was already familiar with his artwork, Barnett explains, "I saw an illustration Jon did in college: a girl was walking her dog and they were wearing matching sweaters. I loved the piece, and as soon as I saw it, I starting thinking up *Extra Yarn*. The illustration in the book where Annabelle walks Mars is very close to the one that started it all" (Danielson 2012).

## SOURCES CONSULTED

Art Tattler International. 2011. "Charley Harper's Legacy of Wildlife and Nature Fantasy." http://arttattler.com/archivecharleyharper.html.

Danielson, Julie. June 2, 2012. "'Extra Yarn,' Now with a Boston Globe-Horn Book Award." *Kirkus Reviews*. https://www.kirkusreviews.com/features/extra-yarn-now-boston-globe-horn-book-award/.

Klassen, Jon. December 19, 2012. "Extra Yarn: Illustrator Jon Klassen's 2012 BGHB Picture Book Award Speech." *Horn Book*. http://www.hbook.com/2012/12/news/boston-globe-horn-book-awards/extra-yarn-illustrator-jon-klassens-2012-bghb-picture-book-award-speech/.

———. September 8, 2013. "Extra Yarn: Meet-the-Author Book Reading." *Teaching-Books.net*. http://www.teachingbooks.net/book_reading.cgi?id=8421&a=1.

# Flora and the Flamingo

## 2014 Caldecott Honor

The minimalist setting, limited color palette, use of white space and page turns create a timeless and joyful visual experience. The call-and-response of this balletic duet is cinematic and comedic.—Marion Hanes Rutsch (Rutsch 2014)

*Author/Illustrator:* Molly Idle
*Style:* Cartoon
*Media:* Prismacolor pencil

## ANALYSIS

Lift-up flaps are a unique feature of *Flora and the Flamingo*. Every third spread includes interactive flaps that allow for multiple interpretations. The reader engages with the book by lifting the flaps and, depending on the order of lifting, defines the meaning. In the second opening, the first with flaps, the flamingo stands gracefully on the verso, one leg raised, and Flora mimics him on the recto. Lift the flamingo's flap, and he turns to stare at Flora. Lift her flap, and her leg is down as she turns her head nonchalantly away. If Flora's flap is not lifted, the flamingo catches his copycat in the act. If the flap is lifted, Flora is innocent.

The flaps also create movement, though the movement may be subtle, such as a head turn or an arm lift. Movements can be done simultaneously, if both flaps are lifted in unison, or consecutively, if the flaps are lifted one after the other. Flora and the flamingo have individual flaps until they begin to dance together. Then they share a flap and a gatefold. Molly Idle was an animator prior to becoming a picture book author and illustrator, and she

states, "I can't help but be influenced by my work in animation. Animation is always about creating an illusion of movement. I enjoy bringing a sense of movement to a still image" (Margolis 2013, 20).

Fluid lines also depict the graceful, and sometimes not so graceful, movement of the dancers. Idle considers line her artistic strength (Idle 2011). Curved lines express the elegance of the ballet poses. Diagonal lines depict flowing movement as the flamingo lands on the title page or Flora and the flamingo soar in the air. The flamingo's straight vertical leg in openings one and two depicts the stillness of his pose. Every move of the flamingo exudes dignity and grace. Flora tries hard to imitate him, but in the third opening, when the flamingo points his foot down, her flipper points up. In the next opening, when the flamingo points his foot up, Flora's flipper points down.

In addition to line, the positions of the bird and the girl on the page show an ebb and flow of movement. Initially the gutter separates them, the flamingo on the verso, Flora on the recto. As Flora becomes bolder, she crosses the gutter and stands next to the flamingo on the verso. When the flamingo mocks her in the seventh opening, Flora somersaults back to the recto in three swift movements. The page turn reveals them facing away from each other, positioned far on the edges of the double-page spread with an expanse of white space between them. On the next page, they turn, move closer, and reach for each other. Finally, in the tenth opening, the flamingo crosses the gutter to the recto, takes Flora's hand, and the dance begins. It is now, when they begin to dance together, that Flora is able to overcome her awkwardness and dance with poise and grace.

Each illustration is a double-page spread with a similar clean design. The uncluttered white space focuses attention on the characters. A floral border above balanced by water below creates symmetry that suggests the dancers are on a stage. It is not until the thirteenth opening that the border changes. Flora and the flamingo grow larger and larger as they dance diagonally across the page. The pace increases as they progress to a dramatic leap and cannonball climax. The border also moves position and transforms until the action causes the flowers to rain down in the gatefold finale. In the last opening, petals surround Flora and the flamingo as they bow to each other. The border has become a solitary branch in the upper recto. Idle says, "I like to think of each page as a stage, and I'm directing the actors in a play or a film. I always begin with character. Working out how my characters will look and act, and ways in which they can move across the pages, and tell the story visually" (Idle 2011).

Her ability to visually tell a wordless story qualifies as "excellence of pictorial interpretation of story, theme, or concept." The unique use of flaps to show movement demonstrates "excellence of execution in the artistic technique employed." As the jacket flap states, "Friendship is a beautiful dance."

Using ballet as a metaphor for friendship, Idle fulfills the criterion of "excellence of presentation in recognition of a child audience."

## FOR FURTHER CONSIDERATION

- Molly Idle states, "I work solely with Prismacolor pencils . . . they allow me to create really rich and complex colors while still affording me a ton of precise control" (Idle 2011).
- The limited palette of pink with a touch of brown highlights the characters against negative white space. Flora's yellow swim cap gives her emphasis. Both pink and yellow colors are reflected in the water, and the yellow is also repeated on the endpapers.
- Idle created a sequel to *Flora and the Flamingo* titled *Flora and the Penguin.*

## ILLUSTRATOR NOTE

The inspiration for *Flora and the Flamingo* was threefold, though not necessarily in this order. First, when Idle's oldest child began kindergarten, she noticed that his process of making friends was much like the back and forth choreography of a dance. Second, her children mixed up words, just as she did as a child. She used to think that "flamenco dancing" was "flamingo dancing." Third, with friendship, dancing, and flamingo connected, she needed a dance partner for the flamingo. She recalled how her nieces used to perform dance routines when they were in elementary school for her and her husband. Completely unabashed by their round tummies, they became the models for Flora. Idle dedicated her book to her nieces Sarah and Katie (Starr 2013).

## SOURCES CONSULTED

Idle, Molly. 2011. "Wackiness Ensues . . . A Mini-ME-Interview!" *Idle Illustration.* http://idleillustration.com/2011/11/02/a-mini-me-interview/.
Margolis, Rick. 2013. "Pretty in Pink." *School Library Journal* 59 (4): 20.
Rutsch, Marion Hanes. 2014. "Welcome to the Caldecott Medal Home Page!" *Association for Library Service to Children.* http://www.ala.org/alsc/awardsgrants/bookmedia/caldecottmedal/caldecottmedal.
Starr, Lara. March 5, 2013. "Pink Flamingos and Rubber Chickens: Tour Illustrator Molly Idle's Studio." *Chronicle Books Blog.* http://www.chroniclebooks.com/titles/flora-and-the-flamingo.html.

# Freight Train

## 1979 Caldecott Honor

*Freight Train* was [created] close to the time when I was doing most of my work as a designer, and abstraction and brevity and symbol were more important to me, were more significant to the way I did my work.—Donald Crews (Bodmer 1998)

*Author/Illustrator:* Donald Crews
*Style:* Minimalistic
*Media:* Preseparated art; airbrush with transparent dyes

## ANALYSIS

"Everyone has trains in their lives," Donald Crews contends (Marcus 2007, 10) and he pays tribute to this nearly universal experience in *Freight Train*. In an elegantly straightforward presentation, Crews follows a train on its cross-country trek using clear and recognizable shapes in primary, secondary, and neutral colors.

On the preliminary pages, an empty railroad track carries readers into the story, with ties, rails, and gravel in neutral tones. After the promise, "A train runs across this track," the reader meets up with the red caboose of a freight train, then tank, hopper, cattle, gondola, and box cars in the spectrum of solid primary and secondary colors. Spare black or white lines, dots, and shapes add detail to the simple forms that represent the cars. Crews introduces the black tender and steam engine, whereupon the adventure begins.

In the fifth opening, the perspective widens to show the entire train on the double-page spread. Clearly defined cars and the billowing smoke suggest

that the train is at rest or moving slowly. A turn to the sixth opening shows the train at high speed, the colors blending from one car to the next.

Crews reaches the pictorial climax of the book in the ninth opening as the freight train crosses a trestle. For the first and only time in the book, the position of the tracks changes dramatically from their sturdy, predictable line near the bottom of the page. Now the train races across the top third of the spread, high above a ravine. As in the previous three illustrations, airbrushed cars overlap to show movement, their colors streaked. The end of the caboose blurs into white space. The steam engine smoke billows above the cars to reinforce the sense of motion.

Here, as in most of the illustrations, a stark white background calls attention to the relevant elements on the page: train and track over trestle and hillsides. The spread is well balanced, the gutter dividing the trestle and ravine equally. The geometric design of the large structure fills much of the opening. While visually dizzying, the solid trestle stands tall upon the landscape. The train is off center, engine almost charging off the recto. The reader's eye rests on the white space following the caboose, where the two-word text describes this leg of the journey. The clean sans serif typeface suits the unadorned illustration, its rich brownish hue tying into the trestle colors.

In the two concluding spreads, the pace of the book picks up, moving toward a breathless ending. The tenth opening shows the single train in the striking contrast of night on the verso and day on the recto. The words "Going, going . . ." lead to a final page turn and an abrupt single-page illustration with the sole word "gone." The train has raced ahead, leaving a bare track and a wisp of smoke in the air.

The art style of *Freight Train* fits the definition of minimalism, "a form of abstraction that pares its forms down to the simplest and most elemental shapes" (Gersh-Nesic 2013). Crews's illustrations are intentionally flat and two-dimensional. With the focus on the foreground and few images with backgrounds, there is little depth to the compositions. In addition, the only shadows appear subtly in the mountains and hillsides in the seventh and ninth openings. Thus, the train and its travels are of fundamental importance. The artist explains, "I attempt to isolate an area of interest and to involve my readers in my excitement about that area. Style is less important than effect. . . . [*Freight Train* is] involved primarily with movement" (Telgen 1994, 45).

In his interpretation of a subject of interest to young children, Donald Crews successfully employs a clean, stylized rendition of a locomotive and its seven cars. This fulfills the Caldecott criterion of "excellence of pictorial interpretation of story." The engaging artwork demonstrates "excellence of presentation in recognition of a child audience." With minimal text, the illustrations drive the linear action forward, effectively "[delineating] information through the pictures."

## FOR FURTHER CONSIDERATION

- Donald Crews uses the Helvetica Bold font throughout this fifty-five-word book, and the typeface color changes on each page. In fact, the artist uses a wider variety of colors in the typeface than in the illustrations themselves. About his penchant for the font, Crews says, "Helvetica lets us create simple and beautiful words, phrases, and paragraphs that meld perfectly with the geographic, iconographic imagery in modern design solutions" (Marcus 2012, 41).
- Although *Freight Train* was not Crews's first book, he considered himself a designer at the time of its publication rather than picture book creator. The works of renowned designers Paul Rand and Bruno Munari influenced his early book illustration (Bodmer 1998); Rand is known for his iconic UPS, ABC, and IBM logos, and Munari for his industrial design work and picture books.
- The back and front covers show the full freight train, similar to the illustration in the fifth opening. On the cover, however, the engine nudges the edge, beckoning the reader to open the book. Two bold words proclaim the title of the book while the name of the author/illustrator is partially obscured by engine smoke.
- In the fourth opening, the "1978" on the tender refers to the year of the book's publication. The "N&A" emblem on the engine honors his daughters Nina and Amy.
- Crews won a 1981 Caldecott Honor for *Truck*.

## ILLUSTRATOR NOTE

Trains played an important role in Donald Crews's childhood as his father worked for the railroad. Further, Crews reminisces, "I grew up in Newark, New Jersey, and spent fifteen summers in [Cottondale,] Florida at my grandmother's farm. As exciting as being at Bigmama's were the trains we rode south to get there and back" (Marcus 2007, 10). The dedication to *Freight Train* acknowledges "the countless freight trains passed and passing the big house in Cottondale." Crews wrote two autobiographical picture books based on visits to his grandmother and his encounters with trains there in *Bigmama's* (1991) and *Short Cut* (1992).

## SOURCES CONSULTED

Bodmer, George. 1998. "Donald Crews: The Signs and Times of an American Childhood—Essay and Interview." *African American Review* 32 (1): 107.

Gersh-Nesic, Beth. 2013. "Minimalism or Minimal Art—Art History 101 Basics." http://arthistory.about.com/od/modernarthistory/a/minimalism-10-one.htm.

Marcus, Leonard S. 2007. "The Crews and Jonas Family." *Pass It Down: Five Picture-Book Families Make Their Mark*. New York: Walker.

———. 2012. "Give 'Em Helvetica: Picture Book Type." *Horn Book Magazine* 88 (5): 40–45.

Telgen, Diane, ed. 1994. "Donald Crews (1938–)." *Something about the Author*, vol. 76, 41–45. Detroit: Gale.

# *Frog and Toad Are Friends*

## *1971 Caldecott Honor*

Arnold Lobel's creation of a kinder, gentler world, where laughter, happy endings, and the return to a snug home are the norm, have become his signature in the I-CAN-READ, EASY READER, and PICTURE BOOK annals of children's literature.—Sandra Ray (Ray 2002, 270)

*Author/Illustrator:* Arnold Lobel
*Style:* Cartoon
*Media:* Pencil, pen, and watercolor wash

### ANALYSIS

Arnold Lobel evokes a feeling of tranquility in *Frog and Toad Are Friends* through repetition and rhythm of the text. His illustrations also contribute to this mood. The *Frog and Toad* books are described as "pastoral" (Shannon 1989, 87). A pastoral idealizes rural life and "portrays the simple life of country folk, usually shepherds, as a timeless world of beauty, peace, and contentment" (Ferguson et al. 2005).

The setting of *Frog and Toad Are Friends* is the countryside. The book cover shows Frog and Toad sitting close together. Toad is aptly perched on a toadstool as he reads to Frog. Grasses, flowers, and plants in muted shades of green, brown, and gray frame the two friends. Centering Frog and Toad in the lower third of the illustration and silhouetting them against a white background focuses attention on them and prevents them from being lost in the scenery. The limited use of color repeated throughout the book maintains a sense of bucolic serenity.

In addition to the peacefulness of the rural setting, Frog and Toad's homes are comfortable and cozy. They have porches and shutters and latticed windows. On page 6, inside Toad's cottage, a stuffed easy chair and floor lamp stand next to a fireplace stacked with logs. On the recto, Toad is snuggled in bed. A tulip light with pull chain hangs conveniently above him. His wallpaper is patterned. The shapes of the furniture and fireplace are curved, which creates a sense of safety and warmth.

Lobel's illustrations reflect the text of the story. When the text states, "He knocked on the front door," the illustration shows Frog knocking on Toad's door. There are a few illustrations that do not align with the text. The illustration on the front book cover shows Toad reading to Frog. None of the stories include a scene in which Toad reads to Frog. Yet he reads to Frog again in the illustration on the contents page. On the title page, Toad is serving Frog tea. Though Toad brings Frog tea in bed in "The Story," the text never describes a scene in which they sit at a table enjoying a cup of tea together. These illustrations extend the idea of the pastoral for they are tranquil activities of a quiet life.

Even though Lobel's style is cartoon, other than the main characters dressed in human attire, everything is drawn realistically and to scale. Frog and Toad are small animals, and their houses are tiny, too. Toad's house is nestled within the grass on page 5. On page 29, and again in the spread on pages 54 and 55, the amphibians' size, as well as the miniature fence and mailbox, contrast against the size of the flowers. When compared with the sparrow on page 32 and the raccoon on page 34, the sizes of the animals are accurate. Lobel said, "A good picture book should have drawings that are neither too cartoony cute at one end of the scale, nor too sophisticated and adult at the other" (Lobel 1981, 74).

*Frog and Toad Are Friends* has been described as "one of the best children's books about friendship" (Silvey 2012, 172). In a tribute to Arnold Lobel after his death, children's author and illustrator James Marshall said, "With Frog and Toad, Arnold Lobel put friendship on the map. . . . Arnold was the best friend anyone could ever have" (Marshall 1988, 326). Though Frog and Toad have opposite personalities, Toad being excitable and emotional and Frog being reasonable and calm, they are the best of friends. Lobel shows this through the kind ways they treat each other in each story and also indicates it through the illustrations. On the title page, the friends' heads tilt toward each other in attentive conversation, and in the illustrations on pages 9 and 62, Frog wraps his arm around Toad's shoulders in loving companionship.

Honored as "one of the very finest watercolorists who ever lived" (Marshall 1988, 326), Lobel uses washes to lighten and darken the values of his limited palette, which provides variety and also maintains a peaceful mood throughout all the stories. With this technique, he demonstrates "excellence

of execution in the artistic technique employed" as well as "delineation of plot, theme, characters, setting, mood, or information through the pictures." Frog and Toad exist in a timeless world "self-contained and secure: a child's paradise" (Ray 2002, 270). *Frog and Toad Are Friends* shows us how to be friends and meets the criterion of "excellence of presentation in recognition of a child audience."

## FOR FURTHER CONSIDERATION

- *Frog and Toad Are Friends* is the first in a series of four *Frog and Toad* books. The second book, *Frog and Toad Together*, won a Newbery Honor in 1972.
- Lobel won a second Caldecott Honor in 1972 for *Hildilid's Night*, by Cheli Duran Ryan. He also won the Caldecott Medal for *Fables* in 1981.

## ILLUSTRATOR NOTE

Lobel once said, "All the *Frog and Toad* stories are based on specific things in my life" (Natov and Deluca 1977, 84). Instead of sending their children to summer camp, the Lobels would vacation on a lake in Vermont. The children played outdoors all day, and one day they explored a swamp and brought home a frog and two toads. The children kept a toad as a pet (frogs don't eat in captivity), and later, as Lobel was searching for the subject of a new book, he thought back on the family's summer vacation. "He wrote the words, 'Frog ran up the path to Toad's house,' and the story began to pour forth" (Silvey 2012, 172).

## SOURCES CONSULTED

Ferguson, Margaret, Mary Jo Salter, and Jon Stallworthy. 2005. *The Norton Anthology of Poetry*. New York: Norton. http://www.wwnorton.com/college/english/nap/glossary_p.htm.

Lobel, Arnold. 1981. "A Good Picture Book Should . . ." In *Celebrating Children's Books: Essays on Children's Literature in Honor of Zena Sutherland*, edited by Betsy Hearne and Marilyn Kaye, 73–80. New York: Lothrop, Lee & Shepard.

Marshall, James. 1988. "Arnold Lobel." *Horn Book Magazine* 64 (3): 326.

Natov, Roni, and Geraldine Deluca. 1977. "An Interview with Arnold Lobel." *Lion and the Unicorn* 1 (1): 72–96.

Ray, Sandra. 2002. "Lobel, Arnold." In *The Essential Guide to Children's Books and Their Creators,* edited by Anita Silvey, 270–71. New York: Houghton Mifflin.

Shannon, George. 1989. *Arnold Lobel*. Boston: Twayne.

Silvey, Anita. 2012. *Children's Book-a-Day Almanac*. New York: Roaring Brook.

# Grandfather's Journey

## 1994 Caldecott Medal

> Exquisite watercolors portray vast landscapes along with intimate family por-
> traits that communicate hope, dignity, sadness, and love. Say powerfully con-
> nects the personal and the universal to create a rare harmony of longing and
> belonging.—1994 Caldecott Award Committee (ALSC 2013, 110)

*Author/Illustrator:* Allen Say
*Style:* Realistic
*Media:* Watercolor

## ANALYSIS

In photographic style, Allen Say's autobiographical work recounts his mater-
nal grandfather's journeys to the United States from Japan. The first image of
his grandfather is a formal portrait, the young man in traditional dress. It is
paired on the recto with a view of the traveler in Western garb, clutching his
hat on the ship deck as the wind blows his coat. At first he appears to be
standing vertically, but he is actually leaning to stay upright on an uneven
surface. The slight diagonal line of the ship and the sea is unsettling, appro-
priate as Grandfather embarks upon an uncertain adventure.

In the initial spreads of Grandfather's travels in the States, Say presents
two illustrations as companion pieces, placing a panoramic land- or water-
scape with an image of Grandfather as if posed for a photograph. For exam-
ple, on page 8, abstract rock formations in reds and violets, reminiscent of the
work of Georgia O'Keefe, overshadow the small figure gazing at the monu-
mental view. On the recto, in a scene that calls to mind the paintings of

Andrew Wyeth, Grandfather stands in the foreground, surrounded by grain and staring off into the distance. On pages 10 and 11, the lines of the charcoal gray buildings behind Grandfather continue across the gutter to the dark mountains in the foreground. The majestic tableau is similar in style to Ansel Adams's photographs.

Say continues to pair companion images of life in Japan after the family's return. The illustrations on pages 22 and 23 are striking in their beauty and composition. On the verso, the "daughter from San Francisco," dressed in Western clothing, walks away from her mother and village in a dramatic diagonal line toward her husband on the opposite page. The wedding photograph on the recto shows the daughter still dressed in white, but in traditional Japanese clothing, her Korean husband in a black tuxedo. The background is dark, in contrast to the lighter hues on the verso. The pairing of these paintings communicates cultural ambiguity.

The scenes of Japan during and after World War II are spare but powerful. The text on page 26 describes bombs, yet the illustration shows a young Say standing in attention in a uniform with a toy rifle. On the recto, the depiction of the destruction of war is restrained as seven refugees stand on gray rubble with a dark haze behind them.

Many of the paintings are carefully composed with strong horizontal lines that break the illustrations into thirds. On page 12, most of the men are standing on the barbershop porch, about one-third from the bottom. On page 19, the handrail behind the family is one-third from the bottom, while the water meets the land in the background about two-thirds up.

The focal point of most of the artwork is just off center, which visually expresses the underlying disequilibrium of restless and rootless characters. On page 18, Grandfather stands on the right side of the illustration, staring out the window with his songbirds behind him. On page 25, he is back in Japan, sitting on the right side of the page, observing his caged birds in a diagonal line to the left.

The book resembles a photograph album, with precise, thin lines to frame each illustration set upon cream pages with wide margins. The pattern is broken on the last pages. Page 30 shows a young Say, newly arrived in the United States at age sixteen; the recto includes only text. The narrative describes the similar journeys taken by Say and his grandfather and their shared sense of unease, as they love one land while longing for the other. The final illustration of a framed portrait of Grandfather sits slightly askew on the page, cropped from the same painting that begins the story. Say describes this concluding image as "my grandfather's story merging with mine, one journey linking with another to form a circle. The endless circle" (Say 1995, 31).

Allen Say's technical skill as a watercolor artist is noteworthy, including both finely detailed illustrations and broadly rendered landscapes, and meets

the Caldecott criterion by demonstrating "excellence of execution in the artistic technique employed." The tone of the book is powerfully introspective, and the controlled style is "[appropriate] to the story, theme or concept." Say successfully "[delineates] plot, theme, characters, setting, mood or information through the pictures" as he explores his parallel life journey with that of his grandfather.

## FOR FURTHER CONSIDERATION

- Say generally portrays people as posed and static. The expressions of the grandfather and family members are controlled and serious, especially once they are resettled in Japan. The exception is a smiling grandfather crouched with his grandson on page 24. The most natural image is that of friends gathered on a Japanese hillside on page 21.
- Say's photographic style and careful attention to light and shadow reflect his twenty years as a professional photographer before beginning his work as a children's book illustrator and author.
- Under the dust jacket, the book's plain tan cover is bare, except for a gold-stamped outline of an origami boat. A painted image of this boat appears on the title page, slightly off center, leading readers to the page turn. This boat is featured on the back of the gold book jacket as well.
- The only photographs Say used for reference were of himself. He explains that "the faces of the others are purely imaginary" (Say 1995, 31).

## ILLUSTRATOR NOTE

Unlike many picture book illustrators, Say does not make storyboards or dummies of his books before creating the artwork. "Usually, my books start with a very vague notion or idea. Then I begin to draw things that come into my mind" (Loer 2013).

"When I feel good about what's coming out, I put that on a stretched watercolor paper. . . . I start painting from the first picture, and by the time that's done the second picture—I call it a scene or frame—forms in my mind. After the fourth or fifth frame, I'm often surprised to see a story line developing. It's a kind of pattern recognition" (RIF 2013). He composes the text only when all the paintings are finished.

## SOURCES CONSULTED

Association for Library Service to Children (ALSC). 2013. *The Newbery & Caldecott Awards: A Guide to the Medal and Honor Books*. Chicago: American Library Association.

Loer, Stephanie. 2013. "Interview with Allen Say by Stephanie Loer." http://www.houghtonmifflinbooks.com/authors/allensay/questions.shtml.

Reading Is Fundamental (RIF). 2013. "Meet the Authors and Illustrators: Allen Say—Illustrator." *RIF Reading Planet*. http://www.rif.org/kids/readingplanet/bookzone/say.htm.

Say, Allen. 1995. "Grandfather's Journey." *Horn Book Magazine* 71 (1): 30–32.

# Grandpa Green

## *2012 Caldecott Honor*

Elaborate topiary sculptures give visual form to memories in a wildly fanciful garden tended by a child and his beloved great-grandfather. Using an inspired palate [*sic*], Lane Smith invites readers to tour a green lifetime of meaningful moments.—2012 Caldecott Award Committee (ALSC 2013, 95)

*Author/Illustrator:* Lane Smith
*Style:* Cartoon, abstract
*Media:* Characters rendered with brush and waterproof drawing ink. Foliage created with watercolor, oil paint, and digital paint.

### ANALYSIS

In the illustrations of a boy tracing his great-grandfather's life through the living sculptures in a topiary garden, white space plays with various green hues. The shrubs, created without outlines in mottled shades of green, contrast with the narrow black lines of the trees, the gardener and child, and the objects retrieved by the boy. Lane Smith also uses soft browns throughout the book and occasional pastel blues; these subdued colors impart a sense of serenity. In contrast, red appears less often for humorous or dramatic effect, emphasizing the great-grandfather's chicken pox rash or the ravages of war, for example.

Smith uses no shadows in the compositions, lending a flat look to the illustrations. However, he adds shading to the dense, textured topiaries to give them a three-dimensional quality as they play a central role in the

storytelling. Smith achieves the unusual textures in the illustrations through a "media extravaganza" of various techniques.

> [For the grass] sometimes I used a sponge dipped in watercolor. On the bottom of the tree trunk [on the spread "Now he's pretty old"] I used an oil-based paint and a lot of thinner. I sprayed the paint with a water-based varnish. Blow-drying the wet surface separates [the paints]; the water repels the oil and it mottles up, leaving a beaded look. The leaves on the top of the tree are in watercolor and waterproof India ink. (Brown 2011)

The boy and great-grandfather are drawn with simple outlines in black ink with portions filled in with touches of dappled green and brown. These colors add visual interest and link the characters to the garden they care for. Because of the delicate, uncolored outline of the boy, Smith explains, "I could never put him in front of a bush or he would look like a white ghost. I always had to figure out a way to leave a white space open on the page for the boy so I could draw him in an outline" (Zenz 2012).

The belongings that the boy recovers along his walk are also drawn in black ink and subtly colored. In most scenes he picks up a new object that he carries, eventually in a wagon, to Grandpa Green. This visual story element is reinforced by the text only near the end of the book, when the boy admits that the gardener "sometimes forgets things."

After the stroll through the topiary garden reveals great-grandfather's life, the story reaches a turning point in the twelfth opening. In this spread, the boy swings on the branch of a broad tree with a strong horizontal line. Its leaves turn from green to brown across the image, and a single brown leaf floats past the boy. Like Grandpa Green, the tree is old with its wide trunk, gnarly roots, and rambling branches, two of which have been cut from the tree. The branches on the recto almost extend off the page, leading the reader's eye to a topiary elephant in the background.

A page turn shows a closer view of the elephant, upon which rests great-grandfather's "favorite floppy straw hat." On the verso, the elephant stands alone, while on the recto, the boy reaches from a ladder to remove the hat. The same elephant is featured on the front cover, where Grandpa Green is trimming the sculpture while the boy plays on a nearby tree. In proverbs the elephant is regarded for its memory, a primary theme of the story.

A straight or curved horizontal line at the bottom of most pages carries the boy along his journey. This pattern changes in three consecutive spreads. The wedding cake is viewed upward from its base for a stunning perspective. The following double-page spread shows the boy walking along a stone path around the outside of an oval maze. A page turn shows an almost dizzying vista of dozens of topiary "kids [and] way more grandkids" standing with the "great-grandkid" among a dozen tall tree trunks.

While a contemplative book, humor in the illustrations lightens the mood. Smith recalls, "I tried to be playful with objects." For example, in the first opening, the tears of the crying baby flow from a hose that the boy is holding on the following page. A rabbit munches on a giant topiary carrot in the third opening. In the spread with the cannon, Lane "thought of silent films starring Buster Keaton. He'd bend over just as the cannon ball was coming out. That's the type of gag I tried to incorporate" (Brown 2011).

Recounting Grandpa Green's life through his topiary garden demonstrates the Caldecott criterion of "excellence of pictorial interpretation of story, theme, or concept." In his unconventional combination of highly textured shrubs, simple line drawings, and abundant white space, Lane Smith shows "excellence of execution in the artistic technique employed." The clean presentation and limited palette embody the reflective tenor of the story, "[delineating] plot, theme, characters, setting, mood or information through the pictures."

## FOR FURTHER CONSIDERATION

- While some of the topiaries seem fantastical, Smith tried to remain true to nature and the topiary arts. "For some of the garden scenes . . . I asked a gardener friend, 'Is this possible?' . . . [For example,] with something called an espalier, you can force a plant to grow a certain way," as shown with the horizontal branch with the cannon ball (Brown 2011).
- Smith says that the distinctive style of the book "was influenced by no one in particular (well, maybe a little [Edward] Gorey in the way I drew the lines on the trees) but I feel a strong 1970s vibe when I look at it. That limited color (mostly green), against ink-lines that you saw in a lot of books of that era" (Streetman 2011).
- Smith won his first Caldecott Honor in 1993 for his illustrations of Jon Scieszka's *The Stinky Cheese Man and Other Fairly Stupid Tales*, featuring a dark palette of oil paint and mixed media.

## ILLUSTRATOR NOTE

The spectacular gatefold at the end of the book retells Grandpa Green's life and showcases his final sculpture of his adoring great-grandson. When editor Simon Boughton suggested this scene, Smith was unenthusiastic at first but then embraced the idea. "I became a cartographer charting a map . . . putting the topiaries in context [as the child traversed the garden]. . . . To Simon's credit, it really works because the final line of the book is about how 'the garden remembers' for the grandfather. The man's whole life is shown on this spread" (Brown 2011).

SOURCES CONSULTED

Association for Library Service to Children (ALSC). 2013. *The Newbery & Caldecott Awards: A Guide to the Medal and Honor Books*. Chicago: American Library Association.

Brown, Jennifer M. August 2, 2011. "A Garden of Memories." *Curriculum Connections*. http://web.archive.org/web/20120519131956/http://www.schoollibraryjournal.com/slj/newsletters/newsletterbucketcurriculumconnections/890968-442/a_garden_of_memories.html.csp.

Streetman, Burgin. October 2, 2011. "Meet Lane Smith: Part Two." *Vintage Kids' Books My Kids Love*. http://www.vintagechildrensbooksmykidloves.com/2011/10/meet-lane-smith-part-two.html.

Zenz, Aaron. July 5, 2012. "Interview #16: Lane Smith." *Bookie Woogie*. http://bookiewoogie.blogspot.com/2012/07/interview-16-lane-smith.html.

# Green

## 2013 Caldecott Honor

In this original concept book, Seeger engages all the senses with her fresh approach to the multiple meanings of "green." Using thickly-layered acrylics, word pairings, and cleverly placed die cuts, she invites readers to pause, pay attention, and wonder.—2013 Caldecott Award Committee (ALSC 2013, 93)

*Author/Illustrator:* Laura Vaccaro Seeger
*Style:* Realistic
*Media:* Acrylic paint on canvas

## ANALYSIS

Laura Vaccaro Seeger establishes an overall sense of unity through the use of color and die-cuts in a tribute to green in her book of the same name. When asked what *Green* is about, Seeger says, "It is showing the interconnectedness of the world" (Children's Book Guide 2013). All the manifestations of green—forest green, sea green, lime green, pea green, and many other shades—are associated together based on their hue. Thus the reader connects seas, forests and jungles, trees, grass and ferns, turtles and geckos, limes and peas. All of them are natural, and their connectivity through color suggests the environmental theme of the book.

    *Green* is further unified by Seeger's use of die-cuts. She says, "Because each and every page contains die-cuts, this book was a challenge as each painting, in effect, is a part of the painting before it and the painting after" (Seeger 2013). The use of die-cuts encourages the page turn as the reader wonders what will be revealed on the next page. The leaves of the forest

become fish in the sea. The nail head on the "faded green" page becomes a light above the barn door when the page is turned. Careful examination reveals the precision of this die-cut. Part of the cutout is the light, and a very tiny part to the right of the light flawlessly continues the seam between the barn boards. Seeger hides the word "khaki" in the tall grass of the "jungle green" spread. And, the word "jungle" is hidden in the Jackson Pollock splashes of the "khaki green" spread. The words would not be visible without the white framed die-cut.

The illustrations interpret the words of Seeger's poem. They also include a short narrative story. In "shaded green," a young boy reads beneath a tree. Four pages later, in the only wordless opening, the boy plants a seedling. The lack of words provides a dramatic pause. Time passes and the leaves of that seedling become leaves on the mature tree in the next opening. The little boy has grown into a man and stands with his daughter admiring the tree planted in his youth. This "forever green" spread includes the barn from the "glow green" pages, the apple tree and shade tree from the "shaded green" pages, and the boy, now a father, plus the seedling, now a tree, from the wordless spread. Repeating elements from previous pages unify the whole book.

While this is a book about the color green, green in all its values and chroma does not dominate each illustration other than the cover. Here the reader can appreciate the various shades of green. The title and three leaves in lighter shades are contrasted against a darker shade of green. Seeger also provides contrast on the title page, where the title *green* stands out against the dark brown. The green and brown remind the reader of tree leaves and bark and lead to the first illustration of "forest green." The title page also connects with the closing illustration, in which the tree is the focus.

Of *Green* Seeger says, "I wanted the paintings to be lush, so I used a very painterly style with acrylic paint" (Danielson 2012). Acrylic allows the artist to apply the paint thickly in layers to provide texture. In the last illustration, the texture of the tree trunk begs for the reader's touch. Acrylic can also be applied thinly like watercolor to allow for some transparency. The texture of the canvas is visible through the grass in "forever green." The painterly style is most evident in the tree leaves where brush strokes are deliberately apparent.

Of many of her books, Seeger says, "The biggest challenge is to turn the concept into a cohesive, well-designed package with a simple story woven subtly throughout" (Rattigan 2008). She meets this challenge as well as the Caldecott criteria of excellence "of execution in the artistic technique employed," "of pictorial interpretation of story, theme, or concept," and "of presentation in recognition of a child audience."

## FOR FURTHER CONSIDERATION

- Seeger says her favorite painting in *Green* is "all green" because "this spread is composed of swatches from every other painting in the book." She explains, "What is seen through the holes on this spread is at once part of the art on this painting, and part of the art on the paintings before and after this one, as well" (Seeger 2013). That shows the interconnectedness of all the paintings in the book.
- Seeger alternates the placement of text on each two-page spread to provide variety and interest. All the text is simple sans serif except "faded green" to match the simplicity of the poem.
- Seeger won a previous Caldecott Honor in 2008 for *First the Egg.*

## ILLUSTRATOR NOTE

One evening Laura Vaccaro Seeger received an e-mail from her editor suggesting that she write a book with the title *Green*. Usually Seeger's books evolve from her journal notes and sketches. She questioned her editor if this was to be an environmental book. He responded, "I have no idea." After some initial work, the concept seemed too large, and Vaccaro set it aside. About a year later the title *Green* came to mind again, and she considered how many things in the world are green. She jotted a simple poem about green. She had been concerned about creating a book that was didactic. But it occurred to her that if she incorporated die-cut holes, she could "illustrate the idea that everything in our world is connected and if we look a little closer, we might see and appreciate that which we stopped noticing long ago" (Seeger 2013). She hoped that her exploration of green would foster an appreciation of the environment that would encourage people to care for it.

## SOURCES CONSULTED

Association for Library Service to Children (ALSC). 2013. *The Newbery & Caldecott Awards: A Guide to the Medal and Honor Books.* Chicago: American Library Association.

Children's Book Guide. 2013. "Green by Laura Vaccaro Seeger." http://childrensbooksguide. com/reviews/green-by-laura-vaccaro-seeger.

Danielson, Julie. April 17, 2012. "Seven Questions over Breakfast with Laura Vaccaro Seeger." *Seven Impossible Things before Breakfast.* http://blaine.org/sevenimpossiblethings/?p= 2331.

Rattigan, Jama. 2008. "Soup's On: Laura Vaccaro Seeger in the Kitchen." *Jama Rattigan's Alphabet Soup.* http://jamarattigan.livejournal.com/90607.html.

Seeger, Laura Vaccaro. 2013. "Writing Green." *Teaching Books.net.* http://forum. teachingbooks.net/?p=9802.

# The Hello, Goodbye Window

## 2006 Caldecott Medal

The richly textured tones of these expressive illustrations convey the emotional warmth of the intergenerational connection.—2006 Caldecott Award Committee (ALSC 2006)

*Author:* Norton Juster
*Illustrator:* Chris Raschka
*Style:* Abstract
*Media:* Watercolor, pastel crayons, charcoal pencil

## ANALYSIS

Bright swaths of color with spare outlines welcome the reader to a joy-filled story of a girl's overnight visit with her grandparents. The abstract art has a childlike quality that reflects the first-person voice of the young protagonist. Humans have large heads and hands out of proportion to their simple body shapes and limbs; lush flora emerges from broad strokes and swirls. Chris Raschka's style and use of color and texture are noteworthy aspects of the striking illustrations.

Deft splotches and squiggles of watercolor and oil pastels create detailed scenes and expressive faces. Minimal pencil lines, as well as scratches in the pastels, help sharpen and define some of the elements of the illustrations. In the busy kitchen in the third opening, Raschka suggests a shelf "full of glass jars" with a simple brown line and vertical strokes of blue watercolor, each embellished with dabs of pastel and topped with a contrasting color. A few pencil lines identify the white and blue colors in front of Nanna as a news-

paper and the colored slashes on the table as crayons. Raschka draws subtle wrinkles on the woman's face and hand by layering different colors of oil pastel and then scratching the surface with a folding bone to reveal a lighter hue. He employs the same technique to embellish the girl's and Nanna's curls, Poppy's plaid shirt, and the kitchen drawers.

The horizontal illustration covers most of the spread, firmly grounded at the base with text at the top. Poppy's stance carries the reader's eye across the image to rest momentarily on the girl's activities in the foreground. Nanna's gaze to the left keeps the reader on the page while the step stool behind her calls attention to the sink near Poppy. White space on the verso balances with the more suffused colors on the recto. Most of the illustration is contained within the edges of the borderless pages, with a few bleeds off the bottom and right edge.

In contrast, the nighttime scene of the sixth opening bleeds off much of the dark spread. Bits of white space near some of the edges and the white text lessen the intensity of the composition. The house, outlined in turquoise, has four glowing windows, one showing the smiling faces of Nanna and the girl. Stars and swirls scratched in the sky and trees, touches of orange and pink, and a strip of light green in the foreground subtly warm the tableau.

For most of the double-page spreads, Raschka positions the illustrations on the bottom of the page "to make them almost come out of the frame, to jump off the page. I work for young kids who want things close up and are immediate and tactile" ("Chris Raschka" 2012). The artist also uses a strong triangular composition in many images, including the first, fourth, and eighth openings, when the girl approaches her grandparents' home, Poppy plays the harmonica, and Poppy makes breakfast. The three-story house also has a broad base and narrower top. A triangle imparts a sense of stability, a concept central to the narrative.

Raschka designs some spreads with two or three smaller illustrations. The appealing tenth opening shows two vignettes on the verso. Here, the companion views of Poppy on the upper right and Nanna on the lower left are well balanced as they both give advice to the girl. On the recto, Nanna stands, her body curved. She frames the action as Poppy playfully chases the girl in the background, leading to the page turn.

Chris Raschka's carefully composed abstract illustrations are imbued with joy and communicate a sense of comfort and security, meeting the Caldecott criterion of "appropriateness of style of illustration to the story, theme or concept." His loose, spontaneous application of color and line achieves "excellence of execution in the artistic technique employed." The cheerful artwork is reminiscent of a child's, demonstrating "excellence of pictorial interpretation" of the story.

## FOR FURTHER CONSIDERATION

- The flower barrel that allows the girl to tap on the hello, goodbye window is firmly in place upon her arrival and throughout her visit. It is missing, however, as she joins her parents and waves farewell to Poppy and Nanna, symbolizing the girl's departure.
- The dust jacket and book cover differ markedly. On the front of the dust jacket, the illustration almost fills the space, bathed in yellow; the title, author, and illustrator are displayed in a bold sans-serif typeface across the top. The back of the jacket shows the girl saying goodbye to her grandparents from the thirteenth opening. However, the cover is predominantly white with a black spine, reminiscent of a photo album. The image on the front cover is smaller and on a white background; the title, creators' names, and publisher appear only on the spine. The back cover shows the girl saying goodbye to her parents from the dedication page.
- After reading the manuscript for *The Hello, Goodbye Window*, Raschka produced a thumbnail dummy for author Norton Juster to react to. These small dummies are a crucial early step in Raschka's creative process. "I write down the idea, and then I make many book dummies of the book itself. I consider the book to be the form, if you will—not the pictures, not the words, but the book itself—so I really need to feel it and see it" (Danielson 2009).
- Raschka received a 1994 Caldecott Honor for *Yo! Yes?* and a 2012 Caldecott Medal for *A Ball for Daisy*.

## ILLUSTRATOR NOTE

Norton Juster and editor Michael di Capua selected Chris Raschka to illustrate the story, which was inspired by Juster's granddaughter. The artist agreed to the proposal. He recalls, "I was thrilled to create something new with Norton Juster. The text was not the kind of thing that I had illustrated before. It was very much a real story. I liked the tone of the child's voice and I wanted to find that same tone artistically" (Marcus 2012, 190).

At the beginning of the project, Raschka saw an exhibition featuring the work of twentieth-century painter Philip Guston, "huge, abstract expressionist paintings with thickly applied paint. They reminded me of the kids' art I was looking at just then. I thought, *This girl is supposed to be about six. I would like to embody some of the qualities of the kids' drawings and Guston's paintings in the illustrations*" (Marcus 2012, 190).

## SOURCES CONSULTED

Association for Library Service to Children (ALSC). 2006. "2006 Caldecott Medal and Honor Books." http://www.ala.org/alsc/awardsgrants/bookmedia/caldecottmedal/caldecotthonors/06caldecottmedalhono.

"Chris Raschka." 2012. *Contemporary Authors Online*. Detroit: Gale.

Danielson, Julie. August 26, 2009. "Seven Impossible Interviews before Breakfast #83: Chris Raschka." *Seven Impossible Things before Breakfast*. http://blaine.org/sevenimpossiblethings/?p=1771.

Marcus, Leonard S., ed. 2012. *Show Me a Story! Why Picture Books Matter: Conversations with 21 of the World's Most Celebrated Authors*. Somerville, MA: Candlewick.

# Henry's Freedom Box: A True Story from the Underground Railroad

## 2008 Caldecott Honor

Inspired by an antique lithograph, Nelson has created dramatically luminous illustrations that portray Henry "Box" Brown's ingenious design to ship himself in a box from slavery to freedom.—2008 Caldecott Award Committee (ALSC 2013, 98)

*Author:* Ellen Levine
*Illustrator:* Kadir Nelson
*Style:* Realistic
*Media:* Pencils, watercolor, and oil

## ANALYSIS

One of Kadir Nelson's editors said, "Anyone who has seen Kadir's work can attest to the power of his paintings, especially his portraits. The subjects often stare frankly and directly at the viewer, conveying so much while hinting at mysteries below the surface" (Bray 2012, 75–76). This is the case with young Henry on the cover of *Henry's Freedom Box*. He sits in a field, hands loosely clasped on his knees, and looks soberly at the reader. He neither smiles nor frowns. Backlight from the sun casts a glow around his figure. His face is luminous, shining with an inner radiance.

This contrasts with the first illustration in the book. In a similar pose, Henry sits on a keg against a brick wall. We learn from the text that he is a slave and isn't sure how old he is because slaves weren't allowed to know

their birthdays. There are no toys, just a quilt in the lower left. Henry sits in shadow, and though he appears dignified, his eyes and mouth exude sadness. There is a stillness to this illustration, enhanced by Henry's erect posture and the horizontal lines of the bricks and keg.

Reviewers comment on Nelson's ability to convey emotions. "You can literally feel what the characters are going through as a result of Nelson's illustrations" (Mann 2007). The two-page spread of the eighth opening is a larger-than-life close-up of Henry's face set against the background of the factory windows. Henry is at work, but the focus is entirely on his thoughts. He is worrying about the fear his wife voiced the night before. Because her master had lost a lot of money, she said, "I'm afraid he will sell our children." Henry's eyes are downcast as he considers this possibility.

Her master does sell both Henry's wife and his children. In the tenth opening, he searches frantically for his family, seeing them at the last moment as they are driven away in a wagon. His children's hands are tied and their faces are frightened. On the next page, a diagonal support board leads to Henry slumped in heartbreaking agony, hands covering his face. He knows he will never see his family again. He sits on the same stool he sat on just the night before while happily playing his banjo for his family. The edge of the quilt that hangs above the fireplace in opening seven is visible on the right edge of the recto in opening eleven. The firelight glows on the front of Henry's shirt and trousers. In this illustration and in all the illustrations, Nelson employs crosshatched pencil lines to add texture and shadows. The crosshatching also suggests that the illustrations are from the past.

Most of the illustrations are full-bleed, two-page spreads. The seventeenth opening is a dramatic change. Against a white background, Nelson presents four vignettes of two men rolling the box in which Henry is hidden. The reader can see Henry in his cramped quarters because one side of the box has been cut away for this purpose. His face shows panic. He tries not to make any noise and braces his hands against the side of the box, fingers splayed. The illustrations are balanced both on the individual pages as well as across the spread. Four small illustrations in quick succession clearly convey this action sequence.

"Nelson's illustrations could tell the story without any help from the words" (Mann 2007). This meets the Caldecott criteria of "excellence of pictorial interpretation of story, theme, or concept" and "delineation of plot, theme, characters, setting, mood, or information through the pictures." His choice of colors and his ability to express characters' feelings fulfill the criteria of "excellence of execution in the artistic technique employed" and "appropriateness of style of illustration to the story, theme, or concept." Kadir Nelson said, "My work is all about healing and giving people a sense of hope and nobility. I want to show the strength and integrity of the human

being and the human spirit" (Nelson 2013). He does this in *Henry's Freedom Box*.

## FOR FURTHER CONSIDERATION

- Though the title is *Henry's Freedom Box*, Nelson does not include the box on the front cover or the title page. The omission of the box causes curiosity about it. The back cover shows three panels of wood from the box.
- Nelson employs a somber palette, suitable for a story about slavery. The endpapers are a golden bronze brown, much like Henry's skin tone.
- Nelson won one previous Caldecott Honor in 2007 for *Moses: When Harriet Tubman Led Her People to Freedom*.

## ILLUSTRATOR NOTE

The inspiration for Kadir Nelson's art in *Henry's Freedom Box* was an 1850 lithograph entitled "The Resurrection of Henry Box Brown at Philadelphia, who escaped from Richmond Va. in a box 3 feet long 2 1/2 ft. deep and 2 ft wide." It is located in the Prints and Photographs Division of the Library of Congress. The last illustration in the book is very similar to the lithograph. "To give the feel of the original lithograph, Mr. Nelson crosshatched pencil lines, and then applied layers of watercolor and oil paint" (Levine 2007). Though the box was addressed to William H. Johnson in the book, when Henry actually emerged, it was in the office of the Pennsylvania Anti-Slavery Society. One of the four men depicted in the lithograph is Frederick Douglass.

## SOURCES CONSULTED

Association of Library Service to Children (ALSC). 2013. *The Newbery & Caldecott Awards: A Guide to the Medal and Honor Books*. Chicago: American Library Association.

Bray, Donna. 2012. "Kadir Nelson." *Horn Book Magazine* 88 (3): 74–77.

Levine, Ellen. 2007. *Henry's Freedom Box*. Jacket flap. New York: Scholastic.

Mann, Frances. 2007. Review of *Henry's Freedom Box*, by Ellen Levine. *Children's Literature Comprehensive Database*. http://clcd.odyssi.com/cgi-bin/sirsi/search/r?dbs+child:@term+@isbn+043977733X.

Nelson, Kadir. 2013. "About Kadir Nelson." *Black Art Depot*. http://www.blackartdepot.com/kadirnelson-bio.htm.

Rowse, Samuel. c. 1850. "The Resurrection of Henry Box Brown at Philadelphia, who escaped from Richmond Va. in a box 3 feet long 2 1/2 ft. deep and 2 ft wide." Lithograph. *Library of Congress*. http://www.loc.gov/pictures/item/2004665363/.

# The House in the Night

## 2009 Caldecott Medal

With her clear artistic vision, Krommes has created visual poetry.—Nell Colburn (Colburn 2009)

*Author:* Susan Marie Swanson
*Illustrator:* Beth Krommes
*Style:* Folk art
*Media:* Scratchboard and watercolor

## ANALYSIS

In her Caldecott Medal acceptance speech, Krommes describes Susan Marie Swanson's text as "lyrical, inspiring, and so open-ended that the story would be told primarily through the pictures. . . . When people ask me what *The House in the Night* is about, I say art, music, books, imagination, family, home, and love" (Krommes 2009, 12). She envisioned a parent and child reading in bed at night and tried to include things they would notice and discuss in her illustrations.

In order to fully appreciate the illustrations, it helps to understand the process of scratchboard drawing. To begin, Krommes applies a thin layer of white clay to a firm base of cardboard or a panel of wood and then coats the clay with a layer of India ink. Working with what is termed "negative imagery," she scratches white lines on the black ink surface using a sharp tool. Usually black lines are drawn on white paper, so this is a reverse process. The more the artist scratches, the more white is revealed and the brighter the

drawing becomes. It is to these white areas that the golden yellow watercolor is added.

A story about light and dark lends itself well to the black-and-white art with yellow accents implying warmth. In the eighth opening, the story within the story has begun. The bird has flown out of the book and through the window with the little girl lying on its back. With a bright swirl of birdsong, they pull a blanket of darkness across the night sky. The darkness reflects the shape of the bird, and the curved white trailing lines indicate gentle motion. In the countryside, outside the glare of city lights, the night is black, save for the stars and the golden glow from the lights in the houses and the headlamps of the cars. The night contrasts with the approaching twilight on the recto. No lights or headlamps shine yet. This page is brighter because more black has been scratched off, producing a range of values and adding depth to the illustration.

Krommes effects both value and texture through crosshatching and stippling. Each field of crops displays a different pattern. Variety appears in the trees and houses, most noticeably in the leaf patterns and rooftops. Like snowflakes, each star is different. Because the perspective is from above, stars float in the sky and dot the landscape below.

This is a circle story, and Krommes employs round shapes to match: rounded trees, rounded stars, and rounded hillsides. Round shapes convey a sense of calm and comfort. Curved lines are restful and ease the reader into the peacefulness that is a prelude to sleep.

Because this is a circle story, Krommes repeats scenes from the journey out to the moon and back again, creating a sense of balance. After the spectacular climax of reaching the moon, the girl and the bird begin their journey home. Echoed illustrations include peeks into the bedroom from the doorway with the golden key hanging on the wall, wide-angle views of the bedroom, the little girl sitting on the bed examining the book, the open window, and the aerial view of the nighttime countryside. The story closes with the little girl tucked up in her bed and the dog curled up in his bed, each with their teddy bears.

The folk-art style of the illustrations match and expand the simplicity of the text to meet the Caldecott criteria of "excellence of pictorial interpretation of story, theme, or concept" and "delineation of plot, theme, characters, setting, mood or information through the pictures." Though Krommes's illustrations appear simple, this effect is achieved through the intricacies of her scratchboard artistry, thus further meeting Caldecott criteria of "excellence of execution in the artistic technique employed" and "appropriateness of style of illustration to the story, theme or concept." Finally, illustrations that depict a reader embarking on a fabulous journey through the pages of a book and returning to the cozy comfort of home certainly qualify as "excellence of presentation in recognition of a child audience."

## FOR FURTHER CONSIDERATION

- Creating a unifying design, the golden endpapers encase the text and match the gold highlights throughout the book.
- The thirteenth opening deserves attention for its composition. Krommes achieves symmetry through balancing the girl and her teddy bear with the dog and the cat. Texts within white half-rounds balance each other at the top and bottom of opposite pages. The book and the lamp are near mirror images across the gutter.
- Krommes pays homage to some famous artists: in the second and eighth openings, the geese resemble those of M. C. Escher in his woodcut *Day and Night*, and a representation of Vincent van Gogh's *Starry Night* hangs in the little girl's bedroom in the fourteenth opening.
- Krommes describes her artistic style as retro, as if the illustrations could be from the 1920s or 1930s. Her illustrations are similar to Wanda Gág's *Millions of Cats* published in 1928. She pays tribute to Gág by including her house, Tumble Timbers, in the lower right corner of the recto in the seventeenth opening. A picket fence surrounds the house and yellow flowers fill the front garden.
- *The House in the Night* is reminiscent of Maurice Sendak's *Where the Wild Things Are*, winner of the 1964 Caldecott Medal. In both stories the child character leaves home on an imaginative journey and returns for warmth, comfort, and love. Each illustrator makes extensive use of crosshatching, but each illustrator employs distinctly different shapes and color.

## ILLUSTRATOR NOTE

Just as authors are instructed to write what they know, Krommes believes illustrators should draw what they know. The story setting is the rolling countryside of Pennsylvania, where she grew up. The little girl is Krommes herself as a child. She also added some of her favorite things. In the fourth opening, the violin is her daughter Marguerite's (her husband and both her daughters play the violin), and the mobile is made from shells collected on a family vacation to the seashore. The doll is one she made for her daughter Olivia, and the teddy bear is her sister's. Because Krommes included things she valued, the room is filled with music, art, animals, and, of course, books. Scamp, her childhood dog, is featured in this illustration and throughout the book, appearing prominently in the first two-page spread, when the little girl receives the key to the house. Very faintly, his name is scratched on his dog tag.

## SOURCES CONSULTED

Brattleboro Museum and Art Center. August 7, 2009. "Beth Krommes: The Poetry of Lines." http://www.brattleboromusseum.org/2009/07/07/beth-krommes-the-poetry-of-lines-2/.

Colburn, Nell. January 26, 2009. "Neil Gaiman, Beth Krommes Win Newbery, Caldecott Medals." *American Library Association.* http://www.ala.org/news/news/pressreleases2009/january2009/ymanewberycaldecott.

Hafesh, Louise B. 2011. "Scratching the Surface: With Scratchboard and Watercolor, Beth Krommes Creates Award-Winning Illustrations That Evoke Vintage Wood Engravings." *Artist's Magazine* 28 (9): 44–50.

International Reading Association. 2009. "A Book Filled with Light: Caldecott Medal Winner Shines Her Talent on *The House in the Night.*" *Reading Today*, 26 (5): 16.

Krommes, Beth. 2009. "Caldecott Medal Acceptance Speech: On 'Pow' Moments and Getting 'The Call.'" *Children & Libraries* 7 (2): 11–13.

# HUSH! A Thai Lullaby

## 1997 Caldecott Honor

Changing perspectives and a strong visual narrative move the action forward as the mother quiets each noisy animal in turn. A strong sense of composition and a soft earthy palette help support a vibrant visual text.—1997 Caldecott Award Committee (ALSC 1997)

*Author:* Minfong Ho
*Illustrator:* Holly Meade
*Style:* Abstract and cartoon
*Media:* Cut-paper collage with ink

### ANALYSIS

In this lullaby, a mother who has put her child to bed is concerned about noisy animals disturbing him. She asks each one to be quiet because "baby is sleeping." The illustrations, however, recount a different story. On lush full-bleed spreads that extend the text, Holly Meade shows a wide-awake child, out of his hammock and playing, just out of view of his mother.

The visual narrative begins before the text. On the title page, the mother is holding a sleeping child. On the dedication page, she is ready to place him in the bright blue hammock that frames the bottom of the illustration in a comforting curve. The burnt orange paper that holds the publishing information balances with the figures on the recto.

In contrast to the lilting, rhyming lullaby, the layout and perspective are dynamic, changing throughout the book. For example, in the fourth opening, two single-page illustrations are strong individual compositions that also

complement each other. On the verso, the action takes place on the lower left with the mother talking to the cat. Her pointing finger and the ladder draw the eye up to the boy, peeking over the hammock. On the recto, the mother's gaze and the roof create a strong diagonal line. The ladder leads to the rice barn entry, outlined in red. The entire spread works well, with darker hues on the verso and a beige background on the recto. Ladders on each page unify the illustrations.

A different page design in the sixth opening conveys action by showing four views of mother pursuing the frog across one continuous landscape. A strip of speckled paper winds through the composition. The reader sees the child's feet in the upper verso, indicating that he is standing on the deck, watching his mother.

Meade takes yet another visual approach in the ninth opening, where the vantage point is from just above the swinging monkey. The mother stands far below, calling to the creature. The soft pool of paint around her feet and the textured paper around the house anchor them to the ground. This time, the child is mimicking the monkey, swinging from a railing beyond the sight of his mother.

The cut-paper collages are in earth tones with many warm hues. A range of pleasing neutrals suffuses the home, with the hammock providing a splash of blue. Outside, shades of tan, green, and blue fill the yard and countryside.

The mother is easily identified by her orange striped blouse, deep rust skirt, and white head wrap. The mischievous child is clad in bright orange, a color that exudes energy. Distinctive red-orange contour lines give definition to the mother and child as well as many of the animals. The outlines curve and flow around the subjects. Interesting papers and woven mats add texture to the images. Subtle shadows, usually under the mother's feet and the child's hammock, provide some depth to the otherwise flat illustrations.

Meade shows the passage of time by deepening the background hues as the story progresses. The mother grows tired as well: by the twelfth opening, her eyes are heavy with fatigue, while in the fourteenth opening she has fallen asleep sitting on the floor, head in her arms.

Meade's artistic style is difficult to classify. The medium of collage has an abstract quality in which "artists exaggerate or simplify objects and forms" (Matulka 2008, 78). For example, in the third opening, horizontal and vertical strips of paper transform into the earth, shadow, and band of sunshine beneath the house, with a ladder, floorboards, and siding above the ground. In the scene with the loose-limbed monkey, the illustrator creates foliage with a large swath of mottled green paper combined with smaller pieces of soft-torn and sharp-cut paper. Throughout the book, the artist uses the "exaggerated expressive qualities" of cartoon art (Galda and Cullinan 2002, 91) to render the characters' facial expressions and stylized poses and gestures.

Through her illustrations, Holly Meade expands the narrative to relate a parallel story of an active, curious child thought to be asleep, meeting the Caldecott criterion of "delineation of plot, theme, characters, setting, mood or information through the pictures." By revealing the baby's antics on the edges of the illustrations, the artist adds an element of delight in an "[excellent] presentation in recognition of a child audience." Meade's intriguing paper collages and noteworthy composition show "excellence of pictorial interpretation of story, theme, or concept."

## FOR FURTHER CONSIDERATION

- Meade explains that "reference materials are important [in the artistic process], as much of what I'm asked to illustrate I haven't directly experienced . . . [such as] a water buffalo in a Thailand jungle" (Danielson 2009).
- A small feather-like motif appears on the title page, dedication page, and dust jacket spine. It closely resembles floral designs in Thai painting and sculpture.
- Unlike the colorful dust jacket, the cover is olive green, with title, creators' names, and publisher in gold type on the spine. An imprinted image of a cat curled in sleep graces the lower right corner.

## ILLUSTRATOR NOTE

When working with collage to illustrate a book, Holly Meade first studies the story and then creates line drawings. She contends that "the initial drawings are the most challenging" (Meade 1998) as she contemplates "what to take from the text to the picture, what to add to the picture that's not in the text, how to compose the picture in the most exciting and pleasing way, how to stay true to the spirit of the story" (Meade 2013).

The drawings are "translated into cut shapes" (Danielson 2009). Meade describes how creating the final artwork involves "choosing paper, considering weight, color, and texture, knowing whether to cut or tear—all this is guided by that part of my mind that feels its way along, seemingly bypassing linear thought. It's tactile and intuitive and immediate. I find it difficult, but more like serious play than serious work" (Meade 1998).

## SOURCES CONSULTED

Association for Library Service to Children (ALSC). 1997. "1997 Caldecott Medal and Honor Books." http://www.ala.org/alsc/awardsgrants/bookmedia/caldecottmedal/caldecotthonors/ 1997caldecott.

Danielson, Julie. August 10, 2009. "Seven Questions over Breakfast with Holly Meade." *Seven Impossible Things before Breakfast*. http://blaine.org/sevenimpossiblethings/?p=1759.

Galda, Lee, and Bernice E. Cullinan. 2002. *Cullinan and Galda's Literature and the Child*. 5th ed. Belmont, CA: Wadsworth/Thomson Learning.

Matulka, Denise I. 2008. *A Picture Book Primer: Understanding and Using Picture Books*. Westport, CT: Libraries Unlimited.

Meade, Holly. 1998. "Watching for Accidents." *Horn Book Magazine* 74 (2): 184.

———. 2013. "Meet the Illustrator: Holly Meade." *Houghton Mifflin Reading*. http://www.eduplace.com/kids/hmr/mtai/meade.html.

# In the Small, Small Pond

## 1994 Caldecott Honor

Fleming doesn't just make paper on which to put her artwork; the paper is the medium from which the art itself is created.—Dilys Evans (Evans 2008, 123)

*Author/Illustrator:* Denise Fleming
*Style:* Abstract
*Media:* Colored cotton pulp poured through hand-cut stencils

### ANALYSIS

As in the commanding artwork throughout the book, color, line, and texture dominate the full-bleed illustration in the ninth opening. In the small, small pond, "sweep, swoop, swallows scoop" in a vibrant double-page spread.

A yellow background imparts the warmth of the summer sun and light green grasses line the shore of the pond. The water is more green than blue, setting off two striking blue and orange swallows. Lily pads are of the same value as the shoreline hues and include a bit of rust, perhaps a reflection of a bird above. A frog appears in every spread of the book, exploring the four seasons and interacting with other animals. Here, only its head peeks out of the pond as it observes the birds. Its colors match the lily pads between which it floats.

The barn swallows dive toward the water in a dramatic diagonal movement, their wings spread. The bird on the recto takes a drink, its open beak skimming the water. Sharp wing feathers, tails, and beaks are similar in shape to the grasses. On parts of the birds, readers can see a subtle red, blue,

or violet outline. In many other illustrations, narrow outlines help define the flora and fauna and give added dimension to the artwork.

The spectacular flight of the birds is in contrast to strong horizontal lines that lend stability to the spread, with the shoreline in the background, the pond in the middle ground, and the lily pad and trail on the water in the foreground. Throughout the book, sturdy horizontal backgrounds provide a foundation for the range of wildlife that finds shelter or sustenance in the aquatic habitat.

The bold, sans-serif typeface is integral to the illustration. The verbs move across the spread in rounded forms to visually describe the action. Indeed, on every spread the text is in motion, deliberately woven into the artwork. Letters and words wiggle and waddle, click and flip, and splatter and stack.

Along with the changing activities of creatures in, beside, and above the pond, Denise Fleming's choice of colors conveys the passing of the seasons. The bright values of spring and summer transform into muted tones of fall and winter. Readers can see this change by comparing the goose in the third opening to that in the fourteenth. In the spring, a proud parent parades with three lively goslings among warm yellow, green, and brown hues. The beak of the robust adult goose breaks out of the page. As winter approaches, however, cool blues and purples penetrate the sky and water, dull green grasses bend in the wind, and white snow flies. In this wider view of the pond, the goose is contained in the frame. Its neck and head are in the same position as in the earlier scene, but its wings are spread as it prepares for flight. The final single page shows a hibernating frog in the right corner, facing left. The flyleaf on the recto makes it clear that the story has drawn to a close.

Fleming's use of colored cotton pulp as her artistic medium gives depth and texture to her illustrations. Dipping a mold (wooden frame with a wire screen) and deckle (frame) into a vat of cotton rag fiber suspended in water, she first makes the background of an illustration. While the paper is still wet, she pours colored paper pulp through hand-cut stencils to create under-drawings or "paints" onto the screen by squeezing pulp from a bottle or pouring it from a cup. She works from background to foreground as if "standing in the back of the picture and walking toward the front" (Evans 2008, 124). Fleming explains, "I layer and slowly build up the pulp. Some of the sheets are three quarters of an inch thick before I press and dry them" (Fleming 2010). Readers can see the texture of the handmade paper and even individual cotton fibers of the pulp.

Denise Fleming's mastery of a unique medium demonstrates the Caldecott criterion of "excellence of execution in the artistic technique employed." The bright, intriguing illustrations effectively "[delineate] plot, theme, characters, setting, mood or information." Her visual interpretation of wildlife in

and around a pond during the course of a year achieves "excellence of presentation in recognition of a child audience."

## FOR FURTHER CONSIDERATION

- On each page, Fleming changes the perspective to best suit the image, from close-ups of dragonflies and whirligigs to wider views of a heron and muskrats. At times, she even brings the reader underwater to observe tadpoles, minnows, and ducks.
- In most spreads, the dominant movement of the animals is from right to left, leading readers to the page turn, such as the goose family in the third, the minnows in the seventh, and the raccoon in the twelfth openings.
- A dynamic illustration extends from the front to the back cover of the book to begin the story. Here, the action of the frog springing toward an astonished child seems to take place an instant before the first opening, when the story begins. In this spread, the frog plunges into the water on the other side of the curious explorer.
- Fleming's choice of color is noteworthy. She acknowledges that she "use[s] strong color, not always the colors that nature chooses, but color that conveys the mood and movement of a particular creature or moment" (Fleming 2010).
- When a book idea is ready for development, Fleming creates drawings for a full-size dummy using a broad china marker on tissue paper. She explains, "I sketch and I cut apart and then I tape together again to make the images." She enlarges or shrinks individual elements on a copy machine until they are the size that best suits the composition. From this "collage of cut-and-pasted ideas," she traces the final design onto tissue parchment (Evans 2008, 123). She cuts stencils for specific shapes from foam meat trays.

## ILLUSTRATOR NOTE

Denise Fleming photographed the animals featured *In the Small, Small Pond* in the same parcel of wild acreage that inspired her earlier companion book *In the Tall, Tall Grass*, published in 1991. The meadow, creek, and woods stood behind her home in Toledo, Ohio, where she and her daughter spent much time observing the plants and wildlife. Fleming recounts the fate of this land after it was sold to developers in *Where Once There Was a Wood* (1996).

## SOURCES CONSULTED

Evans, Dilys. 2008. *Show & Tell: Exploring the Fine Art of Children's Book Illustration.* San Francisco: Chronicle.

Fleming, Denise. August 1, 2010. "A Visit with Denise Fleming." http://www.denisefleming.com/pages/about.html.

# Interrupting Chicken

## 2011 Caldecott Honor

I'll never forget the experience of sitting in a beloved lap and having a whole world open before me: a world brought to life by the pictures and the grown-up's voice. That wonder is what I want to recreate in my own books.—David Ezra Stein (Stein 2013)

*Author/Illustrator:* David Ezra Stein
*Style:* Cartoon and postmodern
*Media:* Watercolor, water-soluble crayon, china marker, pen, opaque white ink, and tea

### ANALYSIS

David Ezra Stein uses three distinct styles to create a bedtime story about bedtime stories: deep crayon and watercolor cartoon illustrations of Chicken and her father in the main body of the book; pen-and-ink line drawings of three classic folktales; and childlike images created by Chicken in her own picture book. The changing styles infuse this energetic tale with humor and tenderness.

Restful aqua-colored endpapers extend an invitation into the bedtime reading ritual of exuberant Chicken and her accommodating Papa. By the twelfth opening, Chicken has interrupted the third story, leaving the pair with nothing else to read. On the verso, Stein's cartoon illustration shows Papa collapsed over their book, exasperated by Chicken's antics of leaping into the stories and hastening their endings. Confident and satisfied, Chicken leans against her bed with one leg crossed in front of the other, pontificating with a

wing raised and eyes closed. The illustration bleeds off the page in rich colors applied to black paper. The weight of this image is balanced by the design of the recto, where abundant white space with a playful font draws the reader's eye to a smaller composition almost contained in an oval. Here, Chicken hugs Papa when she is told they are out of stories to share. She seems close to tears as Papa's rounded head and comb break out of the uneven frame. This same layout is repeated two other times in the book.

In this spread, warm and cool colors are used effectively. Orange stripes and red flowers complement aqua wallpaper. The orange and red chickens are dressed in blue and sport dark green tails. A small lamp provides an important light source for the bedtime setting. Its glow throws yellow tones on the wallpaper and dark floor and brightens the white pillowcase. Light shines upon a small yellow book under the bed, foreshadowing an important turn in the story. The storybook, Chicken, and the bed cast shadows in the nighttime scene.

Chicken and Papa reach this discouraging moment after attempting to read three folktales: "Hansel and Gretel," "Little Red Riding Hood," and "Chicken Little." In each, the gutter of the storybook falls into the gutter of the actual book as if the reader is sharing it alongside father and child. The sepia-toned illustrations are rendered in a loose pen and ink style, giving them an old-fashioned appearance. Just one color is featured in each tale, matching the storybook's binding, and the text of the story is in a formal font. For example, in the fourth opening, a gold-covered book is opened to the story of "Hansel and Gretel" and an earthy orange color decorates the illustrations. Candy and snacks are strewn about the bottom of the book in a humorous reference to the folktale. The tension rises when Hansel and Gretel are invited into an old woman's candy cottage. When the reader turns the page, Chicken herself has jumped into the story to caution the children, "DON'T GO IN! SHE'S A WITCH!" This warning, handwritten in a childlike script within a speech balloon, contrasts with the actual text of the tale, which is now illegible. Chicken's unexpected intrusion alarms the folktale characters as the story comes to an abrupt but happy end. Stein uses this same formula for the two folktales that follow.

The third style represented is the childlike art in the handwritten story "Bedtime for Papa" that "Chikn" creates in her yellow notebook, decorated with crayon pictures, stickers, and glitter. Yellow borders surround Chicken's illustrations, the pages filled with extraneous doodlings. Switching roles, the real Papa interrupts Chicken's story with his snores, startling the characters in her story.

Through varying art styles, David Ezra Stein effectively elucidates the multiple stories of this unified metafictive work, meeting the Caldecott criteria of "appropriateness of style of illustration to the story, theme or concept" and "delineation of plot, theme, character, setting, mood or information

through pictures." The three child-friendly and humorous styles embody "excellence of presentation in recognition of a child audience."

## FOR FURTHER CONSIDERATION

- The front cover introduces the characters and sets the tone of the book. A brief exchange between Chicken and Papa alerts the reader to the child's propensity to interrupt stories. Indeed, Chicken's speech balloon even obscures a bit of the title.
- In the double-page spread of the title page, Stein seems to create a stage for the story. This is fitting given his previous work experience. After graduation from the Parsons School of Design, he held a number of different creative jobs, including window-display artist and interior and set-design illustrator.
- Stein uses a different typeface for each of the three styles of illustration to complement each artistic style.
- To create the background images of the primary narrative, the artist uses crayons on black, rather than white, paper. This subtly darkens the illustrations to reflect the nighttime setting.
- The wallpaper that covers the outer half of the first and final openings presents a clear beginning and end to the story. The wallpaper appears on every spread of the primary story, offering a sense of continuity.
- The title page shows a window with the curtains blowing. A similar illustration is used as spot art on the copyright page at the end of the book. The rising moon indicates that time has passed.
- Some definitions of a postmodern picture book describe its five "motifs" or "themes": nonlinearity of narratives, playfulness bordering on the absurd, irony and contradiction, self-referential text, and a story that invites coauthoring. One or more of these characteristics may define a book as postmodern (Goldstone and Labbo 2004). In a postmodern approach, the protagonist of *Interrupting Chicken* does not merely interrupt Papa's reading but leaps into the tales to interact with characters and change the outcome of the stories in nonlinear, playful, and ironic ways.

## ILLUSTRATOR NOTE

David Ezra Stein considers himself an author/illustrator rather than simply an illustrator. He explains, "I am an idea person! I think in words and pictures, so I use a combination of words and pictures in my work" (Danielson 2008). In the case of *Interrupting Chicken*, Stein based the book on a knock-knock joke (Brown 2011):

Knock knock!

Who's there?

Interrupting chicken.

Interrupting chi—

BWOK, BWOK, BWOK!

## SOURCES CONSULTED

Brown, Jenny. February 28, 2011. "Readeo's Jenny Brown Talks with David Ezra Stein, Author of: *Interrupting Chicken*." *Book Chatter*. http://www.readeo.com/readeo's-jenny-brown-talks-with-david-ezra-stein-creator-of-interrupting-chicken/.

Danielson, Julie. October 30, 2008. "Seven Questions over Breakfast with David Ezra Stein." *Seven Impossible Things before Breakfast*. http://blaine.org/sevenimpossiblethings/?p= 1478.

Goldstone, Bette P., and Linda D. Labbo. 2004. "The Postmodern Picture Book: A New Subgenre." *Language Arts* 81 (3): 196–204.

Stein, David Ezra. 2013. "About David Ezra Stein." *Funny, with Love*. http://www.davidezra. com/About-David-Ezra-Stein.

# The Invention of Hugo Cabret

## 2008 Caldecott Medal

> I wanted to create a novel that read like a movie. What if this book, which is all about the history of cinema, somehow used the *language* of cinema to tell its story? How could I do this?—Brian Selznick (Selznick 2008, 11)

*Author/Illustrator:* Brian Selznick
*Style:* Realistic
*Medium:* Pencil on Fabriano Artistico watercolor paper

### ANALYSIS

In *The Invention of Hugo Cabret*, Brian Selznick's pencil illustrations are intrinsic to the narrative, carrying the story forward in an unconventional and innovative manner. At a length of 533 pages, including 284 pages of illustrations, the work melds the formats of picture book, novel, graphic novel, flip book, and film. Given its size and length, the work does not resemble a typical picture book. Indeed, upon winning the Caldecott, it shattered the concept of the picture book.

The black-and-white illustrations are central to the fictional story, which revolves around early French cinema, timekeeping, automata, and magical illusion in 1931 Paris. The black borders around each page resemble film frames, reflecting an important element of the story. The double-page spreads vary from multipage sequences that depict an entire scene to single illustrations that highlight a significant moment. Selznick explains that he wanted to "recreate the experience of a movie in the turning of pages, to

reflect in the page-turning what Hitchcock and Truffaut were doing with their cameras" (Vulliamy 2012).

Selznick uses crosshatching to create depth, shadow, and texture. The illustrations are generally more dark than light, capturing the mood of this story of a boy who is trying to uncover secrets and a filmmaker who is hiding many.

The first chapter opens with twenty-one wordless spreads that set the scene. In cinematic style, the illustrations pull back from a full moon, to an aerial view of Paris, to daybreak over the city, to a train station, to a boy in a crowd. Heightening the sense of anticipation, these images gradually fill the page until the boy emerges, looking over his shoulder in a close-up view. Through shifting perspectives over several pages, the reader sees the boy's hidden passageway and a man in a toy booth. This visual sequence ends with a close-up of the boy, looking out from behind a large clock to the shop owner and girl at 1:27 in the afternoon. By the chapter's conclusion, Selznick introduces the three main characters and the automaton, always ending with a close-up of their expressive eyes, similar to a technique used in early silent films.

Stand-alone illustrations depict dramatic moments. For example, on pages 230–31, Hugo holds a heart-shaped key first shown in chapter 9; with this stolen key, Hugo can wind the automaton. On pages 252–53 and 260–61, after much suspense, Selznick reveals the automaton's finished drawing and a surprising signature in single images.

A series of three drawings on pages 398–403 shows the illustrator's crosshatching skills. He plays with light and shadow as Isabelle begins to pick a lock. Pencil lines are soft but defined. The reader's eye moves from lock to hairpin to hand, all in subtle light. In the following spread, light shines on the lock, leaving fingers in shadow. Finally, Hugo's and Isabelle's clean profiles lead to the turning doorknob. Details like stray hairs and seams in the wood point out the realistic nature of the artwork.

Brian Selznick's highly visual narrative reflects the era of early filmmaking that is central to the plot, demonstrating the Caldecott criterion of "excellence of pictorial interpretation of story, theme, or concept." The black-and-white drawings with perspectives that evoke cinematic techniques are an "[appropriate] style of illustration to the story, theme or concept." The varied pacing of this heavily illustrated hybrid denotes "excellence of presentation in recognition of a child audience." In merging text, drawings, and film, Selznick's distinguished work redefines storytelling.

## FOR FURTHER CONSIDERATION

- Selznick originally wrote the book as a standard 150-page novel with an illustration for each chapter. When he decided that he "wanted to tell the story like a silent movie" (Selznick 2012), he began revising the book to include illustrations to take the place of descriptive passages. Editor Tracy Mack suggested that he open the book with images rather than words.
- The artist's original drawings for the book are three inches by five inches, and he did much of the work under a magnifying glass. When enlarged to fill the pages, the pencil lines soften.
- Images of the moon recur frequently, most notably in the opening and ending sequences. The automaton's moon drawing is a classic scene from Méliès's film *A Trip to the Moon*. A still from the actual film appears on pages 352–53.
- Clocks and watches are significant to the story. In fact, the book is organized into two parts, both with twelve chapters, reflecting the turning hands of a clock over twenty-four hours.
- While atypical in format and design, *The Invention of Hugo Cabret* satisfies the Caldecott definition that a picture book, "as distinguished from other books with illustrations, is one that essentially provides the child with a visual experience. A picture book has a collective unity of storyline, theme, or concept, developed through the series of pictures of which the book is comprised." By Caldecott definition, children are "persons of ages up to and including fourteen and picture books for this entire age range are to be considered" (ALSC 2009, 10).
- Selznick won a 2002 Caldecott Honor for *The Dinosaurs of Waterhouse Hawkins*.

## ILLUSTRATOR NOTE

After illustrating a string of picture biographies for children, Selznick explains, "I came to an impasse. I needed some kind of change, even though I didn't know what, exactly. Something about my work wasn't satisfying me," and for six months he stopped illustrating as "everything came to a standstill" (Selznick 2008, 10).

During that time, Selznick began a friendship with Maurice Sendak, who felt that the young illustrator did good work but hadn't reached his full potential. Sendak imparted this advice to Selznick: "Make the book you want to make" (Selznick 2008, 10). Selznick, who had long been interested in older films, discovered automata and their connections to French filmmaker Georges Méliès. The idea for the story took hold. Only after beginning the novel did the book's format evolve.

## SOURCES CONSULTED

Association for Library Service to Children (ALSC). 2009. *Randolph Caldecott Medal Committee Manual*. http://www.ala.org/alsc/sites/ala.org.alsc/files/content/caldecott_manual_9Oct2009.pdf.

Selznick, Brian. 2008. "Caldecott Medal Acceptance Speech: Make the Book You Want to Write." *Children and Libraries* 6 (2): 10–12.

———. January 11, 2012. "Flavor of Words: Brian Selznick and Paul O. Zelinski in Correspondence." *Pen America.* http://worldvoices.pen.org/print/5780.

Vulliamy, Ed. February 11, 2012. "Brian Selznick: How Scorsese's *Hugo* Drew Inspiration from His Magical Book." *Guardian.* http://www.guardian.co.uk/books/2012/feb/11/brian-selznick-hugo-martin-scorsese.

# Joseph Had a Little Overcoat

## 2000 Caldecott Medal

The patchwork layout of the pages, the two-dimensional paintings, and the exaggerated perspectives, reminiscent of the folk art tradition, are the very fabric that turn this overcoat into a story.—2000 Caldecott Award Committee (ALSC 2013, 105)

*Author/Illustrator:* Simms Taback
*Style:* Folk art
*Media:* Watercolor, gouache, pencil, ink, and collage

### ANALYSIS

Adapted from a Yiddish folk song, *Joseph Had a Little Overcoat* incorporates cleverly placed die-cuts to show the transformation of the man's worn coat to a jacket, vest, scarf, necktie, handkerchief, button, and finally, the very book readers hold in their hands. Deep colors, playful collage, and cultural references enrich the art and expand the story.

The illustrations almost fill the double-page spreads. The edges of the artwork fade into black borders with space at the top to accommodate the handwritten text. Collage materials include images cut from seed and clothing catalogs, magazine clippings, reproductions of old Jewish postcards, and photographs. Simms Taback sets the story in a fictional Polish *shtetl*, a small village where Jews lived in eastern Europe, "a world I heard so much about as a child, filled with memories of my family and of a thriving culture that no longer exists" (Taback 2001).

Earth tones fill most of the backgrounds with hues appropriate to the rural setting. Taback uses green, blue, violet, and brown for the outdoor scenes, with brown, green, and gray indoors. Brilliant reds dominate the stimulating wedding and city spreads in the fourth and eighth openings. Throughout the book, Taback uses pattern to add interest, such as in the bright clothing, fields of flowers or vegetables, textured floorboards, and colorful rugs.

In the fifth opening, where the little vest "got old and worn," Joseph and his cat stand on the verso looking at two men in the window. The reader follows his wary gaze across the colorful spread in a movement reinforced by the horizontal line of the rugs, floor, and bench. Clothing patches, simple furnishings, and mismatched curtains suggest that Joseph is a man of modest means.

On the wall, references to Yiddish culture abound, including Maurice Schwartz, the first actor to play Tevye in the play *Fiddler on the Roof*; a Yiddish adage appropriate to the story; Molly Picon, a star of the Yiddish musical stage; a book by folk writer Sholom Aleichem; and a menorah. The artist features some family history as well. On the recto, the woman in the babushka is one of Taback's daughters; the ship's name is from the one on which Taback's mother sailed to the United States; and the surname on the envelope is the Polish spelling of his grandfather's name.

The sewing notions on the bench indicate that Joseph's vest is about to be altered. The die-cuts in the windowpanes will reveal Joseph's new scarf in the next opening. The men peering in the window will become part of the chorus.

A familiar pattern emerges from the rhythm and pacing of the story. Joseph's expression shows that he is pleased with each new item of clothing but dismayed when it becomes "old and worn." Recurring images help unify the story, including Yiddish newspapers, Yiddish sayings, letters from Joseph's sister, and the cat, dog, and mouse.

Simms Taback's carefully engineered die-cuts are perfectly suited to this folk song where something old is repeatedly transformed to something new, meeting the Caldecott criterion of "excellence of execution in the artistic technique employed." The *shtetl* setting and visual references to Yiddish culture demonstrate "excellence of pictorial interpretation of story, theme, or concept." The colorful, cluttered mixed-media illustrations in folk-art style keep the reader engaged, showing "excellence of presentation in recognition of a child audience."

## FOR FURTHER CONSIDERATION

- When Taback illustrates a book, he starts at the beginning and finishes the spreads in order. For *Joseph* . . . , he began to incorporate more details and

humor as the project continued. "So, the book builds up and gets more involved . . . by the fourth or fifth spread [where] I'm . . . doing stuff I haven't thought of doing in the first spread" (Giorgis and Johnson 2000).

* The book includes allusions to *Fiddler on the Roof*, with the "Tevye the Milkman" poster, a humorous newspaper headline, and the fiddler himself in the fifth, eighth, and ninth openings.

* In the image of Joseph drinking tea in the tenth opening, Taback pays homage to his grandfather. The artist remembers him "placing a cube of sugar under his tongue and sipping his glass of tea while reading his Bible with a handkerchief always tied loosely around his neck" (Taback 2000, 405).

* In his research, Taback studied period clothing and found that it was "quite drab, probably faded, though beautifully sewn, and the patterns were quite plain and simple. For the book, I decided to take some artistic license and mix it up with more traditional Polish and Ukrainian designs" (Taback 2000, 407).

* The front of the dust jacket shows a worried Joseph with large holes in his overcoat. However, on the front cover Joseph smiles with scissors and fabric in hand, a spool of thread by his feet, and fresh patches on his coat.

* Taback first published the story in 1977 with different illustrations. Caldecott Award terms specify, "There are no limitations as to the character of the picture book except that the illustrations be original work" (ALSC 2009, 10). In this case, "the new edition was considered eligible for the 2000 Caldecott award because the illustrations were entirely new" (ALSC 2009, 67).

* Taback received a 1998 Caldecott Honor for *There Was an Old Lady Who Swallowed a Fly*, which also incorporates paint, collage, and die-cuts.

## ILLUSTRATOR NOTE

Simms Taback met author/illustrator Ezra Jack Keats in the early 1960s when Keats was working on the artwork for *The Snowy Day*. One day when he visited Keats in his studio, he saw sheets of paper splattered with paint and hanging to dry. When Taback understood that these would be cut and used for collage, he recalls:

> How refreshing and exciting it was for me to see how Ezra was working! . . . I was enlightened and encouraged by what he did. And I did have him in mind when I was working on *There Was an Old Lady Who Swallowed a Fly* and later on *Joseph Had a Little Overcoat*. I wasn't thinking only of his technique, which is instantly recognizable, but also of how straightforward, warm, and child-friendly his pictures are. (Taback 2002, 59)

## SOURCES CONSULTED

Association for Library Service to Children (ALSC). 2009. *Randolph Caldecott Medal Committee Manual*. http://www.ala.org/alsc/sites/ala.org.alsc/files/content/caldecott_manual_9Oct2009.pdf.

———. 2013. *The Newbery & Caldecott Awards: A Guide to the Medal and Honor Books*. Chicago: American Library Association.

Giorgis, Cyndi, and Nancy J. Johnson. 2000. "2000 Caldecott Medal Winner: A Conversation with Simms Taback." *Reading Teacher* 54 (4): 418.

Taback, Simms. 2000. "Caldecott Medal Acceptance." *Horn Book Magazine* 76 (4): 402–8.

———. 2001. "Simms Taback." *CBC Magazine: The Children's Book Council*. https://web.archive.org/web/20050603085502/http://www.cbcbooks.org/cbcmagazine/meet/simms_taback.html.

———. 2002. "A Word from Simms Taback." In *Keats's Neighborhood: An Ezra Jack Keats Treasury*, by Ezra Jack Keats, 58–59. New York: Viking.

# *Journey*

## *2014 Caldecott Honor*

First-time author Becker sweeps readers away on the very best kind of journey, allowing a complex color scheme, intricate fantasy environments, and a stirring sense of adventure to tell the story without a single word.—Jesse Karp (Karp 2013, 74)

*Author/Illustrator:* Aaron Becker
*Style:* Cartoon and realistic
*Media:* Watercolor, pen and ink

## ANALYSIS

In the first opening, a young girl sits hunched over on her doorstep. She is outlined against the faded backdrop of receding city buildings. A cutaway wall reveals her family busily occupied. The bright colors of the girl's red scooter and the purple marker of a boy on the verso capture the eye. A small purple bird flies away high above the buildings and foreshadows events in the story.

On the verso of the next page, small vignettes highlighted by generous white space show the girl visiting each family member, but they are too preoccupied to engage with her. On the recto of this same opening, the girl sits dejectedly on her bed while her cat sleeps on the floor, illuminated by the light from the hallway. Though the rest of her room is in shadows, it is clear from the decor that this girl likes adventure. A world map and a drawing of Egypt hang on her walls. A hot air balloon dangles from the ceiling and stickers of outer space adorn her bureau. Her bedspread is a sailboat print.

Even an airplane flies outside her window. Framed within wide margins, the room seems small and confining.

Turning the page, the girl is still in her bedroom, but the cat is leaving. The girl spots her red marker where the cat had been lying. The hallway light casts a rectangle on the wall. Illustrations on the recto depict the girl drawing a door and passing through it in quick succession. These vignettes form a diagonal line to the page turn.

The girl passes through the door into a full-color fantasy forest with twinkling lights and lanterns. The trees in the foreground are so large that they bleed off the top of the page. In the distance is a dock on the stream. Turning the page to the fifth opening, the girl stands on the dock and gazes into the water. Once again, using a series of three vignettes surrounded by negative white space, Becker highlights the girl using her marker to draw a boat and float away.

The sixth opening is similar to the front dust jacket but from a different angle. On the jacket front, the reader views the city from the girl's perspective as she approaches it. The sixth opening is an aerial view and shows the vastness of the city. The succeeding page zooms in for details of canals and locks and waterfalls. The canal boats and clothing of the people and soldiers give the city an Italian feel. The zoom-in technique, as well as the revealing cutaway technique, are repeated in subsequent illustrations of the steampunk airship.

Becker effectively uses color for contrast and emphasis. The drab, mono-chromatic colors of the girl's urban landscape give way to the brilliant colors of the fantasy world. The vehicles of transportation, the boat, the balloon, and the flying carpet, as well as the door into the fantasy world, are deep red gouache, and these are the only red colors in the book. Gouache is an opaque watercolor that provides emphasis when contrasted with regular watercolors.

Becker's buildings are intricately designed. He said he was interested in drawing detailed architecture and he wanted to draw places he would like to inhabit (Danielson 2013). The simplicity of the girl's figure with her straight brown hair, nondescript clothing, and cartoon facial features contrasts distinctly against the elaborate settings of the fantasy world.

Becker said the theme of *Journey* is about the desire we all have for control over our lives. The girl controls her world by drawing with her red marker (Danielson 2013). This wordless narrative invites readers to linger over the illustrations, noting new details with each rereading. Becker meets the criteria of "excellence of pictorial interpretation of story, theme or concept" and "delineation of plot, theme, characters, setting, mood or information through the pictures." By empowering the girl, he also demonstrates "excellence of presentation in recognition of a child audience." With his first attempt, Becker has created a "distinguished American picture book for children."

## FOR FURTHER CONSIDERATION

- The book cover differs from the dust jacket. The book cover is black cloth with a stamped or impressed image of the little girl holding her marker in a hot air balloon. Etched diagonal lines on the lower left underside of the balloon add shadow and dimension.
- Red endpapers contrast with the black cover and make a connection to the red marker in the story. Images of various modes of transportation over time are repeated, from Viking oar boats to lunar landing modules.
- That the father works at a desktop computer rather than a sleek laptop, the mother speaks on a landline phone with a cord connection rather than a cell phone, and the sister appears to be using a handheld electronic game rather than a multipurpose mobile device might suggest that the setting is not the present but perhaps several years ago.
- *Journey* is the first book of a planned trilogy. As the girl and boy ride off on their bicycle in the last illustration, she points forward toward their new adventure.

## ILLUSTRATOR NOTE

Becker began *Journey* with thumbnail sketches, and when he finished with his sketches, he realized the story didn't require words. After he completed the storyboard, he designed what the city would look like and made a large scale drawing of the castle first. He built a digital model of the drawing using 3-D animation software to help with perspective and lighting. He built similar models for other places in the book. He added details to the models with scanned pencil-sketch overlays. After he printed out the image on watercolor paper using a large-format printer, he added the pen-and-ink details and the watercolors. The illustrations for *Journey* took nearly two years to complete (Danielson 2013; Gurney 2013).

## SOURCES CONSULTED

Danielson, Julie. November 17, 2013. "Seven Questions over Breakfast with Aaron Becker." *Seven Impossible Things before Breakfast.* http://blaine.org/sevenimpossiblethings/?p= 3255.

Gurney, James. September 16, 2013. "Aaron Becker's *Journey*." *Gurney Journey.* http:// gurneyjourney.blogspot.com/2013/09/aaron-beckers-journey.html.

Karp, Jesse. 2013. "Journey." Review of *Journey. Booklist* 109 (22): 74.

# *Jumanji*

## *1982 Caldecott Medal*

Masterly use of light and shadow and exaggerated changes of perspective create a bizarre and mythical world that leaves one wondering whether the adventure was real or imagined.—Stephanie Loer (Loer 2002, 456)

*Author/Illustrator:* Chris Van Allsburg
*Style:* Surrealistic
*Media:* Conté pencil with conté dust

## ANALYSIS

Van Allsburg said, "If all artists were forced to wear a badge, I'd probably wear the badge of surrealism . . . a gentle surrealism with certain unsettling provocative elements" (Ruello 1989, 169). Van Allsburg juxtaposes ordinary objects in fantastic or unexpected ways. He introduces surrealism on the front book jacket of the thirtieth anniversary edition with the illustration of rhinos charging through the living room and dining room. Of this illustration he said, "A rhinoceros by itself isn't all that strange. And there's certainly nothing strange about a dining room. But a rhinoceros in a dining room is a very strange image" (Marcus 2008, 31).

The illustration of the charging rhinos is the same one that appears in the ninth opening. All the illustrations are confined within a white border except this one, in which the border is broken by a tipping chair. This indicates just how out of control the situation has become, and the diagonal lines of the tilting furniture increase the tension and sense of danger.

Prior to all the action, the story begins quietly enough. The book has a formal appearance with an almost square format. The text, enclosed within a gray border on each verso, is balanced by full-page illustrations on the recto. While their parents attend the opera, Judy and Peter play with their toys until they become bored. When they decide to play a jungle adventure game, their boredom quickly dissolves.

Van Allsburg shifts perspectives to draw the reader into the story. The view is from above the bookcase in the third opening as Judy and Peter begin the game. Light shines in from a window, casting shadows that move the eye diagonally from the lower left to the upper right corner of the illustration.

On the next page is a close-up from below as both Peter and the reader stare up at the lion perched atop the piano. The low position conveys a feeling of vulnerability. Even though the lion is partially shadowed, his dominant position in the illustration makes him threatening. His head is too large to be contained within the border. His dark form contrasts vividly above the white sheet music. Sheet music belongs on a piano; a lion does not. This illustration and the seven illustrations that follow are all surrealistic.

In the next illustration, the bedroom appears normal except for the lion stuck under the bed. What helps make the bedroom seem so ordinary are the strong horizontal lines of the wainscoting and furniture. The bed is centered in the room and balanced by two tables with lamps and two prints on the wall above. The viewpoint has shifted back slightly and the reader feels removed, as if observing the scene.

This feeling of observation lasts only until the page is turned and once again the perspective is from below. The reader is in the kitchen with the monkeys while Judy gapes from the doorway. Van Allsburg creates a sense of immediacy, like a moment captured in time. A can hangs in midair as it falls from the cupboard. Liquid drips from an overturned bottle.

In addition to varying perspectives, Van Allsburg skillfully uses light and dark through gradations of black, gray, and white. The kitchen scene is divided in half, with bright sunshine from an unseen window casting light on the right side while the monkeys appear in shadow on the left. The light and dark create balance and the shadows create depth. From a low vantage point, the size of the monkeys with their sinister grins makes them appear menacing. What is even more disturbing is that two additional monkeys lurk in open cupboards. A tail extends up from a fifth monkey on the floor.

The patterned upholstery of the furniture, the clothing of the characters, and the almost grainy black-and-white illustrations set the story in the 1950s. The photographic appearance of the illustrations is achieved using "waxy, pressed charcoal, a Conté-filled pencil, and dust grindings [from the pencil] rubbed in with cotton" (McElmeel 2000, 487). The rubbed-in grindings create the velvety texture and the differing values that achieve the realistic three-dimensional effect.

Van Allsburg illustrates "things that seem impossible in ways that make them seem possible" (Teaching Books 2011). With this, he meets the criteria of "excellence of execution in the artistic technique employed" and "appropriateness of style of illustration to the story, theme, or concept." Children love to pretend, but there was no need for imagination with *Jumanji*. The board game came to life. Or did it? This question demonstrates "excellence of presentation in recognition of a child audience."

## FOR FURTHER CONSIDERATION

- Fritz, the little dog that Van Allsburg introduced in *The Garden of Abdul Gasazi* and hid in each subsequent book, is a pull toy in the third opening.
- The text on the back jacket indicates that "Jumanji" is a game. The illustration of die and game pieces on a game board reveal that it is a board game.
- *Jumanji* was made into a movie starring Robin Williams. The sequel *Zathura* was also made into a movie. It chronicles the space adventures of the Budwing brothers. They appear in the last illustration of *Jumanji*, running out of the park with the game under the arm of one boy.
- Van Allsburg won a Caldecott Honor for his first book, *The Garden of Abdul Gasazi*, in 1980. After winning the medal for *Jumanji*, he won a second Caldecott Medal for *The Polar Express* in 1986.

## ILLUSTRATOR NOTE

When Van Allsburg taught at the Rhode Island School of Design, he gave his students an assignment to find pictures of house interiors and wild animals. He then instructed them to create drawings combining the two so as to make wild animals inside a house seem convincing. He also completed the assignment and realized how powerful the drawings were (McElmeel 2000). Combining these drawings with the idea of a board game that becomes real, at least during the time it is being played, Van Allsburg created *Jumanji*. "Jumanji" is a word Van Allsburg made up. He thought it sounded exotic and junglelike.

## SOURCES CONSULTED

Loer, Stephanie. 2002. "Chris Van Allsburg." In *The Essential Guide to Children's Books and Their Creators*, edited by Anita Silvey, 455–57. Boston: Houghton Mifflin.

Marcus, Leonard S. 2008. *A Caldecott Celebration: Seven Artists and Their Paths to the Caldecott Medal*. New York: Walker.

McElmeel, Sharron L. 2000. *100 Most Popular Picture Book Authors and Illustrators*. Westport, CT: Libraries Unlimited.

Ruello, Catherine. 1989. "Chris Van Allsburg." In *Something about the Author*, edited by Anne Commire, 160–72. Detroit: Gale.

Teaching Books. April 27, 2011. "Chris Van Allsburg In-depth Written Interview." *Teaching Books.net*. http://www.teachingbooks.net/interview.cgi?id=92.

# King Bidgood's in the Bathtub

## 1986 Caldecott Honor

The realistic figures are executed in glowing colors, and the rich detailing both in costumes and settings brings the Renaissance court to life.—Ilene Cooper (Cooper 1985, 272)

*Author:* Audrey Wood
*Illustrator:* Don Wood
*Style:* Realistic
*Media:* Oil paint on pressboard

## ANALYSIS

When the sun comes up and King Bidgood refuses to get out of the bathtub, a young page summons the help of the court. The knight's effort to lure the king to battle results instead in a waterlogged escapade, so the queen attempts to entice the monarch to lunch. In response, he proclaims, "Today we lunch in the tub!" In the sixth opening, a large stone tub holds a jubilant king on the verso and an exasperated queen on the recto. Between them sits an opulent meal. In the background, the page fills the queen's goblet, holding yet another tray of edibles. In this humorous spread, Don Wood shows his technical skill as a painter, with strong composition, fine details, and adept use of light.

In this image, as in the previous and following bathtub scenes, the full-bleed composition is almost symmetrical with tub mates on either end. The edge of the tub provides a solid base for the illustration. The swath of food

dominates the spread, weighted more to the left to balance with the figure of the page on the right.

The reader's eye is drawn from left to right. King Bidgood is in direct light as he grasps a drumstick in one hand and raises a fork with the other, leading to a stunning centerpiece: a castle, with small reproductions of the Bidgood court at the base and the bathing king at the top, the page at his side. The miniature sun and moon above the figurines suggest that the bathtub ordeal is not likely to end soon. Beyond the centerpiece is the page himself; the position of his food tray continues the movement to the right, ending at the feathery flourish of the queen's hat. Here sits the queen, fully clothed, gown billowing around her as she raises her gloved palms and head upward in a gesture of surrender or prayer. Wood uses the gutter to his advantage to show the contrast between the smiling king, wearing only his crown, and the displeased queen, donning her royal attire and jewels.

Wood is a master of detail. For example, the three-tiered tray in the foreground holds sweets in the shape of sheep, including a small shepherd holding a staff. Trails of steam waft from the royalty, and individual bubbles fill the tub and rise into the air. The artist carefully renders the king's curls and the queen's voile.

Use of light heightens the drama. In this illustration, sunlight from an unseen window plays upon the torso of the king and bodice of the queen. In subdued lighting the page tends quietly to his duties; later he will play a key role in the story's resolution. Light accentuates the folds of the clothing and the texture of the turkey, sauces, breads, fruit, and desserts. Fully lit in the tub's lower left corner is the chain to the plug, foreshadowing the climax to the story.

Wood "wanted a lavishly theatrical effect, almost operatic" (Commire 1988, 231) in the structured story, which he conveys in five acts of three scenes each. A repeating sequence of images carries the story along: the page calls out for help, a member of the court offers a suggestion, and then the king and his guest share time battling, lunching, or fishing in the tub. The final tub scenes involve the entire court, so Wood shows a wider view of the bathroom, curtains pulled aside as if a stage. Throughout the book, the exaggerated expressions and gestures of King Bidgood and the members of the court enhance the theatricality of the illustrations. "That staginess is right up my alley," explains the artist (Commire 1988, 231).

Don Wood's finely detailed and comical illustrations demonstrate the Caldecott criteria of "excellence of pictorial interpretation" and "appropriateness of style of illustration to the story, theme, or concept" of this Renaissance farce. The humorous reactions of the characters, the unlikely activities in the bathtub, and the wisdom of the ever-present young page denote "excellence of presentation in recognition of a child audience."

## FOR FURTHER CONSIDERATION

- Muted burgundy endpapers have a regal feel and tie in with the hues of the typeface and illustration on the title page as well as with the palette used for the final illustration of the book.
- The visual narrative begins with the title page. This exterior view of the castle shows the morning activities of the court. Through a turret window on the left, the king bathes; the page climbs stairs in a smaller turret, some distance away. The dedication page shows the boy inside the tower, carrying a burdensome water container and towel; far in the background, the king continues his bath.
- The page appears in every illustration except on the final page, where the king dashes off in his towel. The unassuming boy is as central to the story as the king himself. The young hero wears a self-satisfied grin as he pulls the bathtub plug.
- Colors in the anteroom change as the action progresses and morning turns to night. The final bathtub scenes are awash with soft mauve, purple, blue, and gold, lit from several candles against the back wall and a rising full moon.
- At the drenching masquerade ball, the masks worn by the knight (ship), queen (swan), and duke (fish) relate to their earlier activities in the tub (Wood 2013).
- Wood's favorite medium is oil paint. "I'm a fumbler and a fiddler and a doer-over. . . . Because [the paint] dries so slowly, you have lots of time to change things. You can sand down and start again from scratch if you want to" (Commire 1988, 227).

## ILLUSTRATOR NOTE

Don Wood prefers to work with models for the characters in his books. The courtiers in *King Bidgood's in the Bathtub* are all based on his family and friends. Notably, the queen is his wife Audrey, the page his son Bruce at age eleven, and King Bidgood a childhood friend. Even his editor has a role (Commire 1988; Wood 2013).

## SOURCES CONSULTED

Commire, Anne, ed. 1988. "Don Wood (1945–)." In *Something about the Author*, vol. 50, 224–31. Detroit: Gale.
Cooper, Ilene. 1985. "Review of *King Bidgood's in the Bathtub*, by Audrey Wood." *Booklist* 82 (3): 272.
Wood, Audrey. 2013. *Audrey Wood Club House*. http://www.audreywood.com/.

# Kitten's First Full Moon

## 2005 Caldecott Medal

Thoughtful design, from the front jacket with reflective silver letters to the final image, sustains a completely satisfying read-aloud experience. Kitten's frustration and eventual triumph—emotions familiar to young children—find artistic expression in a meticulously crafted book with classic appeal.—2005 Caldecott Award Committee (ALSC 2013)

*Author/Illustrator:* Kevin Henkes
*Style:* Cartoon
*Media:* Gouache and colored pencil

### ANALYSIS

In contrast to brightly colored picture books with his celebrated mice characters, Kevin Henkes created black-and-white illustrations on creamy paper for *Kitten's First Full Moon*. In his Caldecott Medal acceptance, Henkes said he loved color, but he pictured this book in black and white from the start. "I thought that by keeping everything as simple and spare as possible, a better, tighter, more complete book would result. I liked the idea of having a white moon, a white cat, and a white bowl of milk surrounded by the black night" (Henkes 2005, 401). The sans serif font and square format also add to the simplicity of the design.

The various values of black and white give depth as shown with the charcoal gray shadows on Kitten. Henkes used colored pencil to achieve a "velvety look" (Marcus 2012, 95). He used black and gray colored pencil and black gouache for the line. The book was printed in four colors on a full-

color press. Henkes claims, "This gave the illustrations a richness and depth they wouldn't have had if the book had been printed with black ink only" (Henkes 2005, 401).

Henkes admits to loving rhythm and repetition in picture books (Horning 2004, 52). He incorporates this in the text, "Poor Kitten!" and in the illustrations. The title page and openings three, five, and seven are similar, beautifully balanced illustrations. From the lower left verso, Kitten gazes up at the moon in the upper right recto. In the seventh opening, Kitten is in her same position, but now she is ready to pounce at the moon. Kitten's diagonal sight line leads to the moon and the page turn.

The horizontal panels in the sixth opening are another example of repetition. Though Kitten chases the moon, she never gets closer. The quick succession of panels depicts Kitten's pursuit, but within each panel both Kitten and the moon remain in the same position. The vertical line of moons mimics the pattern of moons on the half-title page.

*Kitten's First Full Moon* is a circle story. Kitten spies the moon, believes it to be a big bowl of milk, and goes on a quest to achieve her desire. After several mishaps and disappointments, Kitten returns home to find "a great big bowl of milk on the porch, just waiting for her." Henkes employs the circle motif throughout the book. Curved lines predominate from the moon and flowers on the cover to the endpapers with endless moons, to firefly lights, and to Kitten's round eyes when frightened or sad. Their softness creates a feeling of comfort that supports the satisfaction of Kitten and the reader when the big bowl of milk is finally attained.

Kitten's dogged determination to get what she wants, alternately brave or frightened, demonstrates that Henke understands children and meets the criterion of "excellence of presentation in recognition of a child audience." Through use of panels to pace the story, he has designed a book that excels in "execution of the artistic technique employed." *Kitten's First Full Moon* shines as brightly as the silver letters of the title on the jacket cover.

## FOR FURTHER CONSIDERATION

- An artist Henkes admires is Clare Turlay Newberry. Two of her four Caldecott Honor books include black-and-white illustrations of cats: *April's Kittens* and *T-Bone the Babysitter*. In his Caldecott Medal acceptance Henkes said, "Although she isn't given a name other than Kitten, I secretly think of my heroine as Clare" (Henkes 2005, 401).
- The dust jacket and the book cover differ noticeably. The illustration on the front dust jacket shows Kitten in a field of flowers against a backdrop of the moon containing the name of the book and author. The back jacket exclaims "What a night!" within a moon shape. The illustration of Kitten

on the front book cover is very simple. Kitten is still licking her paw, but her tail is curled around her rather than pointing erect, and her shadow appears behind her. She sits within a circle of the moon, but the flowers, title, and author have disappeared. The back cover is a pattern of moon circles duplicating the endpapers. Title, author, and publisher are printed in silver lettering on black cloth that wraps around the spine to the front and back covers, lending a classical feel to the book.

- Horizontal and vertical panels show Kitten's movement. In the sixth opening, Kitten trots along the sidewalk, through the flowers, and across a field. Both her direction and the panels are horizontal. In the eighth opening, the panels are vertical as Kitten attempts to climb up to the moon. The vertical panels, like vertical lines, pause the action.
- Both Kitten and Max in Maurice Sendak's *Where the Wild Things Are* go on adventures and return home to find their suppers waiting for them.
- Henkes won a Caldecott Honor in 1994 for *Owen*.

## ILLUSTRATOR NOTE

After Henkes became a parent, he tried to write a simple concept book. One was all about circles and a line he wrote for it read, "The cat thought the moon was a bowl of milk." Though the concept book never developed successfully, he did like that sentence. Several years later it became the basis for *Kitten's First Full Moon*, which contains an incredible number of circular shapes.

## SOURCES CONSULTED

Association for Library Service to Children (ALSC). 2013. "2005 Medal Winner." *Caldecott Medal and Honor Books, 1938–Present.* http://www.ala.org/alsc/awardsgrants/bookmedia/caldecottmedal/caldecotthonors/caldecottmedal.

Henkes, Kevin. 2005. "Caldecott Medal Acceptance." *Horn Book Magazine* 81 (4): 397–402.

Horning, Kathleen T. 2004. "The Complete Package." *School Library Journal* 50 (10): 50–53.

Marcus, Leonard S., ed. 2012. *Show Me a Story! Why Picture Books Matter: Conversations with 21 of the World's Most Celebrated Illustrators.* Somerville, MA: Candlewick.

# Knuffle Bunny: A Cautionary Tale

## 2005 Caldecott Honor

This energetic comedy, illustrated with an unconventional combination of se-pia-tone photographs and wry cartoon ink sketches, charms both parents and children.—2005 Caldecott Award Committee (ALSC 2013, 101)

*Author/Illustrator:* Mo Willems
*Style:* Cartoon and realistic
*Media:* Ink and photography digitally enhanced and colored

## ANALYSIS

Mo Willems's unique artistic style for *Knuffle Bunny* employs photographs and hand-drawn characters. He prepares his reader for this method of illustration on the double-page spread used as the title page. On the verso, three picture frames hang diagonally, leading the reader to the "photo" of Trixie hugging Knuffle Bunny on the recto. This illustration is repeated as the last illustration of the book. The photos chronicle the lives of Trixie's parents from marriage, to her birth, to a family outing, with Trixie held in a baby carrier on her father. The cartoon characters are superimposed against realistic backgrounds of a church, hospital room, and apartment building. Changes in hairstyles and glasses depict the passage of time.

The photographic backgrounds are realistic but not exact representations because Willems used a computer to digitally remove trash cans, air conditioners, and anything else that cluttered the scenes. The black-and-white photos have also been colorized to give them a sepia tone. While a few

photographs bleed off the pages, most are contained within a sage-green background.

The characters are not contained within the photographs, though. When they break a border, it often shows movement. In the first opening, when Trixie and her dad leave the apartment building, they walk out of the photograph and direct the reader to the next page. In the second opening recto, the jogger runs out of the photograph to continue down the sidewalk that extends beyond the margin of the photo. Sometimes the action is just too exuberant to be confined within the borders of a photo, as in opening four, when "Trixie helped her daddy put the laundry into the machine." Strewn clothing leads to Trixie joyfully waving her mother's bra and wearing her father's pants on her head. The clothes trail continues to her father, who is loading the washing machine. Distracted by his lively daughter and watching her with a paternal smile, he inadvertently reaches for Knuffle Bunny. He is completely oblivious to the impending heartbreak he will cause.

The stylized characters have been computer manipulated with the addition of color and they contrast well against the black-and-white photos. Utilizing a full palette, Willems chooses bright but not garish colors. These somewhat soothing colors belie the emotional intensity of Trixie's despair at losing her beloved stuffed animal as well as her parents' panic to retrieve it for her. When asked if he writes sad stories, Willems replies, "Are you kidding me? They're tragedies. I deal in horror" (Messinger 2011).

Willems chooses to use simple lines without elaboration for his characters. This makes them flat and two-dimensional. He states, "I look for simplicity of line, partially to focus on the emotions of the book and partially because I want the main character of each book to be easily copied by a 5 year old" (Scholastic 2013). Three strands of blonde hair top Trixie's spherical head, and huge round eyes dominate her face. Below her perky, pointed nose is a mouth with exactly five teeth, three on top and two on the bottom. Willems states, "I think the cartoon characters in the Knuffle Bunny books are more real than the photographic backgrounds" (Marcus 2012, 272). The cartoon style allows Willems to show exactly what each character is feeling, from Trixie's anguish when she realizes she is without Knuffle Bunny and cannot communicate her thoughts to her father to her father's frustration at his inability to calm his daughter.

Willems acknowledges, "In my heart I'm a cartoonist. My books are really graphic novels, employing comic-book devices such as word bubbles, action lines, and multiple panels" (Scholastic 2013). The multiple panels on the verso of opening fourteen, where "Trixie's daddy looked for Knuffle Bunny," move the action swiftly. Elsewhere, Trixie's flailing arms with action lines show her alarm. The size of the text within balloons is utilized to show volume and emotion. In opening eleven, lightning bolts strike Trixie's father when he realizes why Trixie was so upset.

Willems clearly understands children and what constitutes tragedy in their lives. His minimalist art is easily understood by a child and meets the criterion of "excellence of presentation in recognition of a child audience." His innovative style of combining cartoon and photography fulfills the criteria of "excellence of execution in the artistic technique employed" and "appropriateness of style of illustration to the story, theme, or concept." The story can be "read" in pictures alone, and this meets the criteria of "excellence of pictorial interpretation of story, theme, or concept" as well as "delineation of plot, theme, characters, setting, mood, or information through the pictures." Willems satisfies all the criteria to make *Knuffle Bunny* a truly "distinguished American picture book for children."

## FOR FURTHER CONSIDERATION

- The dedication, found on the recto of the last opening, reads, "This book is dedicated to the real Trixie and her mommy." It also acknowledges the Park Slope neighborhood in Brooklyn where Willems lived with his family. The photos in the book are of his neighborhood, and his daughter is named Trixie.
- The word "knuffle" is pronounced "kuh-nuffle." In Dutch it means "hug or snuggle" (Harvey 2005, 40).
- Openings two and twelve and openings three and thirteen have identical photographic backgrounds. The only differences are the characters in each image. For example, the jogger on the recto in opening twelve is not the same jogger as in opening two. The jogger in opening twelve sports a tee shirt with a Pigeon logo (from Mo Willems's *Don't Let the Pigeon Drive the Bus!* and other "Pigeon" books).
- Foreshadowing the plot, the endpapers show multiple images of Knuffle Bunny spinning in the washing machine.
- There are two sequels to *Knuffle Bunny: A Cautionary Tale*. They are *Knuffle Bunny Too: A Case of Mistaken Identity* and *Knuffle Bunny Free: An Unexpected Diversion*. Willems won Caldecott Honors for *Knuffle Bunny Too: A Case of Mistaken Identity* in 2008 and *Don't Let the Pigeon Drive the Bus!* in 2004.

## ILLUSTRATOR NOTE

When drawing the illustrations for *Knuffle Bunny*, Willems was tracing backgrounds from photographs of his neighborhood, but it wasn't working well. He didn't feel that there was enough focus on the characters. When one of the drawings fell on an actual photograph, he was inspired to combine both

drawing and photograph. Unintentionally, he came up with a unique way to illustrate his book (Marcus 2012).

## SOURCES CONSULTED

Association of Library Service to Children (ALSC). 2013. *The Newbery & Caldecott Awards: A Guide to the Medal and Honor Books*. Chicago: American Library Association.

Harvey, Carl. 2005. "Mo Willems: You Never Know." *Library Media Connection* 24 (1): 48–49.

Marcus, Leonard S. 2012. *Show Me a Story! Why Picture Books Matter: Conversations with 21 of the World's Most Celebrated Illustrators*. Somerville, MA: Candlewick.

Messinger, Jonathan. May 5, 2011. "Guilt for Dinner: The Mo Willems Interview." *Hipsqueak*. http://www.timeoutchicagokids.com/things-to-do/hipsqueak-blog/42213/guilt-for-dinner-the-mo-willems-interview.

Scholastic. 2013. "A Conversation with Mo Willems." *Parent and Child Magazine*. http://www.scholastic.com/parents/resources/article/parent-child/conversation-mo-willems.

# The Lion & the Mouse

## 2010 Caldecott Medal

Here is the heart and soul of this book—it's about what *you* discover in the images, what someone other than the artist can bring to them.—Jerry Pinkney (Pinkney 2010, 24)

*Author/Illustrator:* Jerry Pinkney
*Style:* Realistic
*Media:* Pencil, watercolor, and colored pencils on paper

## ANALYSIS

Except for sounds, *The Lion & the Mouse* is a wordless book. It allows readers to construct their own stories from the illustrations. Through images, Pinkney expresses the terror and dismay the lion feels when caught in the hunters' net and how delighted and satisfied the mouse feels as she is able to gnaw through the ropes to free him. Pinkney researched animal anatomy by studying pictures, but to depict the animals' feelings and movements, Pinkney said, "I would stand in front of a mirror and go through a series of expressions and body movements in order to incorporate what I'd learned into my drawings, and have them mimic the expressions of humans" (Pinkney 2010, 23). In a series of two-page spreads in the fourth, fifth, and sixth openings, Pinkney anthropomorphizes the lion as he debates whether he should set the mouse free. At first he growls as he inspects his captive. Then he considers her size as he holds her in his massive paws. Finally, he releases her, perhaps somewhat surprised at his ability to overcome his beastly tendencies.

Due to his size, the lion dominates in all three illustrations and bleeds off the pages. In the fourth and sixth openings, the diagonal line of the lion's body leads to the mouse. Her "Squeak" in the fourth opening ensures that she is not overlooked against the figure of the lion. Turning the page, all background disappears to focus attention on the two characters. In the sixth opening, grasses reappear, but the lion's gaze directs the reader's eye diagonally down to the mouse scampering away. Her position in the lower right of the recto leads to the page turn that reveals her returning to her nest of babies with the lion in the distance.

Colors of the African plain glow warmly against the creamy pages. Transparent watercolors allow the pencil drawings beneath to show through and add texture to the lion's mane and the mouse's fur as well as many other details. Pencil outlines of the insects, grasses, and contours of the lion's body are clearly visible in the sixth opening. All but a few of the grasses curve around the lion, framing him. Just four stems point away from the lion toward the page turn and the direction the mouse is fleeing. Describing his art, Pinkney's editor states, "His intricate yet organic line work is deftly meshed with layers and layers of transparent color—some of which build to swaths of lush vibrancy" (Spooner 2010, 28).

The title page shows the mouse within one of the lion's footprints. Her diminutive size does not indicate the size of her heart and her courage. Panels in the eleventh and thirteenth openings pace her race to the distressed lion and her rescue of him. In all but one of the panels, some part of her escapes the borders. Her bravery knows no bounds.

Pinkney conveys the narrative and feelings of the characters as well as his major themes of friendship and family through illustrations alone. He meets the criteria of "excellence of execution of pictorial interpretation of story, theme, or concept" and "delineation of plot, theme, characters, setting, mood, or information through the pictures." Before his book won the Caldecott Medal, Pinkney already felt it was a winner because it inspired the imaginations of children (Pinkney 2010, 19). With that he fulfills the criterion of "excellence of presentation in recognition of a child audience."

## FOR FURTHER CONSIDERATION

• The endpapers begin and end the story. The front endpapers set the scene on the African Serengeti. Pinkney is fascinated with Africa, and he says, "The Serengeti provided me with an expansive backdrop that opened a host of visual possibilities" (Pinkney 2010, 23). Adding plants and animals of the Serengeti Plain solidified the setting. The back endpapers conclude the story with a sense of family. The mouse family rides atop the lion's back as his mate walks beside him and their cubs trail along.

- Pinkney says, "The early chapters of my life have knitted themselves into my art" (Pinkney 2010, 20). He was always interested in creatures and insects and includes them as details in many illustrations. He also includes flowers. After art school, his first job was delivering flowers, and later he was promoted to floral designer. "If you look at the body of my work, you'll find flowers embellishing many of my images" (Pinkney 2010, 21).
- The dust jacket and book cover differ markedly. The jacket cover has no words, just a close-up of the lion's face, eyes looking left, causing the reader to turn the book over to find the mouse gazing back. Removing the jacket reveals two panels connected by an ampersand. In the left panel, the lion looks right to the mouse in the second panel. Unafraid, she steadily looks back at him. Below the visual title is Jerry Pinkney's name against a cream-colored background, the same color as the pages of the book. The back cover is Pinkney's homage to Edward Hicks's painting *The Peaceable Kingdom*. He substituted African animals for the biblical animals. "To me the story represents a world of neighbors helping neighbors, unity and harmony, interdependence" (Pinkney 2010, 23).
- Prior to winning the Caldecott Medal, Pinkney won five Caldecott Honors, two in one year: *Mirandy and Brother Wind* (1989), *The Talking Eggs* (1989), *John Henry* (1995), *The Ugly Duckling* (2000), and *Noah's Ark* (2002).

## ILLUSTRATOR NOTE

When Pinkney drew the thumbnail sketches for the story, he intended to add words after he had a better idea of the "visual rhythm and pacing" (Pinkney 2010, 22). Then he wondered if the fable needed words at all. He completed two dummies for his editor—one wordless and one with action words and animal sounds. His editor suggested that he eliminate the action words and keep just the sounds.

## SOURCES CONSULTED

Long, Joanna Rudge. 2010. "Caldecott 2010." *Horn Book Magazine* 86 (4): 10–16.
Pinkney, Jerry. 2010. "Caldecott Medal Acceptance." *Horn Book Magazine* 86 (4): 19–24.
Spooner, Andrea. 2010. "Jerry Pinkney." *Horn Book Magazine* 86 (4): 25–30.

.

# Locomotive

## 2014 Caldecott Medal

Brian Floca's dramatic watercolor, ink, acrylic and gouache illustrations incorporate meticulously-researched portraits of the train, the travelers and the crew as they traverse the American landscape on the new transcontinental railroad.—2014 Caldecott Award Committee (ALSC 2014)

*Author/Illustrator:* Brian Floca
*Style:* Realistic
*Media:* Watercolor, ink, acrylic, and gouache

## ANALYSIS

Brian Floca's exploration of the steam locomotive on one of the first trips on the transcontinental railroad begins on the front dust jacket. A massive yet ornate steam engine almost charges toward the reader while an engineer and fireman look out from either side of the locomotive. Dense front endpapers with maps, small vignettes, and an advertisement enrich the written overview of the rail line's construction. The title page gives insight into the featured travelers: Papa's telegram from California beckons the recipient to "Come West as soon as you are able"; on the left is a family photo, and on the right are two railroad guides. A page turn shows a round, unframed image of a railroad track in a barren landscape.

Floca uses a variety of page layouts in the book. In the fifth opening, four unframed images on the ivory verso introduce the crew; on the recto, the full-page illustration shows the mother and two children boarding the train as the conductor's call fills a large speech balloon. In the following opening, the

layout is reversed and the perspective changes. Here, the reader is inside the cab, just behind the fireman and engineer on the verso; on the recto, three images show the engineer preparing to put the train in motion. A page turn to the seventh opening provides a close-up view of the train wheels on a double-page spread; the diagonal line pulls the eye forward with the train. The old-style red font emphasizes the engine noises, and the bold final word encourages the page turn. In these and other daytime scenes, the brightly colored locomotives stand out from Floca's companion palette of soft browns, yellows, greens, and grays.

The artist uses darker hues for nighttime settings. In the fourteenth opening, the reader is perched near the headlamp, looking at the engineer. Warm light from the lamp and cab illuminates the locomotive and its exterior design: the filigree on and around the oil headlamp, rivets on the bonnet smokestack, and graceful curves of the steam and sand domes. The strong diagonal line begins at one of the bird ornaments, tassel in its beak. The powerful "WHOOs" of the train whistle dominate the recto, the translucent letters floating in the air. In the eighteenth opening, the boy is asleep against his sister while she gazes out the window. Five geographical landmarks are washed in light gray, with moonlight revealing details in the eerie nightscape.

Floca's skilled line work is noteworthy in the sixteenth opening featuring the Dale Creek Bridge. On the verso, a sign warns readers of the bridge ahead. Inside the train, the artist draws dual outlines of the sister and brother to communicate the bone-rattling ride over the trestle. The "rickety" sound effects also appear to be bouncing with multiple words in shadow. The trestle dominates the spread, covering the recto and spilling over the gutter. The illustration is filled with hundreds of fine outlines of beams and planks.

While the illustrations are realistic in style, the level of detail varies. Many of the characters appear to be almost sketched, especially the passengers. More fully realized are the locomotives, the machines that drive the story forward. In the ninth opening of the Platte River Valley, Floca contrasts the remarkable detail of the train with the broadly rendered landscape. The artist carefully delineates the train's exterior and cab, even drawing the box hinges in the tender. In a looser style for the background, he suggests shrubs with squiggly lines and varying shades of green paint. On the recto, wide strokes of yellow, green, and brown communicate the speed of the train as it travels "FULL STEAM AHEAD!"

Brian Floca's successful artistic interpretation of the workings of the locomotive and its crew in the context of a family's journey on the transcontinental railroad meets the Caldecott criterion of "excellence of pictorial interpretation of story, theme, or concept." Through precise ink line work he shows technical details of the steam locomotive, while looser lines bring characters to life and embellish the backgrounds; thus, the artist demonstrates

"excellence of execution in the artistic technique employed." The straightforward presentation of a subject of broad scope shows "excellence of presentation in recognition of a child audience."

## FOR FURTHER CONSIDERATION

- The back endpapers show an informative cross-section of a steam locomotive and visual explanation of the process that powers the machine. Under the dust jacket flap, a replica of a Central Pacific Railroad timetable for 1869 provides details of the journey from Promontory Summit to Sacramento, including the fares.
- Brian Floca's concept for the book shifted over time from "a generic look at a steam locomotive to a book that was interested in the transcontinental railroad, . . . [a topic that] *sprawls*. It's history, it's the landscape, it's the West!" (Danielson 2013). A history major in college, Floca's research for the book included reading several books, "squinting and scrounging" (Danielson 2013) through old photos and stereoscopic images, visiting museums, and following the transcontinental railroad route by car, after which the book grew from forty-eight to sixty-four pages. "Almost everything that has to do with the landscape is indebted to that trip—even the endpaper elevation map" (Brown 2013).
- Floca shares a large art studio with four other children's books illustrators. Most were models for the train passengers (Rosenthal 2013).
- The book cover is markedly different from the dust jacket. While the dust jacket focuses on the machine, the cover shows the vast ecosystem that the railroad disrupted. The bison retreated and were almost obliterated by the unregulated hunting by the new settlers, creating great hardship for the Plains Indians.

## ILLUSTRATOR NOTE

While a student at Brown University, Brian Floca took art classes at the Rhode Island School of Design. He was in a course taught by author/illustrator David Macaulay when Avi was recruiting a student to illustrate his graphic novel *City of Light, City of Dark*. Macaulay suggested Floca for the job. During the project, Avi and editor Richard Jackson "treated a greener-than-green young illustrator with great generosity and trust" (Larson 2008, 33). Floca continued to work with both of them as he established his career. He illustrated Avi's Poppy Stories fantasy series among other books; in fact, *Locomotive* is dedicated to the author. Jackson is the book's editor.

## SOURCES CONSULTED

Association for Library Service to Children (ALSC). 2014. "Welcome to the Caldecott Medal Home Page!" http://www.ala.org/alsc/awardsgrants/bookmedia/caldecottmedal/caldecott medal.

Brown, Jennifer M. September 6, 2013. "Full Steam Ahead with Brian Floca." *School Library Journal Curriculum Connection.* http://www.slj.com/2013/09/standards/curriculum-connections/full-steam-ahead-with-brian-floca-interview/.

Danielson, Julie. September 16, 2013. "Epic, Intimate *Locomotive*." *Kirkus Reviews.* https://www.kirkusreviews.com/features/epic-intimate-ilocomotivei/.

Larson, Jeanette. 2008. "Talking with Brain Floca." *Book Links* 18 (2): 32–34.

# Lon Po Po: A Red-Riding Hood Story from China

## 1990 Caldecott Medal

Using a dramatic style that combines techniques used in ancient Chinese panel art with a powerful contemporary palette of watercolors and pastels, Mr. Young has created a book of classic beauty and charm.—Dust jacket of *Lon Po Po* (Young 1989)

*Author/Illustrator:* Ed Young
*Style:* Impressionistic and realistic
*Media:* Watercolors and pastels

## ANALYSIS

A unique feature of *Lon Po Po* is Ed Young's use of panel art. This type of design is found in many cultures, including China, and it allows the illustrator to offer differing perspectives simultaneously (Matulka 2008). This is accomplished effectively in the second and third openings. In both spreads, the little girls are inside the house while the wolf converses with them outside the door. In the second opening, the middle two panels show the three girls, arranged in size from smallest to largest. Shang, the oldest sister, holds a candle, illuminating the first three panels. Outside, in the night, the wolf appears in the fourth panel. The diagonal line of the girls as well as the brightness of the candle lead the eye to the wolf. Only a portion of his head is visible as the rest of him is shrouded in his blue disguise. His eye, reflected in the candlelight shining through the keyhole, is unnaturally white and surreal.

Turning the page, the girls' faces are lined up vertically in the first panel. They stand still, facing the door and the wolf. Emphasis has shifted to the wolf. Instead of being squeezed into one narrow panel as he was in the previous spread, he now takes up two panels. He looms large over the little girls, his face so big it cannot be contained in one panel. His size and central position dominate the spread. In addition to his gleaming eye that stares down at the sisters, his menacing teeth are prominent. The panels build suspense as the girls wait in darkness, not able to see what the reader sees: the terror outside their door.

In the next illustration, the girls open the door and the wolf leaps in. The light source is from the right, illuminating the sisters' faces on the recto and casting their shadows behind them on the verso. Huddled together, they appear tiny and vulnerable. Their bright-colored clothing draws attention to them positioned near the center at the bottom of the page. The wolf's threatening shadow arches above them across the entire two-page spread. He is so large that his front paw and back legs disappear at the panel frame edges, while his ear breaks the top panel frame.

The wolf appears in one form or another in every two-page spread except the last. Young has incorporated the wolf into the landscape of the first opening, showing the wolf as part of nature. The muzzle is the lower portion of the panel on the verso and slopes up to the eye and top of the head, forming the land in the recto panels. The eye looks closed, as if the wolf might be sleeping, suggesting dormant danger. The sun is rising and casts a yellow glow on the bottom of the clouds. It is the beginning of a new day and the beginning of the story.

The last illustration depicts the same landscape from a different perspective. Now the cottage is located at the top of the scene. "The upper half of a picture is a place of freedom, happiness, and triumph" (Bang 2000, 54). All traces of the wolf are gone, and the mother and her children are safe inside their home. The sky is again golden, this time glowing from the setting sun in the right panel of the recto. Day is done as the story concludes.

Young illustrates with dark colors to coincide with the girls' fears at the beginning of the story. As they show courage, the colors switch to brighter blue, green, rose, and yellow hues. The impressionistic art instills a make-believe quality to the fairy tale. Blended with realistic art, enough details are included to create a sense of danger. This sense is increased by the use of light and shadow. The artwork is distinguished for "excellence of execution in the artistic technique employed" and for "delineation of plot, theme, characters, setting, mood, or information through the pictures." By "doing the books for the child in myself who would love to be told these stories with those images" (Marantz 1992, 228), Young demonstrates "excellence of presentation in recognition of a child audience."

## FOR FURTHER CONSIDERATION

- On the dust jacket, the wolf stares at the reader with eerie white eyes. His dark body wraps around the spine to the back against a fiery red-orange background. However, the book cover is nearly all black with what looks like the fur of the wolf's coat set against a blue background. The endpapers are also blue.
- Using panels, Young avoids the problems of losing some of each two-page spread illustration to the gutter. The gutter always falls in the spaces between panels.
- In addition to winning the Caldecott Medal for *Lon Po Po*, Ed Young won Caldecott Honors for *The Emperor and the Kite* (1968) and *Seven Blind Mice* (1993).

## ILLUSTRATOR NOTE

Ed Young said, "When you tell a story, you have to have evil forces, and you want to find the symbol for it. The wolf is used for the evil force" (Teaching Books 2013). His *Lon Po Po* dedication indicates that he thinks wolves are not intrinsically bad or evil, even though that is how they are portrayed in children's literature. He apologizes "[t]o all the wolves of the world for lending their good name as a tangible symbol for our darkness." To the right of the dedication, against a yellow background, the illustration of a wolf, similar to the cover illustration, morphs into a human. The white eyes of the wolf gaze at the reader while the human face looks to the right. What was the wolf's front right leg on the cover is flesh colored in this illustration and looks like a human arm. The rear of the wolf's body resembles a human body more than that of a wolf's. The wolf within a human form symbolizes dark or evil tendencies within each of us.

## SOURCES CONSULTED

Bang, Molly. 2000. *Picture This: How Pictures Work*. San Francisco: Chronicle.

Marantz, Sylvia S. 1992. *Artists of the Page: Interviews with Children's Book Illustrators*. Jefferson, NC: McFarland.

Matulka, Denise I. 2008. *A Picture Book Primer: Understanding and Using Picture Books*. Westport, CT: Libraries Unlimited.

Teaching Books. 2013. "Ed Young: Meet the Author Program." http://www.teachingbooks.net/author_collection.cgi?id=51&a=1.

Young, Ed. 1989. *Lon Po Po: A Red-Riding Hood Story from China*. New York: Philomel.

# *Madeline*

## *1940 Caldecott Honor*

Lilting rhythmic text and simple, childlike paintings provide a tour of Paris and introduce a spunky heroine.—1940 Caldecott Award Committee (ALSC 2013, 154)

*Author/Illustrator:* Ludwig Bemelmans
*Style:* Expressionistic and cartoon
*Media:* Brush, pen and watercolor

## ANALYSIS

Ludwig Bemelmans's full-color art is an example of expressionistic style (Eastman 1996). Distorted shapes, bold colors, strong, simple lines, and loose brushstrokes are characteristics of expressionism (Frohardt 1999). His strong but simple lines and intense colors often exaggerate or distort objects. His buildings, while recognizable, lack architectural details and don't appear structurally sound. Smoke rises from chimneys in spiral squiggles. Objects in nature such as flowers, trees, and leaves are loosely drawn. The sun sometimes smiles and has rays emanating from it much like a child's drawing. The identically shaped cartoon girls have straight little legs and fingerless hands. Bemelmans draws "from a child's point of view" with "childlike joy, energy, and spontaneity" (Klockner 2002, 40).

Many illustrations convey movement. Madeline and her friends traverse Paris in two straight lines, but the lines are diagonal to show motion. In the fourth opening verso, compare the woman feeding the horse with the girls marching past the opera house. The woman and horse stand still and are

vertical. The girls in their lines are slightly diagonal. On the recto, the girls' line is slightly diagonal again. The gendarme and the robber are drawn with extreme diagonal lines to indicate the speed of the chase. Another example of speed is Miss Clavel's race to the little girls' room in the twentieth and twenty-first openings. As she dresses and then dashes up the stairs and down the hall, the diagonal lines increase in both angle and length until she is almost parallel to the floor. Her robe streams out behind her.

Most of the illustrations are black and white on yellow backgrounds. Excluding the cover and endpapers, only eight illustrations are in full color. There doesn't appear to be any pattern, but the vivid colors contrast notice-ably against the yellow of the other illustrations and provide interest and variety. Almost all of the color illustrations depict famous Paris settings, and the scenes pictured in the book are listed on the last page. Bemelmans says, "I wanted to paint purely that which gave me pleasure, scenes that interest me" (Bemelmans 1954, 272). Choosing to paint subjects of personal interest is also a characteristic of expressionism.

Bemelmans's illustrations demonstrate "excellence of presentation in rec-ognition of a child audience." He treats the traumatic experience of an appen-dectomy with sensitivity in the twelfth opening. After a dramatic rush to the hospital in an ambulance, Madeline awakens "in a room with flowers." No illustration depicts the operation.

The visit to the hospital is greatly enhanced by the illustrations that con-vey more than the text. They show the girls riding a bus and purchasing flowers, and each girl carries a flower to Madeline. Once in the room, Miss Clavel has gathered the flowers into a vase while the girls play with Made-line's toys, eat her candy, and crank her bed. This meets the criterion of "delineation of plot, theme, characters, setting, mood, or information through the pictures."

Miss Clavel's presence at the end of the line, at the head of the table, or in the center of the girls' activities provides a sense of security. The symmetry of living lives "in two straight lines" establishes a feeling of tranquility. Yet mischievous Madeline, as a catalyst for wild adventures, disrupts the harmo-ny. Framed in the doorway with arms outstretched, Miss Clavel restores all to calm in the last illustration.

## FOR FURTHER CONSIDERATION

- There are two illustrations in the nineteenth opening in which the little girls return home from visiting Madeline in the hospital. On the verso, there is an error in the top illustration. It shows twelve girls breaking bread, but since Madeline is still in the hospital, there should only be

eleven girls. The bottom illustration correctly shows eleven girls brushing their teeth.

- Bemelmans appeals to children and stimulates their curiosity with hidden details in his illustrations (Hoffman and Samuels 1972). Though not really hidden, there is the figure of a man in a fez facing away from the reader in the endpapers at the Place de la Concorde. He is not an integral part of the story, but he appears in several more illustrations. In the fourth opening, he is in front of the Opera on the verso and in the Place Vendôme on the recto. He is also in the fifteenth opening as the girls take the bus to the hospital.
- In the last opening, Miss Clavel bids goodnight to the little girls. With diminishing size, the text reads, "And she turned out the light—and closed the door—and that's all there is—there isn't any more." This might suggest that as the type gradually grows smaller, the children's eyes gradually close. Shutting the door ends the story.
- Bemelmans won a Caldecott Honor for *Madeline*, but he won a Caldecott Medal for *Madeline's Rescue* in 1954. He wrote several other books about Madeline.

## ILLUSTRATOR NOTE

Bemelmans writes, "If you know the artist, you will see him always in his pictures, even if they be landscapes" (Marciano 1999, 110). Much of his life is incorporated in the story *Madeline*. His mother attended a convent school in which there were little beds in straight rows and a long table with basins for washing and brushing teeth. Bemelmans also attended a boarding school, and he walked in two straight lines with the other students. He was the smallest, but he walked in the front of the line rather than at the end of the column.

After Bemelmans married and had a little girl of his own, he and his family were vacationing in France. He had a biking accident, and he recovered in the hospital in a bed with a crank. There was also a crack in his ceiling that resembled a rabbit. In the room across the hall was a young girl who had her appendix removed, and she proudly stood on her bed to show Bemelmans her scar. "And so Madeline was born, or rather appeared by her own decision" (Bemelmans 1954, 274).

## SOURCES CONSULTED

Association of Library Service to Children (ALSC). 2013. *The Newbery & Caldecott Awards: A Guide to the Medal and Honor Books*. Chicago: American Library Association.

Bemelmans, Ludwig. 1954. "Caldecott Award Acceptance." *Horn Book Magazine* 30 (4): 270–76.

Eastman, Jackie Fisher. 1996. *Ludwig Bemelmans*. New York: Twayne.

Frohardt, Darcie Clark. 1999. *Teaching Art with Books Kids Love: Teaching Art Appreciation, Elements of Art, and Principles of Design with Award-Winning Children's Books*. Golden, CO: Fulcrum.

Hoffman, Miriam, and Eva Samuels. 1972. *Authors and Illustrators of Children's Books: Writings on Their Lives and Works*. New York: Bowker.

Klockner, Karen M. 2002. "Bemelmans, Ludwig." In *The Essential Guide to Children's Books and Their Creators*, edited by Anita Silvey, 40–41. New York: Houghton Mifflin.

# Make Way for Ducklings

## 1942 Caldecott Medal

The magnificent pictures of ducks and ducklings portray characterization and feathers to an exact degree. Even the uncritical observer would recognize the excellence of illustrations which made this book a true Caldecott winner.

—Helen W. Painter (Painter 1968, 149)

*Author/Illustrator:* Robert McCloskey
*Style:* Realistic and cartoon
*Media:* Lithographic crayon on stone

### ANALYSIS

Based on a true story published in the Boston papers, the illustrations in *Make Way for Ducklings* are also true in that McCloskey has accurately depicted Boston of the 1940s. The Public Gardens with the swan boats, Beacon Hill and the State House, Louisburg Square, and the bridges over the Charles River may lack details, but McCloskey provides a sense of place that is unmistakable.

Twice as long as the normal picture book, all of the thirty-two illustrations in *Make Way for Ducklings* are two-page spreads. McCloskey would like to have used watercolor as his medium, but color printing was too expensive to afford with a young author/illustrator. McCloskey saved the publisher money by doing his final drawings on zinc plates that were the exact size of the book pages. The ink spread over the plates provided the timeless sepia hue of the illustrations and the text. The only other color is the dark green of the book jacket that matches the credits on the title page.

125

Even with just the one color, McCloskey provides texture, light, and shadow. Smooth lines represent the sleekness of the mallard's body, and feathery lines indicate the soft and fluffy down on the ducklings' heads. In the twenty-first opening, probably the most iconic illustration associated with the book, policeman Michael stops traffic to let Mrs. Mallard and her charges cross the road. Stippling creates shadow and texture on the sidewalk, road, wall, and building façades.

The composition of this illustration incorporates several design principles. The space surrounding the text in the upper left balances with the empty space in the lower right. The size of the automobiles, so large that they bleed off the page, contrasts with the diminutive ducklings, one of them struggling to hop off the curb. The vertical lines of Michael's back and his nightstick show stillness that contrasts with the diagonal movement of the ducks marching across the road. The lamppost separates the bulk of the autos and the rotund policeman.

McCloskey imbues Mrs. Mallard and the ducklings with distinct personalities. In this illustration, Mrs. Mallard looks quite smug and perhaps a little proud as she parades her brood in front of the surprised drivers. Each duckling has a different expression in every illustration. No two ducklings are ever doing the same thing at the same time in exactly the same way, but they are always behaving like ducks. Though their names are similar, they are individuals.

McCloskey states, "I paced the illustrations, and gave them a variety of viewpoints—aerial views and others—to create a sense of space and movement and a feeling of something going on" (Marcus 2012, 148). Many perspectives are from the mallards' point of view as they fly over Boston. Others show their perspective from the water or from the pavement. In the sixth opening, the alarmed mallard is knocked off his feet by a boy racing by on his bicycle. His flowing shirttail and tie, as well as his streaming hair, indicate his speed. Frantic honking and quacking accompany rush hour traffic in the nineteenth opening, and speed lines mark the whoosh of tires. Between these episodes is a placid scene of Mrs. Mallard teaching her babies to swim and dive. In this close-up, the ducks are almost life size.

Though interspersed with dramatic scenes of danger, this is ultimately a gentle story of parents finding a safe place to raise their family, and as such it meets the Caldecott criterion of "excellence in recognition of a child audience." McCloskey's Boston is familiar, and each of his characters is individual. This fulfills the criterion of "delineation of plot, theme, characters, setting, mood, or information through the pictures." That this story still continues to appeal is an indication that the Caldecott Medal was justly awarded.

## FOR FURTHER CONSIDERATION

- Even though color printing was too expensive, *Make Way for Ducklings* was published on heavy off-white paper made especially for the book.
- In a two-page spread prior to the title page, an egg cracks and a duckling peeps out, preens itself, and struts off the page. With a diagonal line from left to right, the duckling deftly leads the reader to the page turn and into the story.
- In order to realistically draw mallard ducks, McCloskey observed them as he fed them in the Public Gardens in Boston. He also studied them at the American Museum of Natural History in New York. He even received instruction from an ornithologist at Cornell University. He still didn't draw them to his satisfaction and decided he needed models. So he went to the Washington Market in New York and purchased four mallard ducks and later twelve ducklings. He kept them in his apartment in a little pen and sometimes his bathtub. Every now and then he set them loose and crawled around the apartment after them with a tissue and his sketchpad. In his Caldecott Medal acceptance, McCloskey said, "All this sounds like a three-ring circus, but it shows that no effort is too great to find out as much as possible about the things you are drawing. It's a good feeling to be able to put down a line and know that it is right" (McCloskey 1942, 281–82). McCloskey couldn't bear to sell his ducks to a butcher, so they ended up on a friend's farm in Connecticut.
- Robert McCloskey's work after *Make Way for Ducklings* continued to win recognition. He won Caldecott Honors for *Blueberries for Sal* (1949), *One Morning in Maine* (1953), and *Journey Cake, Ho!* (1954). *Journey Cake, Ho!* was written by his mother-in-law, Ruth Sawyer, who won the Newbery Medal in 1937 for her book *Roller Skates*. McCloskey won his second Caldecott Medal in 1958 for *Time of Wonder*.

## ILLUSTRATOR NOTE

Robert McCloskey repeatedly declined to commercialize his book with sales of products. He did give permission to Nancy Schön to create statues of Mrs. Mallard and the eight ducklings to commemorate the 150th anniversary of the Boston Public Garden. The bronze sculpture stands in the Public Garden near the gate at the corner of Beacon Street and Charles Street. McCloskey gave permission a second time for Schön to create a duplicate of the sculpture for First Lady Barbara Bush to give to the Soviet First Lady Raisa Gorbachev as a gift from the children of the United States to the children of the Soviet Union. It stands in a park in Moscow.

## SOURCES CONSULTED

Isaac, Megan Lynn. 2004. "Remembering a Legend: The Life and Works of Robert McCloskey." *Children and Libraries* 2 (1): 31–34.

Marcus, Leonard S. 2012. *Show Me a Story! Why Picture Books Matter: Conversations with 21 of the World's Most Celebrated Illustrators*. Somerville, MA: Candlewick.

McCloskey, Robert. 1942. "The Caldecott Medal Acceptance." *Horn Book Magazine* 18 (4): 277–82.

Painter, Helen W. 1968. "Robert McCloskey. Master of Humorous Realism." *Elementary English* 45 (2): 145–58.

Schmidt, Gary D. 1990. *Robert McCloskey*. Boston: Twayne.

# The Man Who Walked Between the Towers

## 2004 Caldecott Medal

In *The Man Who Walked Between the Towers*, I didn't want to just tell the story of Philippe Petit's walk—I wanted the book to *be* the walk between the cardboard covers.—Mordicai Gerstein (Giorgis and Johnson 2005, 51)

*Author/Illustrator:* Mordicai Gerstein
*Style:* Realistic and cartoon
*Media:* Pen and ink, colored pencil, and oil paint on heavy paper

### ANALYSIS

It is the early morning of August 7, 1974, in New York City. After a night of dangerous undercover work with friends to secure a cable between the roofs of the not-yet-completed twin towers of the World Trade Center, aerialist Philippe Petit stands ready to embark upon an even more dangerous endeavor: to walk between the towers. In the tenth opening, readers see his left foot on the wire, one-quarter mile above the ground. A page turn to the eleventh opening reveals a gripping scene as the Frenchman begins his walk, balancing pole in hand. The breathtaking image bleeds off all edges, unlike previous illustrations contained in hand-drawn frames.

Blue is the dominant color of the book. In this wordless spread, Mordicai Gerstein uses it in varying values: the steely blue-gray North Tower sharply rising toward the reader; cool blue rectangular shadows of buildings and piers; aqua water aglow in the morning sun; and menacing blue, white, and

yellow clouds encroaching upon a calm rose-blue sky. The illustrator applies a few lines of red paint and colored pencil to catch the eye and tie into the auburn hue of Petit's windswept hair. The aerialist is dressed in black, an effect created with black ink cross-hatching and light blue paint.

A strong diagonal line extends from the lower verso to almost the midway point of the recto as readers follow the aerialist on the cable. The diagonal lines of the North Tower and the buildings' shadows in the water form a "V" with Petit as the focal point. Curves soften the sharp lines and angles with the curvature of the vast horizon line, a roadway that wraps along the shore, Petit's balancing pole, and the graceful aerialist himself.

When the gatefold opens, a striking scene bursts forth. Petit is farther along the wire, and readers see the corner of the North Tower's roof. Three birds circle the aerialist. Lyrical text is set against the sky. In the midst of this splendor, however, turbulent clouds in the distance portend trouble.

A page turn to the twelfth opening offers a very different point of view of the spectacle. Readers must turn the book on its side to see Petit from the eyes of a pedestrian exiting a subway station. The dramatic gatefold brings a slight shift in perspective to show the grandeur of the towers and the now captivated spectators on the street. With the exception of one additional double-page spread, Gerstein returns to framed illustrations as Petit completes his walk and faces the consequences of his illegal act.

As Gerstein's account comes to a close, the seventeenth opening abruptly changes format. The verso is the only page of the book without artwork, bearing these powerful words: "Now the towers are gone." An empty skyline on the recto completes the sobering spread. A turn to the final page shows a ghostlike image of the towers and Petit walking between them to tie the historic feat to the present.

Meeting both the Caldecott definition and criterion, Gerstein's remarkable use of perspective and mastery of line are "marked by eminence and distinction" and demonstrate "excellence of execution in the artistic technique employed." Presenting the story in a series of vignettes similar to a graphic novel provides effective pacing in its "excellence of pictorial interpretation of story." Stunning gatefolds and unusual perspectives heighten the suspense of the story "[recognizing] a child audience."

## FOR FURTHER CONSIDERATION

- Gerstein uses frames and borders in creative ways. Frames contain all but three full-bleed illustrations. In the night scenes, Gerstein has painted the borders in blue "to extend that feeling of the night" (Silvey 2004, 56); dust and lint can even be seen in the brushstrokes. The ninth opening is especially interesting as borders gradually change from darker to lighter blue

to white to show the passage of time. In this opening and four other spreads, Gerstein explains how he "distorted the picture frames" to try to "stretch and open up the space" (Silvey 2004, 56).

- The artist was already working on this book when Philippe Petit was about to publish his personal account of the walk in *To Reach the Clouds*. Gerstein was able to consult the photographs and diagrams in Petit's work when designing his picture-book illustrations.

- The vantage point of the title page and the first opening of the book matches that of the final two illustrations of the book, the towers notably absent from the city skyline at the end.

- Gerstein usually designs the cover last when he has the "full feeling of the book" (Silvey 2004, 56). The front cover is similar to the recto of the tenth opening, but the artist widens it to the back. The dust jacket flaps extend the illustration even further. The original dust jacket was designed with no title or author's name, but just before publication Gerstein and editor Simon Boughton decided to include it (Silvey 2004, 56).

- Gerstein's style is difficult to succinctly define in this book. His work is largely realistic, yet many facial expressions and gestures of secondary characters suggest a cartoon style, and some of the angles are exaggerated for dramatic effect.

- Before illustrating children's books, Gerstein spent many years creating animated films and commercials. He unfolds the story of Philippe Petit's endeavor much like an animated film, with a sequence of framed vignettes and frequently changing perspectives.

## ILLUSTRATOR NOTE

In the 1970s, Gerstein remembers watching Philippe Petit perform on the sidewalks of his New York City neighborhood. He did not witness the performing artist's famous walk between the towers, however, but read about it in the *New York Times*. "I was thrilled to my toes and thought it was one of the most wonderful things anyone had ever done" (Gerstein 2004, 12).

A 1987 *New Yorker* profile of Petit inspired Gerstein to write a fictional story that was never published, so he set the project aside. When the World Trade Center was destroyed in 2001, Gerstein was no longer living in New York City, yet he "experienced the destruction of the Towers in a personal way" (Gerstein 2004, 12). He retrieved the article from his shelf and began to write a tribute to Petit and the Twin Towers.

## SOURCES CONSULTED

Gerstein, Mordicai. 2004. "The Importance of Wonder." *Children and Libraries* 2 (2): 11–13.

Giorgis, Cyndi, and Nancy J. Johnson. 2005. "Talking with Mordicai Gerstein." *Book Links* 14 (6): 50–53.

Petit, Philippe. 2002. *To Reach the Clouds: My High Wire Walk between the Twin Towers.* New York: North Point.

Silvey, Anita. 2004. "Sitting on Top of the World." *School Library Journal* 50 (5): 54–57.

# Me . . . Jane

## 2012 Caldecott Honor

A unique combination of dreamy watercolor vignettes and nature-inspired vintage engravings complement a simple and evocative text. Every element of the book's design, from its album-like cover and heavy yellowed pages to the inclusion of photographs and Goodall's own childhood drawings, helps create a picture book that feels like a relative's cherished scrapbook.—Eliza Brown (Brown 2012)

*Author/Illustrator:* Patrick McDonnell
*Style:* Cartoon
*Media:* India ink and watercolor on paper

## ANALYSIS

In the eleventh opening, settled in the crook of a tree branch, "Jane could feel her own heart beating, beating, beating." McDonnell said this illustration "sums up the book" (Luderitz 2012). Jane listens to her heart, follows her dreams, and goes to Africa. On the text page opposite this illustration, there are stamps of hearts, including a heart-shaped hot air balloon, implying a journey.

In the next opening, the verso has realistic stamped engravings of a gorilla, lion, and elephant while the recto shows Jane and Jubilee perched in the tree outside her house. Reading Tarzan books, "Jane dreamed of a life in Africa, too," and with a page turn, Jane's dream manifests itself, and she is there. Engravings of a ship, ocean waves, and a map of the world featuring Africa lead the reader to Jane and Jubilee still sitting on the same tree branch

beside her house. However, now the yard has transformed into a jungle. An elephant, lion, and giraffe emerge from tropical foliage. Even the oak leaves have become fernlike. Shown by increasing concentric circles around it, the sun burns hotter.

Later, Jane tucks Jubilee into bed at night. Her bedroom changes into the adult Jane's tent so that in the seventeenth opening, Jane awakes "to her dream come true," a life in Africa as a primatologist devoted to the welfare of animals.

McDonnell describes Jane Goodall as having "the mind of a scientist coupled with the heart of a poet" (Grabarek 2011). He conveys this through contrasting the finely detailed and accurate engraved stamps of flora and fauna with his soft, muted watercolor illustrations with imprecise borders that lend a dreamlike quality to the art.

The nineteenth- and early twentieth-century engraved stamps complement the illustrations: stamps of chickens as Jane and Jubilee peer into the chicken coop, and egg stamps while they wait to discover the origin of the eggs. When there are repetitive stamps, such as the chicken, some are pressed less precisely than others, suggesting they may have been stamped by a child.

The creamy colored pages have a wash of brown, darker along the edges. This gives the book an aged look and feel that works well for a story that takes place during Goodall's childhood prior to World War II. The album-like cover, including the brown printed endpapers resembling African cloth, and the vintage stamps also contribute to the historical design. Even the font appears to be produced on an old typewriter with a slightly worn ink ribbon.

Patrick McDonnell describes the opening and closing of *Me . . . Jane* as a "completed journey" (Sutton 2011). The first illustration and the last photograph unify the story. In the illustration on the first page, the child Jane reaches for a stuffed chimpanzee, a gift from her father. The last page of the story is a powerful and poignant photograph of the adult Jane reaching for the hand of a baby chimpanzee. Including photographs of Jane as a child on the title page and as an adult on the last page emphasizes that this is a story of a real person. It is a story of a childhood dream come true.

McDonnell's simple and cheerful watercolors capture the essence of Jane Goodall's childhood and offer hope to children in pursuit of their own dreams. The illustrations demonstrate "excellence of pictorial interpretation of story" as well as "excellence of presentation in recognition of a child audience." The album-like style of design adds authenticity to this biography, fulfilling the criterion "appropriateness of style of illustration to the story, theme, or concept." For these reasons, *Me . . . Jane* is worthy of its Caldecott Honor Award.

## FOR FURTHER CONSIDERATION

- When McDonnell showed Jane Goodall his first draft of *Me. . . Jane*, he asked her if she would like anything changed. She wanted the red bow in her hair changed to a clip because she never wore bows. Though he didn't want to disagree with her, McDonnell pointed out that she was wearing a red bow in a photograph included in her autobiography. She replied that the red bow was the photographer's and he insisted that she wear it in the photo. So McDonnell revised his illustrations to show Jane wearing a red clip in her hair.

- During one of McDonnell's meetings with Jane Goodall, she told him that she and her sister had a nature club called The Aligator Society (the spelling is Jane's) with some of their friends when they were children. Her institute still had a few of her club's magazines that they shared with McDonnell. The fifth opening shows some of Jane's own childhood writings and drawings.

- The last illustration of the book is a humorous drawing Goodall made while working at the Gombe Stream Game Reserve in Tanzania. In a reversal of roles, it shows Jane sleeping in a tree while a chimpanzee reclines on her cot reading a book.

- The illustration on the dust jacket and the book cover do not match. The design is similar, resembling an old book or photo album, but the book cover has an actual photograph of Jane as a child holding Jubilee while the dust jacket has McDonnell's drawing of Jane and her stuffed chimpanzee. The book cover also has realistic stamped engravings of animals and plants while McDonnell's dust jacket illustration depicts animals and plants in a jungle scene. The same book cover photo of Jane and Jubilee appears on the title page.

## ILLUSTRATOR NOTE

Patrick McDonnell is an advocate for the humane treatment of animals and the creator of the Mutts comic strip. In one strip, his character Jules speaks of his admiration for Jane Goodall. Someone from the Jane Goodall Institute saw the comic and contacted McDonnell to ask permission to use it on their website. McDonnell agreed and asked if he could send the original art to Jane. Since she was going to be in New York near McDonnell's home, he was invited to give it to her in person. After his meeting with Jane, he went home and reread her autobiography *Reason for Hope*. In it is a photo of the child Jane with her stuffed chimpanzee Jubilee. It was that photograph that inspired him to write *Me . . . Jane*.

## SOURCES CONSULTED

Brown, Eliza. February 23, 2012. "Shop Talk." *The Eric Carle Museum of Picture Book Art.* http://www.carlemuseum.org/blog/?tag=patrick-mcdonnell.

Grabarek, Daryl. April 5, 2011. "Jane Goodall: It All Began with Jubilee." *Curriculum Connections.* http://www.schoolibraryjournal.com.

Luderitz, Zoe. December 31, 2012. "Go Ahead and Dream." *The Books of Patrick McDonnell.* Little, Brown Books for Young Readers. http://www.hachettebookgroup.com/features/patrickmcdonnell/book-me-jane.html.

Sutton, Roger. 2011. "Five Questions for Patrick McDonnell." *Horn Book Magazine.* http://www.hbook.com/2011/05/authors-illustrators/interviews/five-questions-for-patrick-mcdonnell/.

# Mr. Wuffles!

## 2014 Caldecott Honor

Crisp watercolor and India ink illustrations shine in an innovative graphic novel, picture book hybrid featuring hidden worlds, alien languages and one peeved cat.—2014 Caldecott Award Committee (ALSC 2014)

*Author/Illustrator:* David Wiesner
*Style:* Realistic and surrealistic
*Media:* Watercolor and India ink

### ANALYSIS

After safely landing on Earth, visiting aliens find themselves at odds with a cat and meet unexpected allies in this visually intriguing picture book. David Wiesner sets the stage for intergalactic household conflict in the first four spreads. On the page opposite the front flyleaf, two horizontal panels show an owner offering Mr. Wuffles a new toy, from which the cat walks away with disinterest. The title page extends to a full-bleed double-page spread with Mr. Wuffles sauntering past a myriad of pristine, neglected cat toys. Upon the official start of the story in the first opening, the cat has passed a small spaceship, the only toy without a price tag; the two panels on the recto show close-ups of the craft and its miniature crew. The trouble begins in the second opening with four panels of the ship's interior. The aliens' jubilance on the verso is tempered by the determined cat on the recto. Here, enormous eyes peer at the aliens in the top panel before aliens are tossed about their craft in the lower panel once the cat begins to play.

Wiesner demonstrates his skill as a visual storyteller throughout this humorous tale. His meticulous watercolor and ink illustrations are filled with details. His use of perspective and scale engages the reader. His melding of traditional picture book illustrations and graphic novel panels help vary the pacing in this nearly wordless book.

In the carefully composed sixth opening, the cat bats at a ladybug in a single-page illustration, while aliens desperately seek shelter in the three panels. The original striped wallpaper is now floral, indicating that cat and aliens have moved to another room. The cat's whiskers, teeth, tongue, and textured coat are precisely rendered. Multiple translucent images of the cat's front legs and the insect's wings show movement. With the reader almost eye to eye with the cat, the aliens look particularly small as they dash away. The point of view changes on the recto, where the reader now observes from floor level. The top panel conveys excitement as aliens run to safety in diagonal lines from the left and the right. In the lower two panels, the cat walks by in the background before the escapees venture further into their hiding place.

A page turn announces a turning point in the story with a double-page spread, where the visitors have discovered a grand lair somewhere behind the radiator cover. The gestures of the standing aliens lead the reader across the spread to the insect inhabitants entering on the right. Murals, reminiscent of those at the Lascaux caves, cover a wall and show the insects' previous encounters with the cat. Except for the characters, the scene is bathed in grays and blacks. Dark wood and conduit frame the scene like a curtain on a stage while the visitors' luminary sheds light on the area.

Wiesner's use of panels expands the visual narrative, such as in the eighth opening when the aliens and insects meet. In ten panels over two pages, the aliens draw their predicament, forge friendships, share food, and finally succeed in verbal communication. At other times, the panels quicken the pace of the story, especially in the getaway scene in the eleventh, twelfth, and thirteenth openings.

The author/illustrator tells the story almost exclusively through images. While there is much dialogue, most of it is unintelligible to the reader as aliens speak in geometric symbols and insects in scratch marks. However, their facial expressions and body language carry the narrative forward.

David Wiesner's realistic style makes this science-fiction thriller almost believable, meeting the Caldecott criterion of "excellence of pictorial interpretation of story, theme, or concept." With only four lines of Standard English, Wiesner's illustrations successfully "[delineate] plot, theme, characters, setting, mood or information." The clever premise of miniature aliens arriving in a toy-sized craft with a cat as their archenemy demonstrates "excellence of presentation in recognition of a child audience." Indeed, readers are the only humans to witness the aliens' adventures on Earth.

## FOR FURTHER CONSIDERATION

- To achieve depth in Mr. Wuffle's predominantly black body, Wiesner applied twelve to fifteen layers of black watercolor on top of a base color (Rosen 2012).
- For his research, Wiesner followed his cat around the house with a video camera mounted to a pole. In this way, he could see the home from a cat's point of view.
- To develop an original language for the aliens, the author/illustrator consulted a linguist. Wiesner uses a recurring triangle as "a sort of all-purpose exclamation" and numerators and denominators for technical jargon (Wiesner 2013b). He jokes that he includes "the universal symbol for cheese—a circle with a triangular piece missing in the panel where the aliens and insects are posing for a photo" (Sutton 2013). After the book was printed, a reader pointed out that the insect language is similar to that of Woodstock from the Peanuts cartoons, an inadvertent homage. Wiesner explains, "I wasn't consciously thinking about Woodstock, but as a kid I loved how he 'talked.' I'm sure I was channeling that memory and reinterpreting it for my bugs" (Wiesner 2013b).
- The front of the dust jacket features an aloof Mr. Wuffles unaware of the spaceship peeking out from other toys on the shiny wood floor; the ladybug, who plays a key role in the book, flies on the jacket's front and back. The book cover, however, shows a dazzling view of outer space, possibly the aliens' home.
- The author/illustrator won three Caldecott Medals for *Tuesday* in 1992, *The Three Pigs* in 2002, and *Flotsam* in 2007. He also won Caldecott Honors for *Free Fall* in 1989 and *Sector 7* in 2000.

## ILLUSTRATOR NOTE

The concept of the book was inspired by David Wiesner's cover for *Cricket* magazine in 1993. The front shows aliens who have crash-landed in a desert; opening up the back cover reveals that miniature aliens are actually exploring a sandbox. He made several attempts to develop the idea into a picture book but was unable to find a compelling plot. In late 2011, Wiesner was sketching a space ship with nodules and realized it resembled a cat toy. He recalls, "And there it was—my story. I immediately started to draw a cat and a little spaceship" (Wiesner 2013a). His black and white cat served as the model. Coincidentally, its name is Cricket.

# SOURCES CONSULTED

Association for Library Service to Children (ALSC). 2014. "Welcome to the Caldecott Medal Home Page!" http://www.ala.org/alsc/awardsgrants/bookmedia/caldecottmedal/caldecott medal.

Rosen, Judith. September 20, 2012. "A Sneak Peak at David Wiesner's Next Picture Book." *Publishers Weekly.* http://www.publishersweekly.com/pw/by-topic/childrens/childrens-book-news/article/54034-a-sneak-peek-at-david-wiesner-s-next-picture-book.html.

Sutton, Roger. September 10, 2013. "Five Questions for David Wiesner." *Horn Book.* http://www.hbook.com/2013/09/authors-illustrators/five-questions-for-david-wiesner/.

Wiesner, David. 2013a. "Creative Process: Mr. Wuffles!" *Houghton Mifflin Harcourt.* http://www.hmhbooks.com/wiesner/wuffles-process.html.

———. 2013b. "Say What?" *David Wiesner: Author & Artist.* http://www.davidwiesner.com/work/say-what/.

# My Friend Rabbit

## 2003 Caldecott Medal

> Eric Rohmann's hand-colored relief prints express a vibrant energy through solid black outlines, lightly textured background, and a robust use of color.—2003 Caldecott Award Committee (ALSC 2013, 102)

*Author/Illustrator:* Eric Rohmann
*Style:* Cartoon
*Media:* Relief prints hand-colored with watercolors

## ANALYSIS

When Mouse receives a plane as a gift, he hops in the pilot seat. His friend Rabbit, "[who] means well," flings the plane into the air with such exuberance that "trouble follows": Mouse tumbles out as the craft flies into the high branches of a tree. Rabbit enlists the help of less-than-enthusiastic animals, which are stacked one upon another, with Mouse at the top trying to reach the plane just as the pile teeters and topples over.

In the thirteenth opening, a double-page spread shows an awkward heap of animals glaring at Rabbit, who is sitting on the alligator's belly in the lower center of the recto. Diagonal lines formed by the sturdy legs of the elephant on the left and the rhinoceros on the right contain the disgruntled animals. The once-confident Rabbit stares at readers with wide eyes and high brows, indicating apprehension and uncertainty. Outside of this strained scene, in the upper left corner, Mouse is flying to the rescue in the recovered plane. A strong diagonal line connects Mouse and Rabbit through the eyes and posture of the animals.

In golden hues, the background color in this emotionally charged spread differs markedly from the rest of the book. In all other spreads, when the tension is muted, blue and violet hues fill the sky.

Eric Rohmann creates the distinct black lines of the illustrations with relief prints, carving images from a linoleum-like material. Bold and clear, the outlines and expressions of the animals are recognizable to the intended young audience. Traces of the uncarved block appear in the background while the borders show small nicks, evidence of the human hand that cut them. These imperfections show evidence of the human hand that cut them. The watercolors, while cheerful, are primarily cool and neutral hues, complemented with warm highlights of the red and yellow plane and golden ducklings.

Uniform black borders surround the single pages and double-page spreads. In many cases, however, the frames cannot contain the action. Rohmann explains, "When I was working on the storyboard for *My Friend Rabbit*, I'd make small sketches inside a rectangle that represented the border of the finished book. Then I'd place that sketch on a larger sheet of paper and draw the action going on outside the book" (Rohmann 2003, 397). For example, in the fourth opening, Rabbit is dragging a large creature into the frame, but readers see only its tail. The next spread reveals an elephant, whose bulk now extends off the opposite page. Rabbit dashes off, but readers see only his hind legs and tail. The eyes of the elephant and Mouse follow him in an energetic diagonal line, encouraging readers to turn the page.

Strong horizontal, curved, and vertical lines carry the reader through the episodic story. On land, a narrow strip of grass provides a foundation for the action. In the air, the reader's eyes follow the erratic path of the plane through twisting dotted lines. In the pictorial climax in the ninth opening, an unexpected double-page vertical spread forces the reader to turn the book on its edge to display the tall tower of animals. Reflecting on this illustration, Rohmann says, "What I hadn't expected until I saw the book turned was the way the story slows, makes the reader look more closely" (Arkoff and Brown 2013).

Elsewhere, Rohmann visually hastens the pacing. In the eighth opening, multiple views of Rabbit are shown on one double-page spread. The reader's eye marches across the verso as Rabbit is shown three times in rapid succession carrying a different large animal; on the recto, the shot closes in on Rabbit with a goose above his head, with goslings and Mouse trailing behind. The illustrator builds suspense in the tenth opening, where two single-page illustrations show close-ups of Rabbit, Squirrel, and Mouse reaching for the plane just before the inevitable collapse of the tower.

Humor is an important element of the artwork. Bold Rabbit is expressive in his fearless enthusiasm. The juxtaposition of small animals dragging, pushing, or carrying much larger creatures is comical. Hippo's reactions are

particularly amusing. In every spread, it is smiling with contentment, even when flat on its back after the fall. In addition, it finds an unlikely place in the stack; while it was pushed in place after the rhinoceros, it has somehow found itself between smaller animals.

With few words to tell the story, Eric Rohmann's clever illustrations succeed in meeting the Caldecott criteria of "excellence of pictorial interpretation of story, theme, or concept" and "delineation of plot, theme, characters, setting, mood or information through the pictures." The bold block prints are an appropriate medium conveying subtle and obvious humor that "[recognizes] a child audience."

## FOR FURTHER CONSIDERATION

- Rohmann describes the heavy black lines of relief prints as "active and chunky and energetic. . . . Because [the cutting surface is] resistant, the line tends to reproduce the force of the making of the line. . . . The black line also settles [that bright, playschool color] a little bit [giving it] a skeleton to sit with" (Reading Rockets 2012).
- The black borders of each spread resemble film frames. The artist points out, "I've always made pictures that told stories—pictures that are like still frames of a film—small bits of a longer narrative" (Burns 2005, 93). Indeed, on the back cover, the round image of Rabbit and Mouse leaping off to their next adventure is reminiscent of the final shot in early films as a camera lens closes in on the action.
- The title and author's name on the cover and title page are hand carved.
- Rohmann won a 1995 Caldecott Honor for his wordless book *Time Flies*.

## ILLUSTRATOR NOTE

When Eric Rohmann set out to illustrate *My Friend Rabbit*, he was not certain which medium to use. At the time, he was known for his realistic oil paint illustrations in picture books and book covers for Philip Pullman's His Dark Materials series.

> I took a few weeks to experiment and tried just about every medium I could think of. I made linocuts, woodcuts, scratchboard, gouache, collage, 3-dimensional paper sculptures, watercolor, pastel, pen and ink. Some media were more effective than others—often depending on my skill and experience. Finally, I decided on the relief prints because the bright watercolor and chunky, active relief-cut line made most sense with the story. (Arkoff and Brown 2013)

## SOURCES CONSULTED

Arkoff, Vicki, and Stephanie Gwyn Brown. 2013. "My Friend Eric Rohmann: Q&A with the 2003 Caldecott Medal Winner for Illustration." *SCBWI Tri-Regions of Southern California: Kite Tales Articles*. http://www.scbwisocal.org/kitetales/rohmann.htm.

Association for Library Service to Children (ALSC). 2013. *The Newbery & Caldecott Awards: A Guide to the Medal and Honor Books*. Chicago: American Library Association.

Burns, Tom, ed. 2005. "Eric Rohmann (1957–)." In *Children's Literature Review*, vol. 100, 93–110. Detroit: Thomson Gale.

Reading Rockets. 2012. "Transcript from an Interview with Eric Rohmann." *Reading Rockets*. http://www.readingrockets.org/books/interviews/rohmann/transcript/.

Rohmann, Eric. 2003. "Caldecott Medal Acceptance." *Horn Book Magazine* 79 (4): 393–400.

# No, David!

## 1999 Caldecott Honor

Shannon's childlike paintings and inventive use of line, color, and perspective bring David to life.—1999 Caldecott Award Committee (ALSC 2013, 106)

*Author/Illustrator:* David Shannon
*Style:* Naïve and realistic
*Media:* Acrylics and colored pencil

## ANALYSIS

Shannon's artwork in *No, David!* is a naïve style. "Naïve art is very childlike and is identifiable by its flat, two dimensional quality. There is little detail and no regard for anatomy" (Matulka 2008, 80). Shannon drew David with an overly large round head, a triangle nose, black button eyes, and sharp, pointed teeth. His hair is a single strip of spiky short black lines. In the fifth opening, as David exuberantly runs naked down the sidewalk, his fingers and the toes of his right foot end in points. His left foot has four round toes. At first, Shannon drew David realistically, but he felt the character was without personality. "So, I went back to the original, and I tried drawing more like a five-year-old. And, all of a sudden, he just jumped off the page and started picking his nose" (Reading Rockets 2006).

Even though David is drawn simply, his face conveys a wide range of emotions. With tongue sticking out of his mouth, David concentrates on reaching the cookie jar on the top shelf in the second opening. Feet perched precariously on the edge of the chair, he leans diagonally toward the object of his desire. David's red pants and his central position on the double-page

spread make him the focus. The diagonal line of his body and his out-stretched arm show movement and lead the eye to the cookie jar that is also colored red. The red color pops for attention.

On the next page, David's round mouth and eyes with high, arched eye-brows indicate innocence and perhaps surprise that he should be chided as he tracks mud across the carpet. Later, in the ninth opening, when sent to his room, he stalks stiffly. A thin half-circle forms his downturned mouth and diagonal lines form furrowed eyebrows, indicating his anger. Emotions such as glee and contrition are easily discerned in other illustrations.

Though the character David is drawn naïvely, the rest of each illustration is drawn realistically. Dishes, furniture, sidewalks, houses, and toys are all accurate in terms of detail and scale. In the twelfth opening, as David sits way too close to the television screen, some of the toys strewn behind him are clearly identifiable. There is an Etch A Sketch, Legos, and even a self-portrait of David on the floor. In the last illustration, as Mother folds David to her breast, her hands have pale pink fingernails, and lines form creases for knuckles and joints.

Shannon says, "A children's book is like a movie. You have to plan the pacing, the angles and perspective, which pictures will be close-ups, which far away" (Bolle 1999, 169). On the title page, the reader views Mother, hands on hips, from the viewpoint of a child looking up. Mother appears large; her authority is clear, with the title centered at a child's eye level. Often, David's antics are viewed from behind, such as his writing on the wall, running naked down the street, or watching television. Extreme close-ups of David chewing his food or picking his nose increase the gross factor. Though not quite as close, when David asks for forgiveness, arms stretched wide, the reader is drawn into the moment and feels the desire to hug the penitent.

Through his use of bold color and perspective, Shannon's illustrations are distinguished for "delineation of plot, theme, characters, setting, mood, or information through the pictures." He has a unique ability to connect with children and meets the criterion of "excellence of presentation in recognition of a child audience" because children "see a child very similar to themselves in environments they recognize" (Matulka 2008, 124). David is not naughty intentionally, and though Mother may not love all the havoc David wreaks, at the conclusion, she reassures him that she does love him.

## FOR FURTHER CONSIDERATION

- Mother's offstage voice appears in every illustration as child's handwrit-ing, but the figure of Mother appears only twice: in the first illustration on the title page, and in the last illustration. Both times the reader sees just a

portion of her body and never her face. Mother dominates the text, but David dominates the illustrations.

- Shannon uses color to convey emotions. When David is most gleefully boisterous, the background colors are bright yellow, blue, green, and pink. Orange backgrounds signify danger and impending doom: a fishbowl about to crash or a vase about to be smashed. The purple background as David is sent to his room reflects his angry mood.
- Shannon includes his West Highland terrier Fergus in all his books. In *No, David!* Fergus appears in the fifth opening, watching David run down the street. Shannon devoted an entire book to Fergus with the publication of *Good Boy, Fergus!* in 2006.
- Shannon wrote three more David picture books: *David Goes to School* (1999), *David Gets in Trouble* (2002), and *It's Christmas, David!* (2010). He has also written three board books about a younger David, and these are called the Diaper David books: *Oops!* (2005), *David Smells!* (2005), and *Oh, David!* (2005).

## ILLUSTRATOR NOTE

When David Shannon was a little boy, he wrote a book about a boy named David who got into all sorts of mischief. The only words in the book were "no" and "David" because those were the only words he knew how to spell. Many years later, when his mother sent him the book, he was inspired to write *No, David!* The round head and pointy teeth are from the original book, as is the scrawling type. Even the orange endpapers replicate the original. Shannon drew on orange paper his father, a radiologist, brought home from work. It was paper used to wrap around X-ray film.

## SOURCES CONSULTED

Association of Library Service to Children (ALSC). 2013. *The Newbery & Caldecott Awards: A Guide to the Medal and Honor Books*. Chicago: American Library Association.

Bolle, Sonja. July 19, 1999. "David Shannon: A Merry Prankster." *Publishers Weekly* 246 (29): 168–69.

Matulka, Denise I. 2008. *A Picture Book Primer: Understanding and Using Picture Books*. Westport, CT: Libraries Unlimited.

Reading Rockets. 2006. "Meet the Author: Featuring David Shannon." *YouTube*. http://www.youtube.com/watch?v=LBQMTg6BHT0.

# Officer Buckle and Gloria

## 1996 Caldecott Medal

Watercolor and ink illustrations employ brilliant colors that, combined with a
creative use of white space, engage the reader in the humor and warmth of this
stellar performance.—1996 Caldecott Award Committee (ALSC 2013, 108)

*Author/Illustrator:* Peggy Rathmann
*Style:* Cartoon
*Media:* Watercolor and ink

## ANALYSIS

Officer Buckle and Gloria's safety lecture in the state college auditorium was
videotaped! "That night, Officer Buckle watched himself on the 10 o'clock
news." In this two-page spread of the twelfth opening, he is settled on the
couch in his blue bathrobe and his red slippers with safety soles. His pajamas
are designed with "STOP" and "YIELD" signs. With a glass of milk, a bowl
of popcorn, and his faithful partner Gloria beside him, Officer Buckle experi-
ences the big reveal. Much to his chagrin, he sees Gloria's madcap antics
behind him for the first time. He realizes that all the times he thought the
audience was applauding his expressive speeches, they were really cheering
for Gloria's outrageous performances.

The reader's eye is drawn to the dominant television in the lower left
corner and then diagonally up to Officer Buckle and Gloria and the reflection
of the television screen in the mirror behind them. The two televisions estab-
lish unity within the illustration. The brownish-orange television and its re-
flection in the large brownish-orange framed mirror also create a diagonal

balance while the bookcase, shrouded in purple shadows, is balanced horizontally by Officer Buckle and Gloria illuminated from the light of the television screen.

The effective use of shadow and light realistically depicts a darkened room with a television turned on. Even the room behind the television is dark, as can be seen in the purple reflection in the mirror. Though the bookcase is in shadows, the television casts enough light to see the Gloria bookends and several book titles such as *Safety and You*, *Better Safe than Sorry*, and *You Can't Be Too Careful*. The wall above the bookcase is decorated with safety awards.

Feelings and emotion are clearly portrayed in the faces of Gloria and Officer Buckle. Sitting quite still, just the slant of Gloria's eyebrows makes her appear sheepish, worried, even apologetic. Shock is registered in Officer Buckle's widened eyes and open mouth. He is so startled that his arms and legs jerk and his elbow tips the milk while his knee knocks the popcorn bowl, sending kernels flying. Officer Buckle's frown on the next page reveals his devastation as does the one hundredth safety tip he's just written: "Never turn your back on a strange dog."

Many of the illustrations are framed in an outline similar to a stage. Indeed, whenever Officer Buckle and Gloria appear onstage, they are framed. Often there is so much action, it breaks the frame, and Gloria enacting a safety tip usually causes this. Her exuberance cannot be contained, and an arm or a tail escapes. In the first opening, Officer Buckle's chair slides out from under him and the chair, safety tips, and thumbtacks spill out of the frame, creating a diagonal of motion. In the seventh opening, Officer Buckle receives so many thank-you letters that they flutter out of the envelope and onto the following page. Sometimes Rathmann places an item outside the frame to create emphasis, such as the microphone in the eleventh opening and the television in the twelfth opening. At the end of the story, when chaos is controlled and safety reigns, the last two illustrations remain within their frames.

Rathmann describes *Officer Buckle and Gloria* as a "picture-dependent book" (Berry 1999), and the detailed illustrations carry much of the narrative. Gloria's clowning behind Officer Buckle's back is never described in words, only shown in the illustrations. This meets the Caldecott criterion of "delineation of plot, theme, characters, setting, mood or information through the pictures." The vibrant watercolors and cartoon style are a perfect match for the slapstick humor of the book and meet the Caldecott criteria of "appropriateness of style of illustration to the story, theme or concept," and "excellence of presentation in recognition of a child audience."

## FOR FURTHER CONSIDERATION

- Safety tips appear in stars on the front cover, the endpapers, and also thumbtacked to Officer Buckle's bulletin board. None are repeated. In her Caldecott acceptance speech, Rathmann shared, "Back when I was collecting the 101 safety tips for the endpapers and the bulletin boards in this book, I offered my nieces, my nephew, and a dozen other young friends twenty-five dollars for any safety tips that made it past my editor. The response was very expensive" (Rathmann 1996, 426).
- The star motif is repeated throughout on safety tips, the dedication, Claire's notes to Officer Buckle, Gloria's dog tag, Officer Buckle's badge, and the side of the police car.
- Whenever Officer Buckle appears, he is dressed in his blue uniform. The only time he is not in his blue uniform, he is dressed in his bathrobe of a matching blue. This continuity of color makes it always easy to spot Officer Buckle in the illustrations. There is also continuity of color with the pink curtain backdrop in several illustrations.
- Rathmann knows children pay attention to details, and she includes little subplots in the illustrations. On the title page, Officer Buckle has a jar of candy on his desk. After Gloria becomes his partner, the jar is filled with dog treats. There are more changes throughout the book. After Officer Buckle delivers his safety tips, the children become more safety conscious. The shoelaces of the boy in the back row during Officer Buckle's first appearance with Gloria are untied. When Gloria appears solo, they are tied. There is also someone holding a white rat in his hand. Later, the rat is in a cage.
- Not only does Gloria mime safety accidents behind Officer Buckle's back, she also signs autographs while he purchases ice cream. She is left-handed.

## ILLUSTRATOR NOTE

Peggy Rathmann suspects her family's dog, who did naughty things while no one was watching, was an influence on her writing. On her website, Peggy relates the story of the time her mother was being videotaped in the dining room, and the dog was licking all the poached eggs on the buffet behind her. Neither her mother nor the cameraman noticed. Filming continued while the family ate breakfast and commented on the delicious eggs. Peggy writes, "The first time we watched that tape we were so shocked, we couldn't stop laughing" (Rathmann 2013).

# SOURCES CONSULTED

Association of Library Service to Children (ALSC). 2013. *The Newbery & Caldecott Awards: A Guide to the Medal and Honor Books*. Chicago: American Library Association.

Austin, Patricia. 1999. "The Story behind the Artist and Her Stories: An Interview with Peggy Rathmann." *New Advocate* 12 (4): 305–13.

Berry, Mary. 1999. "A Funny Thing Happened: An Interview with Peggy Rathmann." *Teacher Librarian* 26 (5): 57–58.

Rathmann, Peggy. 1996. "Caldecott Medal Acceptance Speech." *Horn Book Magazine* 72 (4): 424–27.

———. 2013. "Books by: Peggy Rathmann—Official Site." http://www.peggyrathmann.com/.

# Olivia

## 2001 Caldecott Honor

With the touch of a minimalist, Falconer has created an exuberant character using deft black lines, delicate charcoal shading, generous white space, and spots of brilliant red.—2001 Caldecott Award Committee (ALSC 2013, 104–5)

*Author/Illustrator:* Ian Falconer
*Style:* Cartoon
*Media:* Charcoal and gouache

## ANALYSIS

Ian Falconer describes his picture books as "clean and spare" (Minzesheimer 2003). Using fine line drawings against stark white backgrounds, he employs few colors, just black, gray, and splashes of red to emphasize Olivia's energy. He explains, "I think black-and-white can be just as arresting as color. . . . It can also be much less information going into your eye, your brain, so that you pay attention to subtler detail in, say, facial expressions" (Brown 2000, 26). The velvety gray is achieved with gouache, an opaque watercolor.

There are two all-gray illustrations in the book, on the versos of openings eleven and fifteen. In the first, Olivia is imagining herself onstage as a ballerina. In the other, Mother reads her a biography of Maria Callas. The remaining illustrations make ample use of white space with red accents. Because white space dominates the pages, Falconer places gray shadows under figures to offer depth. In the tenth opening, without the gray shadow to ground him, Olivia's little brother would look like he was floating.

There is no real plot to *Olivia*. It's more of a "day in the life of" story. Falconer draws the pictures before he writes the story. "I tell the story first in pictures, which is how kids, who don't know how to read yet, will see it" (Minzesheimer 2003). He provides variety by alternating full-page art and double-page spreads with little vignettes. The vignettes help pace the story. In the fourth opening recto, Olivia moves the cat, brushes her teeth, and moves the cat again. In the ninth opening, instead of napping, Olivia practices ballet moves in four spot drawings. With her last move, she leaps to the page turn.

The second and the fifth openings are similar in that Falconer draws multiple Olivias in action. On the verso of the second opening, Olivia hammers, jumps, stands on her head, and engages in all sorts of activities. On the recto, she runs and jumps rope and finally wears herself out. The four spots begin in the upper left and move diagonally down the page to Olivia flat on her back. It leads perfectly to the page turn. In the fifth opening, Olivia tries on all her clothes and accessories. Everything is her favorite color, red, except her tights. In the lower left of the verso, Olivia has both legs in one leg opening.

With words and illustrations, Falconer creates surprises for the reader with several of the page turns. When teaching Olivia how to make sand castles, her mother pats a little mound of sand between her legs. Turning the page, Olivia has sculpted a skyscraper. At the museum, Olivia views a Jackson Pollock painting and observes, "I could do that in about five minutes." Turning the page, her dismayed mother sees Olivia has created her own Pollock-style painting on her bedroom wall. The setups are one-page illustrations followed by double-page surprises.

Olivia demonstrates energy, resourcefulness, creativity, and imagination. She has well-developed skills in negotiating bedtime stories. By creating a memorable character that children identify with, Falconer meets the criteria of "excellence of presentation in recognition of a child audience" and "delineation of plot, theme, characters, setting, mood, or information through the pictures."

## FOR FURTHER CONSIDERATION

- Ian Falconer's name is not on the cover of *Olivia*. He thought the book would be stronger without it. There is just the title and Olivia against a white background to keep with his minimalist approach. The back cover shows Olivia reading glowing reviews of her book.
- The front endpapers lead us into the book with a trail of Olivia's cast-off clothing. The verso of the title page shows her pulling on the dress she wears on the cover and on the title page. She leans toward the title page

and one hoof points to her name. The back endpapers show Olivia removing her dress. She's not quite ready to end her day, though. She's still dancing on the back jacket flap and underneath the flap.

- Falconer shows just a portion of a Degas painting and a Pollock painting in openings ten and eleven. To show the entire paintings wouldn't have worked on the pages. The Degas painting is in the public domain, but copyright permission for the Pollock would be granted only if the entire painting were shown. Reduced versions of the complete Pollock and Degas paintings with credits appear on the copyright page (Feldman 2001).

## ILLUSTRATOR NOTE

When Ian Falconer's niece Olivia was born, he wanted to create something for her as a Christmas present. He wrote a book and thought it turned out well, so he took it to an agent who liked the drawings but felt the book would be accepted better if written by an established author. Falconer didn't want to turn his book over to someone else, so he kept it. Later, an editor saw his illustrated covers for *The New Yorker* and invited him to illustrate a children's book written by another author. He didn't want to do that, but he showed her the book he'd written for his niece. The editor realized Falconer instinctively understood kids. The book was a little too long and sophisticated, but about 90 percent perfect. She signed Falconer to a two-book contract. Of course, he's written many more than two books about Olivia.

## SOURCES CONSULTED

Association of Library Service to Children (ALSC). 2013. *The Newbery & Caldecott Awards: A Guide to the Medal and Honor Books*. Chicago: American Library Association.

Brown, Jennifer M. 2000. "Flying Starts: Ian Falconer." *Publishers Weekly* 247 (51): 26.

Feldman, Gayle. 2001. "Anne Schwartz/*Olivia*: A Star Is Born." *Publishers Weekly* 248 (37): 54–55.

Minzesheimer, Bob. October 6, 2003. "Oink If You Love *Olivia*." *USA Today.com*. http://usatoday30.usatoday.com/life/books/news/2003-10-06-olivia_x.htm.

# One Cool Friend

## 2013 Caldecott Honor

Energetic line and dizzying perspective combine for a rollicking tale of Father, Elliot and a highly improbable pet (or two). . . . Small's ink, watercolor and pencil illustrations with chilly details and visual jokes . . . invite many repeated readings.—2013 Caldecott Award Committee (ALSC 2013, 94)

*Author:* Toni Buzzeo
*Illustrator:* David Small
*Style:* Cartoon
*Media:* Pen and ink, ink wash, watercolor, and colored pencil

## ANALYSIS

Elliot is introduced in the first opening: "Elliot was a very proper young man." He is the entire focus of the page as he stands solo amid all the white space. He faces sideways and looks at the reader out of the corners of his eyes with a half-smile. Self-assured, hands tucked behind his back, he strikes a debonair pose in his tuxedo. His shadow points to the page turn.

We learn more about Elliot in the next opening. We also meet his father. On the verso, Elliot's father spreads across half the couch, legs wide apart, reading the newspaper. He leans toward Elliot, and his body angle and the diagonal line of the newspaper draw attention to the boy. In contrast to his father, posture perfect, Elliot sits primly with ankles crossed, reading a book to his carefully arranged stuffed animals. Again, white space is used effectively to focus attention on Elliot and his father. The horizontal line that extends to either side of the couch is the only indication of a room, and no

157

other details distract from the characters. These two pages are perfectly balanced, with the long sofa divided evenly by the gutter. Text matches text across the tops of the pages. Elliot and his menagerie balance the bulk of his father.

The third opening is another well-balanced double-page spread. Each page is balanced, and the pages balance each other. On the verso, Elliot disappears through a tunnel while his father sits on a bench reading his *National Geographic*. His shadow resembles that of a tortoise, and his head pokes out of his turtleneck sweater like that of a tortoise head poking out of his shell. Elliot's shadow looks similar to a penguin. On the recto, the two tunnels balance each other. The black dotted line of Elliot's path shows him avoiding the screaming girl racing toward him and follows him marching off the page.

Curved blue grid lines of the aquarium walls and floor lead the eyes to Elliot. Typically, angular shapes are used for man-made structures and curved shapes are used to depict items in nature (Horning 2010, 96). Small deviates from this practice, using fluid lines inside the aquarium to establish a link to the marine life within.

Blue is a cool color that suggests water and ice, also appropriate for the aquarium. The blue and white endpapers and spine have an opposite color pattern to the grid used for the aquarium interior. Small minimally uses color, mostly primary colors of blue, red, and yellow. All of the green in the house and the father's clothing relate to the tortoise Captain Hook. The majority of the illustrations are black and white. About color, Small says, "That whole basis of working in black and white and grays became the basis of my understanding of color, because it's all about tone, it's all about light and dark" (Allen 2009). His mastery of achromatic colors is most noticeable in the illustrations of the penguin colony in the aquarium and again in the thirteenth opening showing scenes of the kitchen and bathroom.

"The demands of the picture book are great. You have to retell the entire story in purely visual terms," says Small (Danielson 2008). Small accomplishes this as well as meeting the Caldecott criteria of "excellence of pictorial interpretation of story, theme, or concept" and "delineation of plot, theme, characters, setting, mood, or information through the pictures." By including humor that appeals to both adults and children, he meets the criterion of "excellence of presentation in recognition of a child audience."

## FOR FURTHER CONSIDERATION

- Small includes many visual clues of Captain Cook's existence, some subtle and others not so subtle. That Elliot's father wears a green suit the same color and with a similar pattern to the tortoise's shell doesn't seem like a

clue at first. But his pajamas with overall tortoise print are very obvious. Other clues include the *HMS Beagle* painting, the tortoise clock, and tortoise anatomy charts, Captain Cook himself as a footstool, the box of Turtles chocolates on the side table, and the tortoise back scrubber. Small says that his picture book is an exercise in "sharpening your perceptions," discovering "what's been right before your eyes all along" (Danielson 2012).

- Tuxedos are sometimes referred to as "penguin suits." Both Elliot and his father wear clothing reminiscent of their pets.
- Dialogue is encapsulated within speech balloons with tails pointing to the speaker. When Elliot thinks, "Kids, masses of noisy kids," that balloon is cloud shaped with little bubbles leading to Elliot to indicate that these words are thought rather than spoken. The jagged lines of the penguin's speech balloon "Grock!" and Elliot's father shouting "Elliot!" indicate increased volume and excitement of the speakers.
- *One Cool Friend* is Small's second Caldecott Honor. He won his first in 1998 for *The Gardener*, a book written by his wife, Sarah Stewart. In 2001 he won the Caldecott Medal for *So You Want to Be President?* by Judith St. George.

## ILLUSTRATOR NOTE

David Small has always liked the books of Roald Dahl because he appreciated that they had a "certain kind of sophistication" (Allen 2009). They were the kinds of books that he wanted to write and draw, books that entertained both children and their parents. "That's what I try to do in my picture books, is to be all-inclusive, but not exclusive, to not exclude the kid and not exclude the parents from the experience" (Allen 2009). With sly details, Small extends the story of Elliot and his father with jokes to appeal to both children and adults.

## SOURCES CONSULTED

Allen, Austin. 2009. "Big Think Interview with David Small." *Big Think*. http://bigthink.com/videos/big-think-interview-with-david-small.

Association for Library Service to Children (ALSC). 2013. *The Newbery & Caldecott Awards: A Guide to the Medal and Honor Books.* Chicago: American Library Association.

Danielson, Julie. 2008. "Seven Questions over Breakfast with David Small." *Seven Impossible Things before Breakfast*. http://blaine.org/sevenimpossiblethings/?p=1328.

———. 2012. "One Impossibly Cool Friend before Breakfast." *Seven Impossible Things before Breakfast*. http://blaine.org/sevenimpossiblethings/?p=2289.

Horning, Kathleen. T. 2010. *From Cover to Cover: Evaluating and Reviewing Children's Books*. Rev. ed. New York: Collins.

# Owl Moon

## 1988 Caldecott Medal

This ability to see and then to capture in an illustration or painting not only what is obvious in the world around us but also what is silent and sometimes hidden is so clearly a mark of John's work.—Patricia Lee Gauch (Gauch 1998, 460)

*Author:* Jane Yolen
*Illustrator:* John Schoenherr
*Style:* Realistic
*Media:* Pen and ink and watercolor

## ANALYSIS

Except for the last illustration and the spots on the title and dedication pages, all of the illustrations for this book are two-page spreads. In this way Schoenherr captures the vast expanses of the landscape and highlights finding an owl in the woods at night with dramatic effect. Using strong lines, varying perspectives, and minimal color, the illustrations convey the mood of this quiet story.

The first full spread is an aerial view of a farm. The red barn dominates the center of the verso, but the reader's eyes are drawn to the little girl and her father near the bottom of the page, their footprints indicating the only movement. From this perspective, they appear tiny and alone. Stable horizontal and vertical lines emphasize the stillness that is broken only by the far-off whistle of a train vaguely discerned in the distance. Bright moonlight casts shadows from behind.

Light and shadow were critical to the mood of the story. Schoenherr describes going for a stroll in the woods one cold January night. "The full moon on the snow was dark blue, and trees and shadows were dead black! I had to interpret the color very freely. There was no other way to make the pictures interesting" (Schoenherr 1992, 178–79). The shadows are bluish-gray against milky white snow. In the shadows of various illustrations, a rabbit, fox, mouse, raccoon, deer, and squirrel keep still, watching and listening.

Strong diagonal lines pace the story and move the reader's eye across the pages. Shadows as well as footprints in the snow lead up to the father and daughter and the page turn in the third opening. Diagonal lines are very effective in the illustrations climaxing the story. In the twelfth through fourteenth openings, the owl lands, stares at the parent and child, and then flies away. The lines of the branch and tree trunk direct the eyes to the owl and to the next page.

These three illustrations display different perspectives in quick succession. First is the aerial view of the owl's back as it lands on the branch. Next is the full frontal view of the owl from the viewpoint of the man and girl gazing up. Brightly bathed in flashlight, the owl dominates the page, sharply contrasted against the dark woods. Finally, still illuminated by the flashlight, the view shifts to a point midair between the people and the bird. The reader can see the detailed feathers of the underside of the owl's body and wings while still viewing the people from above.

Wonder and awe are apparent in the eyes of the little girl as she watches the owl when it lands and later in the way she holds her hands as it flies away. Even her father crouches as if to diminish his size and not frighten the owl. Schoenherr writes, "The main interest of the story was in the feelings of the little girl, and that feeling of meeting wildness that I treasured" (Schoenherr 1992, 179).

Respect for nature is an apparent theme in all Schoenherr's illustrations. Of the wild animals he encounters in their natural world he writes, "The more I learn about them, the more I respect them. For me, art is a means of communicating that awe and respect" (Schoenherr 1992, 179).

Another theme is the tender bond of parent and child. The cover illustration of the father helping his daughter down the hill and the last illustration of him carrying her home bookend their loving relationship. Several illustrations show them holding hands.

The comforting protection of a father appeals to a child audience. Schoenherr's ability to capture the mood, theme, and setting of a cold winter walk in the woods in his luminous nighttime watercolors meets the Caldecott criteria of "excellence of pictorial interpretation" and "appropriateness of style of illustrations." Schoenherr's realistic paintings perfectly complement Yolen's

poetic prose, and together they capture the magic of finding an owl in the night.

## FOR FURTHER CONSIDERATION

- As models, Schoenherr used his house, the trees in his woods, and his friend's barn. He also had a father and his six-year-old daughter spend a Sunday afternoon walking in the woods with him.
- *Owl Moon* is the first book Schoenherr illustrated in full color. Though few colors are used in the illustrations, he conveys mood through varying the values of black, blue, and brown. The muted red of the girl's clothing and the stark whiteness of the snow provide contrast.
- Purposeful use of space conveys wide-open countryside or the closeness of the woods. Text is carefully framed in snow, sky, or tree branches, adding balance to pages.

## ILLUSTRATOR NOTE

John Schoenherr was a noted wildlife artist. He illustrated other animal stories, such as Sterling North's *Rascal*, Walter Morley's *Gentle Ben*, and Jean Craighead George's *Julie of the Wolves*. He agreed to illustrate *Owl Moon* because he had owls and other animals living in the woods surrounding his house, and he felt he knew them intimately. He'd also had similar experiences to the man and his daughter in the story sharing special times in the woods with his children. In his Caldecott acceptance speech he said, "On the night after being notified of the award, I was leaving my studio under a full moon. Two owls were calling to each other from the trees. I listened for some time and silently thanked them for being, and for being there" (Schoenherr 1988, 458).

## SOURCES CONSULTED

Gauch, Patricia Lee. 1988. "John Schoenherr." *Horn Book Magazine* 64 (4): 460–63.
Schoenherr, John. 1988. "Caldecott Medal Acceptance." *Horn Book Magazine* 64 (4): 457–59.
———. 1992. "John Schoenherr." In *Something about the Author Autobiography Series*, edited by Joyce Nakamara, vol. 13, 165–80. Detroit: Gale.

# The Polar Express

## 1986 Caldecott Medal

Van Allsburg's books are art works in the shape of books, art works accompanied by mysterious and thought-provoking stories. To examine them carefully is to give oneself a lesson in how picture books work.—Peter F. Neumeyer (Neumeyer 1989, 2)

*Author/Illustrator:* Chris Van Allsburg
*Style:* Realistic and surrealistic
*Media:* Full-color oil pastel on pastel paper

### ANALYSIS

In a departure from his previous Caldecott Medal and Honor books (*Jumanji* and *The Garden of Abdul Gasazi*), in which he used pencil as his medium to create photographic illustrations, Van Allsburg employs full-color pastels to create a dreamlike quality in a story of a boy's train ride to the North Pole on Christmas Eve. Even though the palette is dark and somber, red and brown hues dominate the illustrations, lending them a warm glow. Red is particularly dominant in the interior illustrations of the train and the boy's house. It is also noticeable in the clothing of Santa and the thousands of elves.

The dark colors and the misty quality of the illustrations contribute to the haunting atmosphere of the story. All the edges are soft, and there are many shadows for the imagination to fill. When asked what he likes to draw most, Van Allsburg said that things are not important to him as much as the feeling the picture gives him. "I have a favorite kind of mood I like in my art. I like things to be mysterious" (Cummings 1992, 81).

Van Allsburg achieves a mysterious mood through use of light and shadow. In the first opening, the light from the train shines in the boy's window, lighting his face and the wall behind him but leaving the rest of his bedroom in shadows. In the fifth opening, the moon shines on the right side of the mountains while the backsides and the valleys are dark. The lights of the train near the top of the peak draw the reader's attention. In the following spread, as the train crosses the bridge into the city, the moonlight, barely visible behind the farthest right arch, casts light that causes reflection in the water. All is in shadow in the eighth opening except the square in the center. Upon turning the page, the bright light reveals Santa greeting his elves and welcoming the train. The elves in the foreground work in the shadow of the enormous sleigh.

The various perspectives allow for play of light and shadow in illustrations that are cinematic. In his Caldecott Medal acceptance, Van Allsburg said, "Because I see the story unfold as if it were on film, the challenge is deciding precisely which moment should be illustrated and from which point of view" (Van Allsburg 1986, 423). The view of the train passing through the forest from the wolves' perspective in the fourth opening zooms out to a panoramic view of the train from far below on the next page. The perspective switches to an aerial view when Santa flies over the elves in the eleventh opening.

The third, fourth, and fifth openings are an interesting series of illustrations moving from safety to danger to safety again. The children are smiling and toasty warm in their pajamas while they enjoy hot cocoa inside the train coach. The ceiling is curved like a cocoon, but the world outside the windows is black. Turning the page, wolves lurk in the forest. Wolves traditionally symbolize danger. They appear larger than the train due to their proximity to the reader. The trees closest to the reader also appear larger than those on the other side of the train because their trunks are wider. Van Allsburg creates a sense of the trees' height by cropping off their tops. They dwarf the train as it passes between them. The train, highlighted by brightly lit windows, appears long because the beginning and end are not visible. Upon turning the page, the diagonal line of the mountain, created by effective use of light and shadow, leads the reader's eye to the top of the page. The train is elevated to safety above the forest below. It circles the mountain, its length seemingly never ending.

Other than the first and last, all illustrations spread across two pages, leaving just a narrow column for the text. The columns shift from verso to recto, but the text always begins at the top. The illustrations are contained in borders, and the minimalist text is matter of fact. This serious and formal design belies the fact that the story is a fantasy. The magical realism of the illustrations adds credibility to text that reads like a factual report.

The dreamy quality of Van Allsburg's illustrations fulfills the Caldecott criteria of "excellence of execution in the artistic technique employed" and "excellence of pictorial interpretation of story, theme, or concept" as well as "appropriateness of style of illustration to the story, theme, or concept." By enchanting the reader into believing that imagination is real, Van Allsburg fulfills "excellence of presentation in recognition of a child audience."

## FOR FURTHER CONSIDERATION

- Even though this story is fantasy, Van Allsburg's illustrations are realistically painted. The North Pole is depicted as a factory city with elves as factory workers. Santa and the reindeer look somewhat stiff and a bit like statues, but they do not look like the commercialized versions found in holiday advertising. They look real.
- The dust jacket and the book cover are different. The book cover is a rich burgundy cloth with a silver bell impressed, similar to the silver bell in the last illustration of the book. Upon opening the book, the endpapers are a heavy, textured brown of rich hot chocolate. It suggests this book is a *classic*. The cover and the endpapers are values of the most prevalent hues used in the illustrations.
- Van Allsburg won a 1980 Caldecott Honor for his first book *The Garden of Abdul Gasazi*. After winning a Caldecott Medal for *Jumanji* in 1982, he won a second medal for *The Polar Express*.

## ILLUSTRATOR NOTE

Having been trained as a sculptor, Van Allsburg often works with models. In his first book, *The Garden of Abdul Gasazi*, he wanted a bull terrier for the dog Fritz. When his brother-in-law told him that he was going to purchase a dog, Van Allsburg convinced him to buy a bull terrier. Van Allsburg used his brother-in-law's dog Winston as the model for Fritz. Unfortunately, the dog was hit by a car and died. To honor the contribution of Winston to his first book, Van Allsburg gives him cameo appearances in all his books. In *The Polar Express*, Fritz is the puppet on the bedpost in the first opening.

## SOURCES CONSULTED

Cummings, Pat, ed. 1992. *Talking with Artists: Conversations with Victoria Chess, Pat Cummings, Leo and Diane Dillon, Richard Egielski, Lois Ehlert, Lisa Campbell Ernst, Tom Feelings, Steven Kellogg, Jerry Pinkney, Amy Schwartz, Lane Smith, Chris Van Allsburg, and David Wiesner*. New York: Simon and Schuster.
Neumeyer, Peter F. 1989. "How Picture Books Mean: The Case of Chris Van Allsburg." *Children's Literature Association Quarterly* 15 (1): 2–8.

Van Allsburg, Chris. 1986. "Caldecott Medal Acceptance." *Horn Book Magazine* 62 (4): 420–24.
———. 2004. "Finding Fritz." http://www.chrisvanallsburg.com/.

# *Rapunzel*

## *1998 Caldecott Medal*

Richly detailed oil paintings convey dramatic emotions and feature distinctive architecture, lush landscapes and authentic costuming of Renaissance Italy. Classically beautiful illustrations portray this complex love story which can be appreciated on many levels and by all ages.—1998 Caldecott Award Committee (ALSC 2013)

*Author/Illustrator:* Paul O. Zelinsky
*Style:* Realistic
*Media:* Oil on paper

### ANALYSIS

Paul Zelinsky does not have a signature style of art because he likes to match his style to the story. He has often stated that he wants the pictures to speak in the same voice as the words. So, for *Rapunzel*, a story with Italian, French, and German origins, Zelinsky chose a painterly style that mimicked Italian Renaissance masters. He selected Italy as the setting because "the image of a tower evokes the Italian landscape, where the campanile, or bell tower, plays a prominent role in architectural tradition" (Zelinsky 1998, 215).

In imitation of Renaissance art, Zelinsky paints elaborate formal scenes framed within white margins. He includes two double-page spreads. The first is the interior scene of the fifth opening, in which the sorceress carries the baby away from her mother, the diagonal flowing lines of her robes indicating the only movement. The vertical lines of the walls and the paralysis of the grieving parents hold the rest of the image static. Attention to detail is appar-

169

ent in the folds of clothing, the intricately patterned carpet, and the ornately carved cradle and chest. The entire room is in shadow except for the diagonal shaft of sunlight that focuses attention on the sorceress.

The second double-page spread in the fifteenth opening is an exterior scene in which Rapunzel and the prince are reunited. The diagonal lines of the prince and the rock formations on the verso lead to Rapunzel, who dominates the illustration in her white dress and central location on the recto. Brushstrokes add texture to the rocks and Rapunzel's hair. The children regard their parents with curiosity as the cat observes. The lavish costumes are now frayed and torn. Rapunzel's violet dress wraps her twins, yet the graceful folds of the undergarment she wears are still elegant.

In addition to attention to details of dress, architecture, and landscape, Zelinsky imitated the lighting of the master painters. His richly hued illustrations glow in golden tones. He makes use of chiaroscuro, an artistic technique that originated during the Renaissance. As Zelinsky explains, it is "drawing one side of an object pale, and the other side dark, to create the effect of a light shining on the object from one side" (Cummings 1999, 91). As Rapunzel embraces the blind prince, sunlight falls on her forehead, cheek, neck, and side of her dress. The rest of her remains in shadow. Zelinsky employs this technique in several other illustrations, such as when the sorceress cuts Rapunzel's hair and when the prince enters the tower. It is also noticeable in the cover illustration. Light falls on two sides of the tower from the left, and the third side is shaded.

In every illustration that includes it, the tower is prominent. The book's shape and design emphasize the tower's height. On the cover, only a small portion of the tower is visible. It bleeds off the top and bottom of the illustration. It is depicted completely only in one tall, narrow panel in the seventh opening, where it rises above the treetops. The small figure of the sorceress provides contrast in size. This same contrast appears in the illustration of the prince on his horse at the base of the tower in the next opening and again as he lies fallen on the ground in the twelfth opening. Details of color and texture in the stonework and carvings of the tower hint at the opulent interior.

Zelinsky realistically portrays the Italian countryside and the splendor of its architecture using a full palette of rich oils. Intricate details of clothing, hair, and facial expressions are also expertly painted. He meets the Caldecott criteria of "excellence of execution in the artistic technique employed" as well as "delineation of plot, theme, characters, setting, mood or information through the pictures." Imitating Renaissance painters, Zelinsky matches his style of illustration to enhance this classic tale.

## FOR FURTHER CONSIDERATION

- The front and back endpapers are reverse scenes of a peasant walking his donkey toward an Italian village in the distance. He and the donkey lead the reader toward the page turn and into the story. The endpapers include the book jacket flaps with information about the story and the author enclosed within tall wooden cases. Atop the cases are vases of rapunzel. Trios of rapunzel flowers divide the text into sections throughout the book. They also adorn the title page and the tower.
- In Renaissance times it was not considered plagiarism to reuse poses or take costume and architectural details from other paintings. Zelinsky points out that the first illustration of the husband and wife comes from a Rembrandt painting titled *The Jewish Bride*. The source of the last illustration, showing Rapunzel and her family, is Raphael's *Madonna and Child with the Young St. John* (Zelinsky 1998).
- Zelinsky was questioned about the significance of the cat in the illustrations. He answers that he didn't intend the cat to be a symbol, but sorcerers often have "familiars" or close animal companions and they are frequently cats. He thought it made sense for the sorceress to give Rapunzel her cat to keep her company in the tower, as shown in the cover illustration. The cat first appears in the book as a kitten in the sixth opening, when Rapunzel is also a young child. On the next page, as the sorceress leads her into the forest, both Rapunzel and the cat have grown older. The cat next appears in the ninth opening, when the prince climbs through the tower window. It appears in the following two tower scenes and also in the last five illustrations.
- Prior to winning the Caldecott Medal for *Rapunzel*, Zelinsky won three Caldecott Honors for *Hansel and Gretel* (1984), *Rumpelstiltskin* (1986), and *Swamp Angel* (1994).

## ILLUSTRATOR NOTE

In college, Zelinsky took a course titled "The History of the Picture Book" co-taught by Maurice Sendak and a Yale English professor. He gained a better understanding and appreciation of picture books and picture-book art. He'd already decided to major in art in order to teach, but after teaching just a short time, he concluded it wasn't a good career choice for him. Though he hadn't originally intended to be a children's book illustrator, he showed his portfolio to publishers in New York City. After visiting several publishing houses, he finally received his first children's book to illustrate: *Emily Upham's Revenge*, by Avi.

## SOURCES CONSULTED

Association for Library Service to Children (ALSC). 2013. "Medal Winner." *1998 Caldecott Medal and Honor Books*. http://www.ala.org/alsc/awardsgrants/bookmedia/caldecottmedal/caldecotthonors/1998caldecott.

Cummings, Pat, ed. 1999. *Talking with Artists: Volume Three; Conversations with Peter Catalanotto, Raul Colon, Lisa Desimini, Jane Dyer, Kevin Hawkes, G. Brian Karas, Besty Lewin, Ted Lewin, Keiko Narahashi, Elise Primavera, Anna Rich, Peter Sis, Paul O. Zelinsky*. New York: Clarion.

Evans, Dilys. 2008. *Show & Tell: Exploring the Fine Art of Children's Book Illustration*. San Francisco: Chronicle.

Zelinsky, Paul O. 1998. "Artists' Notes on the Creation of Rapunzel." *Journal of Youth Services in Libraries* 11 (3): 214–17.

———. 2013. "Questions and Answers." http://www.paulozelinsky.com/paul-faq.php.

# Red Sings from Treetops: A Year in Colors

## 2010 Caldecott Honor

Computer illustration and mixed media painting on wood combine rich textures, intriguing graphic elements, stunning colors and stylized figures to reward attentive readers with a visually exciting interplay of poetry and illustration.—2010 Caldecott Award Committee (ALSC 2010)

*Author:* Joyce Sidman
*Illustrator:* Pamela Zagarenski
*Style:* Surrealistic and folk art
*Media:* Mixed-media paintings on wood, computer illustrations

### ANALYSIS

Pamela Zagarenski breathes life into the colors of the seasons in her detailed and intriguing multimedia illustrations. Upon close examination, her work reveals recurring motifs, hidden words, and ghostlike images as readers follow a fancifully clad figure and a dog, often accompanied by a fox and cardinal and all wearing crowns.

The artist offers a visual interpretation of Joyce Sidman's poetic personification of the colors of the seasons. The page format varies throughout the book, which includes four double-page spreads among several single-page illustrations. Except when an illustration meets a margin or gutter, the paintings bleed off the edges of the pages. Poems are usually placed within the illustration itself, although a few are on white margins on the right or left.

When a color is described in a poem, the typeface of the word appears in that color.

In the illustration for the first stanzas of "Spring," featuring the color red, readers find themselves embarking on a journey led by a guide and dog traversing a golden path. The image covers most of the double-page spread, with a wide white margin on the right to display the poem.

The orientation of the illustration offers strong horizontal lines: the swath of sky in the background, block of green landscape in the middle ground, and path with patterned edging in the foreground. The action moves horizontally as well, with cardinals flying from the tree and bursting from the house, robins plucking worms along the path, a fox trotting on a trail, and our guide and dog walking (or rolling) toward the page turn. The strong vertical line of the tree on the verso anchors the image.

A bright blue sky meets hills of muted green. The yellow and gold hues of the sun, horizon line, house, lane, and clothing bring warmth to the scene. Red musical notes surround cardinals singing from treetops and the roof of a home. A red swing beckons, and a door welcomes "COME IN." Red in the guide's clothing and dog's collar connect them to the poem. In fact, in most illustrations, the guide wears clothing in the featured colors.

Texture adds interest to the illustration. Brushstrokes in the layers of paint rise from the wood, particularly in the sky and sun; the weave of a cloth or canvas emerge from blue highlights in the fields and parts of the sky; and patterns, applied digitally or by hand, embellish the broad landscape and lower edge of the lane. Words incorporated into the illustration also create texture and pattern, as with the word "tree" that repeats vertically in the bark. The single word "GO" is revealed in the peak of the roof that has opened to release birds singing "Love."

Windows hang from the tree and float in the sky, providing a bridge from indoors to outdoors and a view of a wider world. An open birdcage is suspended from the tree, symbolizing freedom. Wheels of four or eight spokes remind readers of the cycle of the seasons. The house number 15 recurs in the book, as do 193, 5, 1, and 0.

Pamela Zagarenski's unusual mixed-media paintings enhance Sidman's poems of the four seasons, meeting the Caldecott criterion of "excellence of pictorial interpretation of story, theme, or concept." By creating a guide and dog to explore the seasons, the illustrator successfully "[delineates] plot, theme, characters, setting, mood or information through the pictures." Filled with recurring, obscured, and unexpected images, the illustrations "[recognize] a child audience."

## FOR FURTHER CONSIDERATION

- Zagarenski's exploration of the seasons begins on the front cover, where four trees represent each of the seasons and a red cardinal sings from the top of each tree. Handwritten words identifying every season are barely visible. Four-paned windows, ladders, circles, checkerboards, butterflies, arrows, and boats reappear throughout the book. In the lower left corner of the cover, a small door with a red doorknob and crown extends the invitation to "ENTER." Upon opening the book, red sings from the solid-colored endpapers.
- The double-page spread of the title page is in the similar blue-green tones of the cover. The names of the seasons in various typefaces form the base of the composition for a collage effect. The fox appears for the first time.
- Many spreads include letters and words. For example, on the verso of the second opening, letters decorate the guide's clothing while the word "CIRCLE" repeats along the rim of the wheel and the word "spring" creates bark in the trees.
- The dramatic eleventh opening is dark, but the stunning moon in a collage of muted backward letters casts its glow on the guide and dog in the lower left of the spread. A strong white horizontal line lights their path. Adding to the mystery, two gentle whales swim in the sky. Zagarenski often includes whales in her paintings (Zagarenski 2013).
- The word "Love," sung by the birds in the first stanzas of "Spring," appears in the white background and foreground of the final stanzas of "Winter." The pattern of the guide's clothing is similar in both spreads, as is the position of the guide and dog. The book has come full circle, as the end of winter promises the emergence of spring.
- Zagarenski uses bits of her great-grandmother's passport from Lithuania in her artwork (Zagarenski 2013). The passport appears in bushes on the full title page, sixth and fourteenth openings, and final page in the book.
- The artist received a 2013 Caldecott Honor for her illustrations for *Sleep Like a Tiger*, by Mary Logue.

## ILLUSTRATOR NOTE

Pamela Zagarenski has what she considers "one really quite crazy habit. . . . While working on a big painting, series of paintings, or book, I will find a song—or perhaps maybe it is that the song finds me—and I will listen to just that one song over and over" for hours, a week, or a month. "The song becomes a kind of working meditation. The song will even be in my head while I sleep" (Danielson 2009).

"It's almost like I feel like I'm orchestrating with my paint brush. So I feel like I become part of the music almost, and then the music becomes the colors of the paint and the whole thing" (Dorsey 2010).

## SOURCES CONSULTED

Association for Library Service to Children (ALSC). 2010. "2010 Caldecott Medal and Honor Books." http://www.ala.org/alsc/awardsgrants/bookmedia/caldecottmedal/caldecotthonors/2010caldecottmedalhonors.

Danielson, Julie. June 18, 2009. "Seven Questions over Breakfast with Pamela Zagarenski." *Seven Impossible Things before Breakfast*. http://blaine.org/sevenimpossiblethings/?p=1707/.

Dorsey, Kristina. September 14, 2010. "Caldecott Award-Winning Artist Gets a Mystic Solo Show." *The Day*. http://www.theday.com/article/20100914/ENT16/309149975/1044.

Zagarenski, Pamela. 2013. "About Me . . ." *Pamela Zagarenski*. http://www.pzagarenski.com/About_Me.html.

# A Sick Day for Amos McGee

## 2011 Caldecott Medal

Endearing, expressive characterization in spare illustrations rendered in muted tones distinguish this timeless picture book. It's a great day for Amos McGee!—Judy Zuckerman (ALSC 2011)

*Author:* Philip C. Stead
*Illustrator:* Erin E. Stead
*Style:* Realistic
*Media:* Oil ink woodblock prints and pencil

## ANALYSIS

Following a visual narrative of three two-page spreads, the eleventh opening is one of the most dramatic page turns of the story. The animals have left the zoo and arrive in Amos McGee's bedroom. He clasps his hands in surprise and delight as he exclaims, "Hooray! My good friends are here!"

Too large, the dominant elephant and rhinoceros bleed off the verso while the penguin, holding the balloon aloft like a tourist guide, spills onto the recto. The reader's eye is led diagonally from the elephant to Amos in bed, creating an informal balance. The weight of the elephant in the upper left corner is balanced by the weight of Amos in bed in the lower right corner. The string of the balloon separates them. Balance is also achieved with the use of color: the reds of the rhinoceros's scarf with the balloon and the green of the tortoise with Amos's pajamas.

Strong horizontal lines of the floor and bed along with the vertical lines of the wallpaper provide stability and calm. The horizontal lines begin on the

177

title page and continue throughout the book, pulling the reader along. The vertical lines are repeated in wallpaper, fences, wainscoting, and bed frame. In the illustration of the twelfth opening, the vertical frame at the head of the bed stops the eye to focus on Amos.

The animals are rendered realistically, even while unrealistically appearing in Amos's bedroom. The grain of the woodblock print gives a leathery texture to the skin of the elephant and rhinoceros, and the thin lines of the pencil work add delicate detail. The naturalistic depiction of each animal with comparatively accurate size lends them dignity and expressive personalities. Their curved shapes suggest gentleness.

The muted color palette throughout the book, interrupted with splashes of red, is also comforting and creates a quiet, gentle mood. The blue of the endpapers matches the blue of Amos's house on the title page. The words of the title are red to match the balloon. The soft, flat colors on creamy matte paper are as unpretentious as Amos. There is nothing glossy, splashy, or bold about him.

From the moment Amos arises from bed in the morning, the illustrations provide insight to his character. He is a simple man. His bedroom is furnished sparsely, and his armoire contains just one set of clothes. Though an adult, he is childlike, sleeping with a teddy bear and wearing bunny slippers. He follows a predictable morning pattern, leaving his humble home for work, where he follows an equally predictable routine. From waking up in the morning until going to bed at night, everything about Amos exudes a gentleness of spirit.

This is a warm story of friendship that can be told without words. In every illustration of Amos with his friends, it is evident how much he cares for them. In the fifteenth opening, as the owl reads them a bedtime story, Amos has one arm around the penguin while his other hand gently rests on the elephant's trunk, and his foot caresses the rhinoceros's muzzle. In a very satisfying conclusion, penguin keeps watch as his friends fall asleep and the red balloon floats away in the night sky.

On her blog, Erin Stead describes herself as a "hack printmaker at best" (Stead 2009). Her process proceeds from sketch to carving on woodblock. She then spreads color over the block and presses paper over it. She removes the paper and allows the color to dry before she draws on top of it with pencil. While Stead may not think her process meets high printmaking standards, her illustrations meet the Caldecott Award criterion of "excellence of execution in the artistic technique employed." It also makes a perfect bedtime or anytime story, meeting the criterion of "excellence of presentation in recognition of a child audience."

## FOR FURTHER CONSIDERATION

- There is a balloon in many of the illustrations, and it is often red. This provides interest and focus.
- A little mouse and a little bird are characters in most of the illustrations. When Amos heads off to work, so do they. While Amos goes in one direction, the bird, wearing a tie and with a briefcase under his arm, goes in another. The mouse is waiting at his own mouse bus stop.
- There are many examples of humor throughout the story. In one illustration, the elephant and rhinoceros sit on very tiny stools drinking tea. Other examples of humor include the extremely large animals riding in the bus.
- The strong horizontal lines throughout the book are often embellished. On the title page, a flower stops both ends of the line. When embellishments are included, each one is different.
- A nearly symmetrical balance is achieved in both illustrations of the zoo entrance, one in the third opening and one on the back cover.
- The story begins on the copyright page or title page verso and concludes as the animals return to the zoo in the illustration on the back cover.

## ILLUSTRATOR NOTE

The dedication is a circle that reads, "Phil dedicates this book to Erin dedicates this book to Phil." Erin Stead is married to Philip Stead, the author. He wrote the book for her. Erin had lost confidence in her artistic ability and hadn't drawn for three years. When she realized a part of her was missing without drawing, she drew a picture of an elephant and an old man. Without her knowledge, Philip sent her drawing to his editor, and they both convinced Erin to illustrate Philip's story of Amos McGee. With her very first picture book, Erin won the Caldecott Medal.

## SOURCES CONSULTED

Association of Library Service to Children (ALSC). 2011. *2011 Caldecott Medal and Honor Books*. http://www.ala.org/alsc/2011-caldecott-medal-and-honor-books.
Stead, Erin E. April 30, 2009. "Erin Stead Illustration." http://erinstead.blogspot.com/.
———. 2011. "Erin E. Stead Discusses the Woodblock Printing Process for *A Sick Day for Amos McGee*." *YouTube*. http://www.youtube.com/watch?v=3TuHyU-onkc.
Stead, Philip C. 2011. "Erin E. Stead." *Horn Book Magazine* 87 (4): 24–27.

# Sleep Like a Tiger

## 2013 Caldecott Honor

[Pamela Zagarenski] creates a dream worthy world in her full-page full-bleed illustrations, wherein petite, precise pencil lines contrast with rich grainy textures of paint on wood. . . . Reality and fantasy swim comfortably together in both the domestic scenes and the imagined views of animals, and the visuals effectively evoke that twilight state where dream and reality are hard to differentiate.—Deborah Stevenson (Stevenson 2012)

*Author:* Mary Logue
*Illustrator:* Pamela Zagarenski
*Style:* Surrealistic
*Media:* Mixed-media paintings on wood, computer illustration

## ANALYSIS

Once tucked into bed but "still not sleepy," a girl imagines sleeping with her favorite animals when the bedroom light is turned off. The fifteenth opening shows her "circled around . . . like the curled up snail" and "snuggled deep as a bear."

The two full-bleed images interpret different scenes yet complement one another when viewed as one spread. The dark mass of the giant shell balances with the large white bear with its muted green, blue, and taupe. The depictions of the girl are in the lower outer quadrants of the respective pages, almost mirror images. Spiral shapes of the snail shell and the sleeping girl are matched with rounded outlines of the bear; these curved shapes offer security and comfort. The background of the shell includes soft images of windows,

while stars shine on and around the bear. The textured, scratched surface on the verso contrasts with the softness of the bear.

These two illustrations each feature unique elements as well. On the verso, shadows give the shell depth. The curved text follows the shell's shape. Blades of grass emerge from the light blue background, and scratches fill the space like undergrowth. Within the shell, however, the scratches evolve into subtle, almost secret images: windows, houses, flags, and crowns keep the reader lingering on the page. The stuffed rabbit in the window corner and the striped pillow under the girl's head keep her grounded to her home. Here and throughout the book, the child's stuffed tiger never leaves her grasp or view. A gold orb, seen here in the upper right corner, appears in almost every illustration, the sun beckoning to keep the girl awake.

The bear on the recto is tied to nighttime and sleep. The constellations on the bear's forehead and back feature Ursa Major and Ursa Minor, named for the large and small bears that they resemble. Polaris, the North Star, has a small label that is topped with a tiny crown. Within the bear's crown is a golden clock with a dial pointing to spring, when hibernation ends; this image calls back to the grizzly bear and its red alarm clock in the eighth opening. The triangular flags at the top of the page, the window on the right, and the bedspread print in the lower right corner once again show the girl safely linked to her bedroom.

Zagarenski's mixed-media illustrations are highly textured, multilayered paintings on wood, embellished with collage effects and enhanced digitally. Patterns created with paint or collage also add texture, such as in the girl's bedspread and pajamas. Throughout the book, the illustrator uses a consistent palette in the artwork, with varying degrees of blue, gold, white, brown, and red. The hues deepen as the story progresses and the girl embraces the night.

Pamela Zagarenski adds whimsical, dreamlike elements to this bedtime story, meeting the Caldecott criteria of "excellence of pictorial interpretation of story, theme, or concept" in a "[style appropriate] to the story, theme or concept." The fanciful, detailed illustrations keep the reader poring over the pages in an "[excellent] presentation in recognition of a child audience."

## FOR FURTHER CONSIDERATION

- The striking endpapers extend and unify the story. In the front, a tiger rides on a train transporting the moon as the gigantic sun glows in the center of a wheel. This leads to the first opening of the book, where the tiger discreetly carries off the sun while the moon rises. In the back, the same tiger is riding the departing train that now transports the sun out of town as the full moon shines.

- Tigers fill the book, seen in the girl's tiger-striped leggings, the wallpaper on the verso of the second opening, father's copy of William Blake's "The Tyger" on the recto of that spread, poem verses on the moon in the final opening and back endpapers, and the tiger swallowtail butterflies that dance around both images of the sleeping tiger.
- Zagarenski honors all humans, animals, and significant objects by bestowing them with crowns like royalty. In her early sketches for the book, the humans wear crowns while the animals wear nightcaps (Danielson 2012).
- Circle motifs fill the illustrations, from the wheels that carry many of the human and animal characters to recurring golden orbs, full moon, buttons, upholstery design, and butterfly wing markings. In her notes for the book, the artist mentions placing a circular object "on every page somewhere," followed by the words "cycles" and "secrets" (Danielson 2012).
- The artist received a 2010 Caldecott Honor for her illustrations for *Red Sings from Treetops: A Year in Colors*, by poet Joyce Sidman.

## ILLUSTRATOR NOTE

Pamela Zagarenski hides objects in her illustrations, "subtle things one might not see, like the four-leaf clover, just for the viewer who finds it, in the paws of the tiger, 'gaining his strength'" (Danielson 2012). In addition to some of the visual motifs noted earlier, the artist also incorporates a train, railroad tracks or ladders, the book *The Little Prince*, a fox, and coffee pots in the art.

She is elusive about the meaning of the recurring imagery in her work. The artist contends, "Really what I wish for the person looking at my paintings is to make up stories and reasons for themselves and in that process discover a secret key within themselves that unlocks a mysterious door" (Zagarenski 2013).

## SOURCES CONSULTED

Danielson, Julie. November 9, 2012. "What I'm Up to at *Kirkus* This Week, Plus What I Did Last Week, Featuring Pamela Zagarenski." *Seven Impossible Things before Breakfast*. http://blaine.org/sevenimpossiblethings/?p=2456/.

Stevenson, Deborah. 2012. Review of *Sleep Like a Tiger*, by Mary Logue. *Bulletin of the Center for Children's Books* 66 (4): 202–3.

Zagarenski, Pamela. 2013. "About Me . . ." *Pamela Zagarenski*. http://pzagarenski.com/About_Me.html.

# Snowflake Bentley

## 1999 Caldecott Medal

Mary Azarian, a Vermont artist who loves snow as much as Wilson Bentley, has created strong and skillfully carved woodcuts that portray sensible, sturdy characters and a timeless rural landscape.—1999 Caldecott Award Committee (ALSC 1999)

*Author:* Jacqueline Briggs Martin
*Illustrator:* Mary Azarian
*Style:* Realistic and folk art
*Media:* Woodcuts, hand tinted with watercolors

## ANALYSIS

He's done it! After months of failed attempts, nineteen-year-old Willie Bentley has successfully photographed a snowflake. In the eighth opening, he bounds from his studio to the snow-covered yard, the prized image in hand. A strong diagonal line carries the reader's eye from the camera, sitting solidly in the lower left, to Willie, dashing outdoors towards the upper right of the double-page spread. The young man's movement from darkness to light symbolizes his technological breakthrough.

Solid vertical lines provide order to the composition in the wooden door, door frame, tool handle, folds of the camera, and the cloth draped upon it. Clean lines also create a frame and focal point for Willie, placed against the white snow. To the right of the door frame, a lantern and pail indicate that Bentley's studio is in a shed. These same objects first appear in a figure's hands in the initial illustration in the book, providing continuity.

In depicting Willie's triumph, Mary Azarian chooses the predominantly neutral colors of black, gray, brown, and white, hand-painted on the dried woodblock print. A striking exception is Willie, clad in deep green trousers and dark red jacket. These colors draw attention to the young man and his important discovery. The illustrator uses a limited palette throughout the book, cool and neutral colors for winter scenes with additional gentle greens for spring and summer. In almost every spread, the color red highlights one or more objects.

Except where the main text is placed on the painted black background on the verso, the image is highly textured: wooden door, door frame, and tables; snow and grit on the floor; sharp accordion folds of the camera; and Willie's thick fabric clothing. Interestingly, the absence of texture in the snowy landscape imparts softness, heightened further by the heavy snow that is falling.

The action and drama in this spread are noteworthy. In contrast, most of the illustrations are formal in composition and style, with the characters almost posed. Even the depictions of children playing in the snow in the fourth and fifteenth openings are orderly and controlled. Azarian's use of strong horizontal lines in much of the book evokes a sense of formality and stability, such as with the cows, fence, camera, and table in the seventh opening and the clapboard house siding in several spreads.

Neat black frames contain each illustration in the book. A sidebar flanks one or both sides of almost every spread, giving pertinent information about Bentley's life to extend the main body of the text; this was a novel design at the time of the book's publication. Azarian made the snowflakes in the sidebars by carving the images into the block rather than removing the background; then she printed the block in pale blue-gray ink. One sidebar design is repeated throughout the book.

Mary Azarian's notable skill as a wood-block printer exemplifies the Caldecott criterion of "excellence of execution in the artistic technique employed." Her distinctive style that blends realistic and folk art is particularly appropriate to author Jacqueline Briggs Martin's story, set in the late nineteenth and early twentieth centuries in rural Vermont. The prints clearly "[delineate] characters, setting, or mood" of the picture-book biography.

## FOR FURTHER CONSIDERATION

• Azarian rarely makes detailed sketches before working with the wood. Instead, she usually starts drawing directly on the block. She goes over the preliminary lines with a permanent marker, adding more details. Then she carves around the lines of the actual design, making many revisions along the way. She rolls an oil-based ink on the block to make prints on a hand-operated nineteenth-century Vandercook proof press. The artist made her

first linoleum print in fourth grade and continued with that medium until she was introduced to wood-block printing in college.

- The artist uses Japanese tools to carve her prints on specially prepared Japanese wood.
- Rather than applying color to her images through reduction printing, Azarian hand-paints each black-and-white print. She explains, "Since I [print] multiple copies of [each illustration], I can experiment with painting until I get just what I want" (Azarian 2002).
- Azarian uses dynamic diagonal lines judiciously in this quiet book: on a winter night, a path leads from a dark barn to a house in the first opening to draw readers into the story; a projector throws light on a vivid image of a white snowflake in the twelfth opening; and Bentley trudges home in the stirring fourteenth opening, the snow blowing in the opposite direction.
- The spread of Bentley's walk in the snowstorm shortly before his death is one that Azarian particularly likes. She explains, "I appreciated the idea that he was going off in a blizzard to photograph more snowflakes after spending his life looking at snowflakes. I thought, 'Wow, what a way to go'" (Cooper 1999).
- The front of the dust jacket shows an image of Bentley from the tenth opening and snowflakes similar to those in the sidebars; the snowflake motif continues on the back with a quote from Wilson Bentley. In contrast, the book cover is deep blue, with three stamped snowflakes on the lower right corner. The only writing is silver text on the spine, complementing the simple gray endpapers, an honorable tribute to a modest man.

## ILLUSTRATOR NOTE

Mary Azarian's journey from printmaker to book illustrator evolved over many years. When she was hired to teach in a one-room schoolhouse in Vermont in the 1960s, she made a set of alphabet prints for the spare classroom, where she worked for three years before pursuing printmaking.

In the late 1970s, Azarian created another set of alphabet posters to reflect the quickly disappearing rural way of life. The Vermont Department of Education requested a set for every early elementary classroom in the state. Thinking the posters would make a good children's book, she spent a week visiting art directors who showed "polite indifference" towards her work (Azarian 1999, 425). A year later, publisher David Godine called. He had heard about the prints, asked to look at them, and then worked with Azarian to publish *A Farmer's Alphabet* (1981).

## SOURCES CONSULTED

Association for Library Service to Children (ALSC). 1999. "1999 Caldecott Medal and Honor Books." http://www.ala.org/alsc/awardsgrants/bookmedia/caldecottmedal/caldecotthonors/1999caldecott.
Azarian, Mary. 1999. "Caldecott Medal Acceptance." *Horn Book Magazine* 75 (4): 423–29.
———. 2002. "Mary Azarian." *CBC Magazine*. http://web.archive.org/web/20080509192857/http://www.cbcbooks.org/cbcmagazine/meet/mary_azarian.html.
Bentley, W. A., and W. J. Humphreys. 1962. *Snow Crystals*. New York: Dover.
Cooper, Ilene. 1999. "The Booklist Interview: Mary Azarian." *Booklist* 95 (19/20): 1834.

# The Snowy Day

## 1963 Caldecott Medal

I had no idea as to how the book would be illustrated, except that I wanted to add a few bits of patterned paper to supplement the painting. As work progressed, one swatch of material suggested another, and before I realized it, each page was being handled in a style I had never worked in before.—Ezra Jack Keats (Keats 1965, 239)

*Author/Illustrator:* Ezra Jack Keats
*Style:* Abstract
*Media:* Collage: papers, cloth, paints, and gum-eraser stamps

## ANALYSIS

In brightly colored single-page illustrations and double-page spreads, *The Snowy Day* follows a boy on his adventures in the snow. Ezra Jack Keats's full-bleed collage and paint illustrations exude excitement in the snowy cityscape. The title page is a striking image, with a clear contrast between the subtly mottled snow and the solid periwinkle sky. Peter almost embraces the title as he slides down the hill. The active diagonal line invites the reader into the story.

The first three outdoor scenes reveal Keats's skilled collage work, strong composition, and confident lines. In the second opening, Peter steps outside. His red snowsuit and the dark fence draw the reader to the verso. The fence railing provides a solid foundation for the composition. The reader follows Peter's gaze to the high snow piles with washes of pink, blue, yellow, and green. Beyond the mounds are large buildings in blocks of color, visually

confirming that the boy lives in the city. The bright pink structure guides the reader to the recto and the text below.

The next spread shows the determined horizontal line of Peter's footprints as the boy pauses to look back on his tracks. The stoplight halts the action, encouraging the reader to reflect upon the scene. The curved line of the snowbank also carries the eye across the page, peaking just before the gutter. Behind the snow, the rooflines and strip of sky reinforce the strong horizontal movement. Keats chooses unusually warm colors for the buildings, conveying a friendly inner-city setting rather than a threatening one.

In the fourth opening, the steady forward-moving tracings in the snow contrast with the dramatic curves of the snow piles. The blue sky matches the color of the trails below. The third line that appears on the recto incites curiosity and beckons the reader to turn the page.

The pacing changes in the fifth and sixth openings with four single-page illustrations. After Peter pounds against a snowy branch, a pile of snow lands on his head. This extreme close-up of the boy against a solid blue background contrasts with the recto, a long shot of Peter almost walking off the page against a stark white landscape. In these and all the outdoor scenes, the sky color varies wildly from blue to violet, periwinkle, and teal. The day ends with a dark blue sky and swirling snow, an effect achieved with paper embedded with shredded lint.

To create the distinctive mottled quality of the snow, Keats rolled white paint over wet inks on paper. For the snowflakes on the final two spreads and endpapers, the artist made his own stamps by carving designs out of gum erasers and dipping them into paint (Keats 1965, 240).

Indoors, the colors, patterns, and composition communicate a range of emotions. In the first opening, the vibrant walls in the boy's room convey anticipation of a day in the snow. Later, when Peter's mother is taking off his socks, the oval rug and the parent's rounded back impart security and comfort. In the cheery bathroom, the contemplative boy soaks in a large pink tub, toys at his feet. The mood is broken when Peter finds that his snowball is no longer in his pocket; the dark speckled setting reflects his sadness.

The artist uses a variety of materials in these illustrations. "Peter's bedroom wallpaper is real red wallpaper [and] his pajamas are flowered wrapping paper" (Perry 1971). The mother's dress is oilcloth, the bath bubbles are circles of transparent paper, and the nighttime background is India ink splattered onto paper with a toothbrush (Keats 1965, 240; Perry 1971).

Ezra Jack Keats's mastery of collage exemplifies the Caldecott criteria of "excellence of execution in the artistic technique employed" and "excellence of pictorial interpretation of story." The artist effectively delineates the setting and mood of this slice-of-life story through the pictures. The bold colors and dynamic lines show "excellence of presentation in recognition of a child audience."

## FOR FURTHER CONSIDERATION

- Peter is based on photographs of a boy that Keats cut from *Life* magazine in 1940. The artist recalls how he would place the clipping on his studio wall from time to time, "offering me fresh pleasure at each encounter." When Keats decided that he wanted to write and illustrate his first solo book, the boy became his "model and inspiration. . . . His expressive face, his body attitudes, the very way he wore his clothes totally captivated me" (Keats 1965, 239).
- Children's literature specialists regard *The Snowy Day* "the first full-color picture book to feature a small black hero" (Lanes 1984). Keats explains that in making Peter an African American child, "I wanted the world to know that all children experience wonderful things in life. I wanted to convey the joy of being a little boy alive on a certain kind of day—of *being* for that moment" (Hopkins 1969, 118). "My book would have him there simply because he should have been there all along" (Alderson 1994, 51).
- Keats won a Caldecott Honor in 1970 for *Goggles!*, which portrays an older Peter.

## ILLUSTRATOR NOTE

Collage was an unusual medium in picture books when *The Snowy Day* was published. Because of the difficulties and expense of preparing color separations from collage, Keats originally planned to alternate color with black-and-white pages. However, when his editor Annis Duff saw the first few illustrations, she asked him to create every spread in full color.

Keats explains how in collage

> a pattern that has its own character, when used in combination with other patterns, becomes something else. . . . [For example,] a decorative paper becomes a room; flat shapes of color and designs become buildings, snow, a pillow, pajamas on a boy. . . . No definition of line or shading shows where the pillow meets the bed, nor is the edge of the bed cover defined. The viewer makes it round, gives its space, follows the implications. (Keats 1964)

The artist contends that "collage evokes an immediate sensory response. Because of this quality it has special appeal for children, who experience the world in this immediate way" (Keats 1966).

## SOURCES CONSULTED

Alderson, Brian. 1994. *Ezra Jack Keats: Artist and Picture-Book Maker*. Gretna, LA: Pelican.

Hopkins, Lee Bennett. 1969. "Ezra Jack Keats." In *Books Are by People: Interviews with 104 Authors and Illustrators of Books for Young Children*, 116–20. New York: Citation.

Keats, Ezra Jack. 1964. "The Artist at Work: Collage." *Horn Book Magazine* 40 (3): 269–72.

———. 1965. "Caldecott Award Acceptance." In *Newbery and Caldecott Medal Books: 1956–1965*, edited by *Horn Book Magazine*, 239–40. Boston: Horn Book.

———. April 4, 1966. "Ezra Jack Keats on Collage as an Illustrative Medium." *Publishers Weekly* 189 (14): 94–95.

Lanes, Selma G. 1984. "Ezra Jack Keats: In Memoriam." *Horn Book Magazine* 60 (5): 551–58.

Perry, Erma. 1971. "The Gentle World of Ezra Jack Keats." *American Artist* 35 (350): 48–53, 71–73.

# The Stinky Cheese Man and Other Fairly Stupid Tales

## 1993 Caldecott Honor

*The Stinky Cheese Man* is the book that I am the most pleased with from beginning to end.—Lane Smith (1993, 69)

*Author:* Jon Scieszka
*Illustrator:* Lane Smith
*Style:* Postmodern and surrealistic
*Media:* Oil and mixed media

### ANALYSIS

There is nothing traditional in the text or the art of these irreverent fractured fairy tales. *The Stinky Cheese Man* is not only a parody of fairy tales but also of conventional book structure. In order to appreciate and understand a postmodern picture book, children need to understand some of its special features, such as nonlinearity, self-referential and antiauthoritarian text, and a sarcastic or mocking tone (Goldstone 2001).

The structure of the book itself is nonlinear. The table of contents, which normally follows the title page, concludes the first story of "Chicken Licken." It is the table of contents that falls rather than the sky. It squashes the characters and becomes wrinkled, causing the story titles to misalign. The final story title, "The Boy Who Cried 'Cow Patty,'" slips off the table of contents page and, as a consequence, is not included in the book.

Another example of nonlinear book structure is the insertion of an endpaper before the end of the book. Jack, the narrator, whispers, "I moved the endpaper up here so the Giant would think the book is over." This results in the copyright page occupying space as an endpaper at the back of the book. Jack's comment about moving the endpaper is an example of self-referential text. Readers can never become lost in the story because they are constantly reminded that this is a constructed book.

Nonlinearity appears within the fairy tales also. In the twelfth opening, the "Giant Story" is told in nine lines of various fonts pasted together. It begins with "THE END" and finishes with "Once upon a time." Jack peers over the edge of the story and queries, "That's your story? . . . You've got to be kidding. That's not a Fairly Stupid Tale. That's an Incredibly Stupid Tale." Again, with this self-referential interruption and Jack's sarcastic tone, the reader is pulled out of the story.

A further example of self-referential text is the hands of the illustrator putting together the collage of the "Giant Story." A thumb at the top of the page and three fingers at the bottom are startling because they don't belong in the story. Everything else is included in this story, though! A surreal genie with an upside-down mouth, a Pinocchio nose, and three arms emerges from Aladdin's lamp in the middle of the page. Madeline's hat from Bemelmans's stories is being placed on his head. Surrounding him are images from a variety of fairy tales, nursery rhymes, and children's stories, such as the glass slipper from "Cinderella," the three chairs from "Goldilocks," and the seven dwarfs with thumbprint faces. With one arm the genie balances a pie with a blackbird poking out from the nursery rhyme "Sing a Song of Sixpence." In an allusion to *Make Way for Ducklings*, his other arm, in what might be a policeman's uniform, signals a duck. Even Aesop makes an appearance. The Giant's story is too big to be contained. The illustrations bleed off the page.

The reader wonders who is in control of the book and the stories within it. Certainly it isn't Jack. Though he claims he's "a very busy guy trying to put a book together," the Little Red Hen starts her story before Jack can begin his book. "The Little Red Hen" isn't even a story listed in the Contents, yet she keeps reappearing. This is an example of antiauthoritarian text.

Besides the hen, Jack has trouble with other characters not cooperating. In "Little Red Running Shorts," fed up that Jack has told their entire story in his introduction, the Wolf and Little Red stalk off the page. They leave white cutouts of themselves in the illustration of the ninth opening. Jack cries, "Wait! You can't do this. Your story is supposed to be three pages long. What do I do when we turn the page?" The page turn reveals a blank white page followed by the Red Hen demanding, "Where is that lazy narrator? Where is that lazy illustrator? Where is that lazy author?" The reader, with prior knowledge of how fairy tales should work, recognizes that stories and

characters have run amok in this picture book. No one appears to be in control.

Smith's palette, however, is very controlled. The illustrations are dark in hue and humor. Smith states, "There *is* a definite dark side to my work" (Smith 1993). His somber colors belie the sly but macabre humor of his illustrations. The colors lack cheerfulness, and the stories do not end happily ever after. The final illustration shows the Giant has eaten the Little Red Hen, who once again interrupted the story and the Giant's nap. When she asks who will help her eat her bread, the Giant makes a sandwich out of her. Being a sloppy eater, he dribbles her blue bonnet and feathers from his mouth.

Smith respects his audience and allows children to discover his visual jokes. He meets the criteria of "excellence of presentation in recognition of a child audience" and "delineation of plot, theme, characters, setting, mood, or information through the pictures." The groundbreaking style of illustration, deconstructing both fairy tales and picture books, meets the criterion of "appropriateness of style of illustration to the story, theme, or concept." The originality of the art makes it worthy of its Caldecott Honor.

## FOR FURTHER CONSIDERATION

- Though the illustrations are oil and mixed media, on the copyright page it states, "The illustrations are rendered in oil and vinegar." Like the photos of the author and illustrator on the back flap of the dust jacket, this is another example of the tongue-in-cheek humor of the book.
- Smith's mother was an antiques dealer and worked with collage and decoupage. This early influence is reflected in many of Smith's illustrations (Evans 2008). He uses collage to add texture and interest. The vintage objects he includes in the illustration of the "Giant Story" suggest it might be an authentic fairy tale.
- The "funky smell" of the Stinky Cheese Man appears as fumes that waft across the endpapers.
- Smith won the Caldecott Medal in 2012 for *Grandpa Green*.

## ILLUSTRATOR NOTE

The success of this book is due to the collaborative efforts of Jon Scieszka, Lane Smith, and the designer Molly Leach, who later became Smith's wife. Smith and Scieszka looked for every possible way to poke fun at fairy tales and picture books, often exchanging ideas during games of ping-pong in Smith's studio. Leach took their suggestions and incorporated them into the book's design, adding bold type, various fonts, and other details to extend the humor. Humor requires pacing, so the picture book is fifty-six pages rather

than the standard thirty-two pages. Of the result, Smith exclaimed, "We were just happy they let us get away with it!" (Marcus 2001, 37).

## SOURCES CONSULTED

Evans, Dilys. 2008. *Show & Tell: Exploring the Fine Art of Children's Book Illustration.* San Francisco: Chronicle.

Goldstone, B. 2001. "Whaz Up with Our Books? Changing Picture Book Codes and Teaching Implications." *Reading Teacher* 55 (4): 362.

Marcus, Leonard S. 2001. *Side by Side: Five Favorite Picture-Book Teams Go to Work.* New York: Walker.

Smith, Lane. 1993. "The Artist at Work." *Horn Book Magazine* 69 (1): 64–70.

# Sylvester and the Magic Pebble

## 1970 Caldecott Medal

*Sylvester* is a marvel—daisy fresh and filled with the sheer joy and wit and craft that crowns this book . . . a masterpiece.—Maurice Sendak (1997)

*Author/Illustrator:* William Steig
*Style:* Cartoon
*Media:* Pen and ink and watercolor

## ANALYSIS

William Steig said, "I love to draw, and I love to write—but I hate to illustrate" ("William Steig" 2007). He liked to be spontaneous, but with illustrating, he had to be consistent, remember what it said in the story, and draw characters wearing the same clothing from picture to picture. In *Sylvester and the Magic Pebble*, Steig not only drew characters with the same clothing in several illustrations, but he repeated a scene four times. In the fifth, tenth, eleventh, and twelfth openings, Sylvester appears as a rock in summer, fall, winter, and spring. Flowers and grasses change with the seasons. Leaves turn color and disappear completely with snow. But the contours of the landscape and the rock remain the same. The rock dominates in each spread because of its position in the foreground in all of the scenes and because it is a lighter color against the background in all but the winter scene. To draw attention to Sylvester when snow covers the ground, Steig places a howling wolf on top of the rock.

"Steig's illustrations are instantly recognizable, as he has used a consistent style involving a fairly thick, sketchy black line with watercolor added

197

loosely, often including stripes, polka dots, and flowered patterns in his characters' clothing and in the background" (Robinson 2002, 434). Black lines outline the characters and objects in the ninth opening. Patterns appear in Mrs. Duncan's dress, her knitting, the carpeting, and the tablecloth. Mr. Duncan's suit and tie are striped. The verso and recto are balanced with position of text and illustrations and color. The text at the top of the verso corresponds to the text at the bottom of the recto. The carpeting is the same pattern and shape in both illustrations. The blue of the knitting balances with the blue of the table legs, and the color of the brown chairs matches.

Steig's drawing is described as uncomplicated. It was easy for Steig to draw spontaneously because he drew everything from memory. He only resorted to reference materials when he required historical accuracy. "With image in mind, he would begin drawing with ink, usually starting with a character's head and expanding from there. He had no need for preliminary drawings or even thumbnail sketches. If the occasional drawing didn't work out to his satisfaction, he would simply do another" (Cottingham 2007, 63). After he completed the black-and-white drawings, he would paint in colors one at a time to ensure consistency of color in his characters' clothing (Marcus 2008). Steig employs a wide range of vibrant watercolors.

Steig chose animal characters because he felt children liked seeing animals behave as humans. However, he said, "Drawing animals that behave like humans is always a bit tricky. How human should the animals be made to look?" (Marcus 2008, 28). All of the adult animals that do behave as humans wear clothing in the story. They also have expressive faces. In the first opening, the Duncan family appears content as Mr. Duncan reads the paper, Mrs. Duncan sweeps the floor, and Sylvester sorts his rock collection. In the ninth opening, the Duncans are despondent. Mr. Duncan slumps over the table and a tear rolls down Mrs. Duncan's face. Both have drooping eyelids. Even the flowers droop. When Sylvester changes back into himself at the end of the story, his parents are at first surprised with wide eyes and hooves raised. Then their joy is evident as Mr. Duncan dances a little jig and Mrs. Duncan embraces Sylvester.

Quotes on the back cover of the 1997 Restored Deluxe Edition attest to Steig's high esteem among picture-book illustrators. His art appears simple and effortless and meets the criteria of "excellence of execution in the artistic technique employed" as well as "appropriateness of style of illustration to the story, theme, or concept." This fable about being careful what you wish for shows "excellence of presentation in recognition of a child audience." Steig said that art should give enjoyment and express true feelings (Marcus 2008). He accomplished this in *Sylvester and the Magic Pebble*.

## FOR FURTHER CONSIDERATION

- An assortment of pebbles dots the endpapers, reminding the reader of Sylvester's hobby of collecting "pebbles of unusual shape and color."
- Once an editor approved an idea for a book, it took Steig about a week to write the story and a month to do the illustrations ("William Steig" 2007).
- Steig was already a famous cartoonist for the *New Yorker* when he began writing children's books in his sixties. In addition to winning the Caldecott Medal for his third picture book, *Sylvester and the Magic Pebble*, he won a Caldecott Honor for *The Amazing Bone* and a Newbery Honor for *Abel's Island*, both in 1977. He also won a Newbery Honor for *Doctor De Soto* in 1983.
- Steig is the author of the book *Shrek!* that was made into a movie of the same name. It won an Academy Award for best animated feature film in 2001.

## ILLUSTRATOR NOTE

In 1970, while the country was experiencing social unrest due to Vietnam War protests, the International Conference of Police Associations campaigned unsuccessfully to remove *Sylvester and the Magic Pebble* from libraries because policemen in the story were depicted as pigs. They felt this was derogatory because antiwar protesters called policemen "pigs." Pigs are often characters in Steig's books, such as Pearl in *The Amazing Bone* and Roland in *Roland the Minstrel Pig*. Steig always claimed he did not insert any political or social messages into his children's stories because "only an *idiot* would do something like that, bother kids with that kind of stuff" ("William H. Steig [1907–]" 1993, 216–17).

## SOURCES CONSULTED

Cottingham, Robert. 2007. "One of a Kind." In *The Art of William Steig*, edited by Claudia J. Nahson, 55–65. New York: Jewish Museum; New Haven, CT: Yale University Press.

Marcus, Leonard S. 2008. *A Caldecott Celebration: Seven Artists and Their Paths to the Caldecott Medal*. New York: Walker.

Robinson, Lolly. 2002. "Steig, William." In *The Essential Guide to Children's Books and Their Creators*, edited by Anita Silvey, 433–34. New York: Houghton Mifflin.

Sendak, Maurice. 1997. Dust jacket. In *Sylvester and the Magic Pebble* (restored deluxe ed.) by William Steig. New York: Simon and Schuster.

"William Steig." 2007. *Contemporary Authors Online*. Detroit: Gale.

"William H. Steig (1907–)." 1993. In *Something about the Author*, edited by Donna Olendorf, vol. 70, 213–19. Detroit: Gale.

# This Is Not My Hat

## 2013 Caldecott Medal

With minute changes in eyes and the lightest displacement of sea grass, Klassen's masterful illustrations tell the story the narrator doesn't know.—2013 Caldecott Award Committee (ALSC 2013, 92)

*Author/Illustrator:* Jon Klassen
*Style:* Cartoon and abstract
*Media:* Chinese ink, digital

## ANALYSIS

Jon Klassen uses a combination of single-page illustrations and double-page spreads to recount the adventures of a small fish who has stolen a hat from a big fish. With digitally rendered illustrations that resemble cut-paper collage, Klassen creates an appealing yet unadorned underwater setting. The clean cartoon images convey a different account from the one the protagonist relates, however. The opposing visual and written narratives bring humor to this cautionary tale.

The fourth opening is one of several double-page illustrations that bleed off the sides and bottom of the spread. This long horizontal view barely contains the big fish whose hat has just been stolen. The dark background and the plants at the bottom of the page indicate that the setting is near the water's floor, keeping the reader grounded in the otherwise expansive environs. The fish and plants are muted hues of gray, reddish-brown, and green. Ink splatters and subdued scales add texture to the fish, while the plants appear translucent.

A horizontal line of text appears in a white banner across the top of the spread, in stark contrast to the black background, reinforcing the contradiction between text and image. The reader sees one distinct difference from the previous page: the big fish's pupil shoots upward as he realizes that his hat is gone. Subtly, he also expels a few more air bubbles. The steady movement of these bubbles, as well as the position of the plants below the fish, indicate that he is stationary.

In the fifth opening, the fish's now narrow eye, a small stream of air bubbles, and slight movement of the plants signify his agitation. Another page turn shows the back end of the big fish, charging ahead in pursuit of the thief. The increasing mass of air bubbles and forward motion of the plants carry the reader's eye across the page. The chase has begun.

The page layout changes when the reader sees the small fish. The hat snatcher or his trail is shown on single-page illustrations in the first, seventh, eighth, and tenth openings, where the text appears on the accompanying page. Double-page spreads return as the tension rises, when the small fish approaches and enters his perceived safe haven "where the plants are big and tall and close together."

The climax takes place in the fourteenth opening. Thick plants cover the spread while the vengeful act takes place somewhere within them, unseen by the reader. Mac Barnett, a picture-book author and Klassen's friend, praises this scene. "And so while we're present for the book's dreadful climax, we're not quite witnesses. It's a masterful bit of picture-book craftsmanship" (Barnett 2013, 29). This spread is the first of three wordless illustrations that end the story in an understated yet powerful manner.

The only other character is a crab, adding a humorous element to the story in the eighth, ninth, and fifteenth openings. His eyes and body language show his willing betrayal of the thief. While the tattletale crab experiences no repercussions from his actions, his expression conveys that he is aware of his role in the small fish's demise as the big fish swims out of the plants.

Because an overconfident and unreliable narrator tells the story, the illustrations are essential to communicate the true tale of theft and revenge. Meeting the Caldecott criterion, Jon Klassen clearly "[delineates] plot, theme, characters, setting, mood or information through the pictures." The uncluttered cartoon illustrations focus on characters' expressions and actions in an "[excellent] pictorial interpretation of story, theme, or concept." The humorous visual presentation, especially the sensitive portrayal of a surprising climax, shows "excellence of presentation in recognition of a child audience."

## FOR FURTHER CONSIDERATION

- The background color was initially "more of a mid-tone, like a teal, or a green." With the fishes' eyes so important to the story, a black background proved more effective. Klassen says, "I just like the simplicity of using black. . . . And I just liked the moodiness of it. It felt quiet" (Margolis 2012).
- Klassen admits, "One of the things in the book that is still kind of a mystery to me is the crab. The crab's purpose in the story is not to change or advance the plot." Because the reader sees the crab as the big fish swims away, "we get to see him think about what he did, and I think we get a moment to forgive him. Not because he deserves it, but because we can relate to him. And that, I think, is what makes the book work" (Klassen 2013, 26).
- Making the book cover "scared" the illustrator, from the hand-lettering of the text to the position of the fish. Klassen explains how he lacked confidence in his graphic design skills: "I love doing covers and lettering, but there's so much formality that can be applied to these things. . . . And none of the worries about the type go anywhere near the worries about the placement of the fish" (Klassen 2013, 23).
- Liz Bicknell, Klassen's editor, suggested the lush plants on the endpapers.
- The illustrator also won a Caldecott Honor in 2013 for *Extra Yarn*, by Mac Barnett. He is the second illustrator to win both a Medal and Honor in the same year. The first was Leonard Weisgard, who won a Caldecott Medal in 1947 for *The Little Island*, by Golden MacDonald, and an Honor (then called a "runner-up") for *Rain Drop Splash*, by Alvin Tresselt.

## ILLUSTRATOR NOTE

The book was inspired by Edgar Allan Poe's short story "The Tell-Tale Heart," in which the first-person narrator tries to convince the reader he is sane while describing a murder he committed. Jon Klassen relates, "[The murderer] is given the whole floor, without narrative interruption, to try to make an argument for his reasonableness and sanity by telling [readers] his version of how things went down. . . . This is the same setup as in *This Is Not My Hat*" (Klassen 2013, 24). In the picture book, however, the illustrations are essential to reveal the folly of the small fish's deed and his unrealistic grasp of the situation.

## SOURCES CONSULTED

Association for Library Service to Children (ALSC). 2013. *The Newbery & Caldecott Awards: A Guide to the Medal and Honor Books*. Chicago: American Library Association.

Barnett, Mac. 2013. "Jon Klassen." *Horn Book Magazine* 89 (4): 27–29.

Klassen, Jon. 2013. "Caldecott Medal Acceptance." *Horn Book Magazine* 89 (4): 21–26.

Margolis, Rick. 2012. "This Is Not My Sequel." *School Library Journal* 58 (9): 27.

# The Three Pigs

## 2002 Caldecott Medal

Wiesner uses a range of artistic styles and thrilling perspectives to play with the structure and conventions of traditional storytelling, redefining the picture book.—2002 Caldecott Award Committee (ALSC 2002)

*Author/Illustrator:* David Wiesner
*Style:* Surrealistic and postmodern
*Media:* Watercolor, gouache, colored inks, pencil, and colored pencil on Fabriano hot press paper

## ANALYSIS

When a traditional folktale takes an unexpected turn, mayhem arises. In this sophisticated and clever romp, the three pigs leave their story, enter others, liberate characters, and ultimately find their home. David Wiesner uses multiple styles of illustration and expands the action beyond the confines of the pages in his unconventional interpretation of a familiar tale.

The story opens with an illustration of the wolf gazing at the first pig's straw home. A narrow black line frames the illustration, surrounded by a white border. The pen line and paint artwork is rendered in a style inspired by classic children's illustrators Arthur Rackham and Leslie Brooke (Silvey 2001, 49). The second opening shows a series of smaller illustrations in four panels. Here, the story continues as expected until the third panel, when the first pig is blown out of the image.

As he emerges from the scene onto the white border, the exposed pig is depicted in a more realistic style in watercolor, gouache, and colored pencil.

In the fourth panel, confusion reigns: the text indicates that the wolf "ate the pig up," but the illustration shows a puzzled wolf looking for his missing meal.

By the fourth and fifth openings, the pages are tumbling and the protagonists are ready to explore the white space, first in the air and then on the ground. When their adventures bring them to a nursery rhyme in the eleventh and twelfth openings, Wiesner changes the art once again. Here, the cartoons are painted in typical Mother Goose style with "brilliant watercolors, straight from the tube" (Silvey 2001, 49). Unbeknownst to the pigs, the Cat and its fiddle have followed them out of the page.

The artist changes style once again when the porcine trio discovers the dragon story in the next opening. Here, Wiesner "acknowledge[s] the line work of Howard Pyle, the father of children's book illustration in America" (Silvey 2001, 49). After rescuing the dragon and meeting up with the cat, the animals reconstruct the end of the original story, chase away the wolf, and write a new ending to the tale. They have found their home.

The artist uses white space in an innovative way, introducing a new dimension to the story, where the pigs can even take an exciting ride on a paper airplane. The white space apparently gives the pigs a view of the reader, as when the first pig stares directly out from the eleventh opening to say, "I think . . . someone's out there." This dimension also holds an infinite number of stories, as shown in the thirteenth, fifteenth, and sixteenth openings.

The typeface is an intrinsic part of the artwork. The text of each book has a different font that reflects the nature of the story. Moreover, Wiesner "distorts, crumples, and scatters" the text (Wiesner 2002, 396) as the original tale literally falls apart. The characters even write their own happy ending with the letters they shake loose from the pages.

*The Three Pigs* embraces motifs that define it as a postmodern picture book, notably a nonlinear presentation, "having multiple story lines running concurrently . . . ; an unusual degree of playfulness, bordering on the absurd . . . ; irony . . . both in tone and contradictory story lines; [and a self-referential treatment,] exposing the artistic act of the book's creation" (Goldstone and Labbo 2004).

In his original retelling of a traditional tale, David Wiesner stretches outside the boundaries of the picture-book format, meeting the Caldecott criterion of "excellence of pictorial interpretation of story, theme, or concept." By varying medium and artistic style to best suit the different stories, he demonstrates "appropriateness of style of illustration to the story, theme or concept" and "delineation of plot, theme, characters, setting, mood or information through the pictures." In a novel approach to visual storytelling, filled with humor and unexpected twists and turns, Wiesner shows "excellence of presentation in recognition of a child audience."

FOR FURTHER CONSIDERATION

- Wiesner selected three different breeds for the pigs—Yorkshire, Duroc, and Hampshire—with different colors and markings to set them apart (Giorgis and Johnson 2003). He explains, "But when I began to paint them . . . they began to have personalities. . . . The first pig became happy go lucky; the middle pig, the middle child; and the third pig, the 'take charge' pig" (Silvey 2001, 49).
- The artist designed the cover and endpapers to "reflect the story" (Silvey 2001, 49). "The brick is represented by the burgundy spine, the sticks by the gray cover, and the straw by the ochre endpapers." A stamped image of the pigs graces the front cover, different from the full-color close-up of the pigs on the dust jacket.
- Wiesner reflects, "The word most often used in reviews of *The Three Pigs* has been *postmodern*. The word most often used by me while making the book was *fun*. I saw an opportunity to have some great visual fun, and I wanted to share that with kids. . . . The beauty of the picture book is that despite its seemingly rigid format, it is capable of containing an infinite number of approaches to storytelling" (Wiesner 2002, 396).
- The author/illustrator won Caldecott Medals for *Tuesday* in 1992 and for *Flotsam* in 2007. He also won Caldecott Honors for *Free Fall* in 1989, *Sector 7* in 2000, and *Mr. Wuffles!* in 2014.

ILLUSTRATOR NOTE

David Wiesner's concept of creating a picture that breaks beyond its pages was inspired by a Bugs Bunny cartoon that he saw as a child. In it,

> Elmer Fudd is chasing Bugs Bunny through the forest for the hundredth time . . . when all of a sudden something happens. Bugs and Elmer run right out of the frame of film. We see the sprockets at the edge of the filmstrip as other frames are running by, until the characters are left standing in the middle of a blank white space. They look around for a moment, then run back into the frame of film and the chase continues. (Giorgis and Johnson 2003, 402)

Wiesner found the scene intriguing. He explains, "Even more than all the reality manipulation that was happening in the cartoon, I was fascinated by the idea that behind the 'normal' reality lay this endless, empty, white nothingness. . . . I wanted to be able to push the pictures aside, go behind them or peel them up, and explore the blank expanse that I envisioned was within the books" (Wiesner 2002, 394).

## SOURCES CONSULTED

Association for Library Service to Children (ALSC). 2002. "2002 Caldecott Medal and Honor Books." http://www.ala.org/alsc/awardsgrants/bookmedia/caldecottmedal/caldecotthonors/2002caldecott.

Giorgis, Cyndi, and Nancy J. Johnson. 2003. "Interview with the 2002 Caldecott Medal Winner, David Wiesner." *Reading Teacher* 56 (4): 400–404.

Goldstone, Bette P., and Linda D. Labbo. 2004. "The Postmodern Picture Book: A New Subgenre." *Language Arts* 81 (3): 196–204.

Silvey, Anita. 2001. "Pigs in Space: David Wiesner's Latest Creation Soars beyond the Boundaries of Conventional Picture Books." *School Library Journal* 47 (11): 48–50.

Wiesner, David. 2002. "Caldecott Medal Acceptance." *Horn Book Magazine* 78 (4): 393–99.

# Tuesday

## 1992 Caldecott Medal

David Wiesner's command of watercolor in *Tuesday* (1992) is masterful, and his visual storytelling is flawless.—Jerry Pinkney (Pinkney 2012, 18)

*Author/Illustrator:* David Wiesner
*Style:* Realistic and surrealistic
*Media:* Watercolor

### ANALYSIS

The story begins in three panels before the title page. Without warning, lily pads levitate at dusk, much to the surprise and wonderment of the unsuspecting frogs dozing upon them. As the sky darkens to purple, a mist rises on the pond. A sequence of panels in the first opening shows a full moon ascending and leads to a close-up of a turtle looking skyward. The following two-page spread reveals the turtle ducked into his shell and several fish gaping at the frogs as their magic carpet lily pads skim above them. From a low perspective at the water's surface, the frogs appear huge and would be ominous but for the equanimity of their expressions. Clearly, these frogs are not a threat.

This is confirmed with a page turn to the third opening. Within the three panels of the double-page spread, the frogs approach the village, attempt some stunt flying, and gleefully pursue birds. The panels help the eye move across the page and show action in quick succession. The full moon is now risen above the clock tower, and the time is shortly after 9:00 p.m.

With a full moon, anything is possible. This sleepy pastoral village is soon to be invaded by what look like UFOs. Silhouettes of the flying frogs

and the birds on telephone wires are backlit by the moon against a dark blue sky. Once again, the perspective or "camera angle" is from below. The birds appear large because they are closer to the viewer. Wiesner zooms in on the frogs in the panels for front- and rear-angle views.

The fourth opening is an extreme close-up. Wiesner's alternating points of view create dramatic effect. Each frog is anatomically correct. Wiesner sculpted a clay model of a frog while working on *Tuesday* and also consulted photographs. Each frog has its own distinctive skin pattern (Wiesner 2012).

The richly textured watercolors without ink lines are predominantly dark values of blues and greens and lend an air of mystery to the moonlit night. These hues contrast with the luminescent greens and blues as the sun continues to rise in the twelfth opening. In the bright sunshine, normalcy is restored.

As he did in previous openings, in this double-page spread Wiesner includes three inset panels to show how the action progresses. Frogs tumble from the sky, hop down the road to dive into the pond, and rest disconsolately on their stationary lily pads. There is variety in page design, point of view, and frogs' facial expressions throughout the book. Their emotions range from amazement and delight with their ability to fly, concern at being chased by the dog and as their lily pads lose altitude, to the final disgust with their earthbound status.

Wiesner's watercolor illustrations are rendered so realistically that they appear to be photographs. That increases the humor of the fantastical frog escapades. Stating the time so precisely at intervals in the text, on the clock tower, or on the dozing woman's clock also provides a sense of reality. What it implies is that these are the facts in chronological order. In the morning, the police are puzzled as they examine the evidence: wet lily pads scattered about the pavement. The man in the bathrobe gestures skyward as the television investigative team interviews him. This also adds credibility to the tale. In his Caldecott Medal acceptance speech, Wiesner stated, "By placing my characters in the context of familiar reality, I hoped to entice readers to take that great leap of faith and believe that frogs, and perhaps pigs, too, could fly—if the conditions were just right" (Wiesner 1992).

With his skillful use of light and color and expert alternation of points of view and page design, Wiesner demonstrates "excellence of execution in the artistic technique employed." With a wordless book, he is able to delineate "plot, theme, characters, setting, mood, or information through pictures." His art also displays "excellence of presentation in recognition of a child audience" for the illustrations tell a story of pure joy with no moral or lesson attached.

## FOR FURTHER CONSIDERATION

- The book jacket foreshadows the importance of time in this story. The large moonlit clock face dominates the center of the nighttime scene. Surrounding the clock are hints of what is to come. The reader sees only partial views of frogs on suspended lily pads with shadows of more airborne frogs. The porch light illuminates a dog gazing up from the sidewalk.
- At 11:21 p.m., the flying frogs surprise a man enjoying a late-night snack, and one frog cheerily waves through the window. The man is David Wiesner. As he told Leonard Marcus, "I just felt that I *had* to be in the middle of this story" (Wiesner 2012).
- Wiesner won two additional Caldecott Medals for *The Three Pigs* in 2002 and for *Flotsam* in 2007. He also won Caldecott Honors for *Free Fall* (1989), for *Sector 7* (2000), and for *Mr. Wuffles!* (2014).

## ILLUSTRATOR NOTE

Wiesner created a cover illustration for the March 1989 *Cricket* magazine. He received no direction other than the themes of that issue would be St. Patrick's Day and frogs. Finding amphibians more interesting, he drew frogs on flying lily pads resembling flying saucers. On his website, Wiesner wrote, "They looked pretty silly, yet up in the air they clearly felt dignified, noble, and a bit smug. I wanted to know more about them. . . . I wondered what happened before and after this scene" (Wiesner 2012). He wrote *Tuesday* to find out.

## SOURCES CONSULTED

Evans, Dilys. 2008. *Show and Tell: Exploring the Fine Art of Children's Book Illustration*. San Francisco: Chronicle.

Marcus, Leonard. 2008. *A Caldecott Celebration: Seven Artists and Their Paths to the Caldecott Medal*. New York: Walker.

Pinkney, Jerry. 2012. "My Favorite Caldecott." *Horn Book Magazine* 88 (4): 18.

Wiesner, David. 1992. "Caldecott Acceptance Speech." *Horn Book Magazine* 68: 416–22.

———. July 7, 2012. "The Creative Process: *Tuesday*." *David Wiesner*. http://www.houghtonmifflinbooks.com/authors/wiesner/process/process.shtml.

# What Do You Do with a Tail Like This?

## 2004 Caldecott Honor

The artist uses exquisite cut-paper collage to detail basic forms combined with clever placement of the spare text to create an interactive visual display.— 2004 Caldecott Award Committee (ALSC 2004, 101–2)

*Authors:* Steve Jenkins and Robin Page
*Illustrator:* Steve Jenkins
*Style:* Minimal realism
*Media:* Cut- and torn-paper collage

### ANALYSIS

This informational picture book begins with an invitation to explore the remarkable features of various animals. The first opening depicts an archer-fish entering the verso in a dramatic diagonal line, moving like an arrowhead. In the series of six paired double-page spreads that follow, Steve Jenkins and Robin Page present close-up views of a specific animal attribute: nose, ears, tail, eyes, feet, or mouth. The companion illustration reveals the identity of each animal and describes its unique trait.

The close-ups offer a range of unusual and familiar creatures as well as a query about them. The "answer" spread shows full views of the animals against a clean white background, with some shown in water. The animals on a page are not necessarily shown to scale, such as a similarly-sized cricket and humpback whale in the fifth opening; however, the back matter discloses the actual sizes of the animals as well as other relevant facts.

Steve Jenkins's paper collages are noteworthy for their strong composition and detail. For example, in the sixth opening the reader contemplates five tails of various shapes, sizes, and colors. The tails enter from all four edges, leaving the reader to ponder, "What do you do with a tail like this?"

A page turn discloses the identities of the animals. The reader's eye moves easily across the spread, first traveling up the giraffe's back and neck. The giraffe's gaze leads to the striped skunk, standing on its front legs in an unexpected pose. The skunk balances just above the lizard's tail, cleverly broken at the gutter. The lizard and scorpion move in opposite directions, with the scorpion reaching toward the spider monkey. The vertical line of the hanging monkey stops the movement at the far edge of the page.

The narrative accompanying each image is positioned carefully, often playfully, on the page. Four lines of text spray from the skunk's rear, the sentence that winds along the lizard's tail is also broken in two, and the text for the monkey follows its vertical tail.

Jenkins cuts and tears a variety of papers to create interesting effects. The mottled papers for the scorpion and lizard provide patterns and shadows. Fibrous papers resemble skunk fur, while the end of the giraffe's tail is coarse, almost bark-like.

The artist strikes a balance between simplicity and sophistication in his illustrations. The monkey's unadorned body is cut from thick dappled paper with jagged outlines to suggest fur. However, its small face includes increasingly refined layers, with minuscule nostrils and fine wrinkles around its eyes. For the scorpion, Jenkins constructs the exoskeleton, legs, and tail from overlapping pieces of paper in subtle shades of red, lending texture to the image.

Jenkins acknowledges, "There's something about the cut-paper medium that requires some input from the viewer, because all the details aren't there. Even a young child can kind of see how an image was assembled, and they can see the illusion it creates of actually being a representation of something" (Engberg 2004, 19). In a style similar to minimal realism, the artist "capture[s] the essence of . . . subjects with the fewest possible visual elements" (Art Tattler International 2011).

Steve Jenkins's striking renderings of the animals he introduces meet the Caldecott criterion of "excellence of execution in the artistic technique employed." The collage technique and unusual papers encourage the reader to pore over the pages, in an "[appropriate] style of illustration" for the guessing-game format. The compelling illustrations demonstrate "excellence of presentation in recognition of a child audience."

## FOR FURTHER CONSIDERATION

- Jenkins purchases the paper for his books from several sources: "a funky little art supply store in Manhattan," small shops he discovers when he travels, or online sites for Asian papers. "Sometimes I just use things like wrapping paper or butcher paper" (Sutton 2013).
- Jenkins uses a craft knife to cut papers. "Inevitably, even after the hours I've spent using them, I end up stabbing myself. Never seriously, but enough to hurt" (Sutton 2013).
- To construct his illustrations, the artist uses a double-sided archival adhesive film rather than glue or rubber cement. "The adhesive is not repositionable, so I have to be confident about what I'm sticking down and where it's going. Some illustrations come together beautifully. Others I may do several times before I get them right" (Prather and Danielson 2008).
- Most of Jenkins's illustrations have two or more layers of paper, requiring him to construct the images from the bottom up (Prather and Danielson 2008).
- Author and designer Robin Page is Jenkins's creative partner and spouse. "She does the concept development, designs the pages, and works out how the book flows . . . she does her work on the computer and mine is torn and cut" (Children's Literature 2005).

## ILLUSTRATOR NOTE

When Steve Jenkins begins to illustrate a book, he does research to look for "reference images." For animals, "finding the right reference is important, and often takes more time than making the illustration itself. I use images from the internet, sketches and observations that I make in zoos, aquariums and museums, and, especially, books" (Jenkins 2013). He typically collects four to ten pictures from which he makes a pencil drawing. "I found that tracing doesn't really work; the images tend to acquire too much of a sense of a photograph. I might use a grid on the reference image just to get accurate proportions, but I think the little bit of distortion that creeps in when I draw freehand helps give the illustration some character" (Engberg 2004, 19).

He chooses the colors and patterns for an illustration as he works on the outline drawing. "There is often an element of surprise at this point. I rarely know ahead of time what paper I'm going to use for a particular creature, and I may find a paper works in some unexpected way to evoke fur, feathers, skin, or whatever" (Prather and Danielson 2008). Photocopies of the final drawing serve as patterns for cutting the individual pieces of paper he will assemble for the illustration.

## SOURCES CONSULTED

Art Tattler International. 2011. "Charley Harper's Legacy of Wildlife and Nature Fantasy." http://arttattler.com/archivecharleyharper.html.

Association for Library Service to Children (ALSC). 2013. *The Newbery & Caldecott Awards: A Guide to the Medal and Honor Books*. Chicago: American Library Association.

Children's Literature. July 11, 2005. "Meet Authors & Illustrators: Steve Jenkins." *Children's Literature: Independent Information and Reviews*. http://www.childrenslit.com/childrenslit/mai_jenkins_steve.html.

Engberg, Gillian. 2004. "Steve Jenkins on Cut Paper and Science." *Book Links* 14 (2): 18–20.

Jenkins, Steve. 2013. "Making Books." *Steve Jenkins Books*. http://www.stevejenkinsbooks.com/.

Prather, Eisha, and Julie Danielson. February 4, 2008. "Seven Impossible Interviews before Breakfast #64 (The Nonfiction Monday Edition): Steve Jenkins." *Seven Impossible Things before Breakfast*. http://blaine.org/sevenimpossiblethings/?p=1112.

Sutton, Roger. November 26, 2013. "Steve Jenkins Talks with Roger." *Horn Book*. http://www.hbook.com/2013/11/talks-with-roger/steve-jenkins-talks-roger/#_.

# *Where the Wild Things Are*

## *1964 Caldecott Medal*

What makes it a masterpiece is the way he works on many levels to convey the depth of feeling of the young protagonist through color, form, and composition.—Martin Salisbury and Morag Styles (Salisbury and Styles 2012, 38)

*Author/Illustrator:* Maurice Sendak
*Style:* Cartoon
*Media:* India ink line over full-color tempera

## ANALYSIS

The night Max wears his wolf suit, he makes "mischief of one kind and another." Readers are not told what the mischief is; they are shown. In the first illustration, Max cracks the plaster hammering a huge nail into the wall. In the second illustration, he chases a worried dog while brandishing a fork. Discussing his art, Sendak wrote, "You must never illustrate exactly what is written. You must find a space in the text so that the pictures can do the work" (Carle et al. 2007, 74). He does this throughout the book, most eloquently in the three rumpus scenes.

The wild rumpus is the climax of the story. These three scenes are the only full double-page spreads, and the action is so exuberant that the illustrations bleed off the pages. Max and the wild things howl at the moon, swing through the trees, and finally parade with Max triumphantly riding atop the bull wild thing. Instead of a fork, he holds his scepter high. The illustrations expand as his fantasy grows and then contract as he retraces his journey back to reality. Sendak explains his motive for the changes: "A book is inert. What

I try to do is animate it, make it move emotionally" (Sendak 1988, 96). The expanding and contracting illustrations demonstrate brilliant composition.

In the last illustration of Max's bedroom, it is larger than the earlier illustration in the third opening, before it transforms into a forest. Just as Max was confined to his room, the illustrations were confined within wide white margins. Max has grown from his experience and now the room is larger, more real, and no longer part of his fantasy. In taming the wild things, Max has also tamed his own wildness. His emotions spent, Max begins to shed his wild thing persona by removing the hood of his wolf suit.

As large as the wild things are in all the illustrations, Max dominates in his white suit contrasting against their darker colors. All of the colors Sendak uses throughout the book are represented in the foliage of the endpapers. Sendak employs hatched and crosshatched lines to increase value and give objects dimension. The more dense the lines, the darker the color appears. In the fifteenth opening, Max sits in his tent, and the crosshatching shows that part of him is in shadow. Crosshatching on the wild things gives them texture and contour. Their curved shapes add a softness that makes them nonthreatening.

Adults have often thought the wild things were too scary for children. Yet Max is not alarmed in the least as they roar their terrible roars and gnash their terrible teeth and roll their terrible eyes and show their terrible claws. With hand on hip, Max regards their pathetic attempts to frighten him with disdain. In the tenth opening, he frightens them. Thereafter, they are all smiles, some having very humanistic features. Sendak made his wild things look like some of his relatives that used to visit his family when he was a child. They had bad teeth and hairy noses and said such things as "You're so cute, I could eat you up" (Lanes 1980).

In his Caldecott acceptance speech, Sendak said, "*Where the Wild Things Are* was not meant to please everybody—only children" (Sendak 1988, 154). For his ability to remember the emotional life of children, Sendak meets the Caldecott criterion of "excellence of presentation in recognition of a child audience." Understanding a child's vulnerability and also his capabilities, he portrays a child who finds a way to deal with his anger and accept the unconditional love of his mother as demonstrated by the supper awaiting Max, "and it was still hot." Thus Sendak fulfills another Caldecott criterion of delineating the "plot, theme, characters, setting, mood, or information" through his pictures. After half a century, *Where the Wild Things Are* continues to be one of the most distinguished American picture books for children.

## FOR FURTHER CONSIDERATION

- The dog Max chases is a Sealyham terrier. Sendak had a Sealyham named Jennie, and she appears in several of his books.
- The first illustration of the bedspread tent and stool and the second illustration with the drawing of the wild thing signed "by MAX" foreshadow Max's upcoming fantasy.
- The moon changes size during the story. When Max is first sent to his room, it is a crescent moon. It is still a crescent moon when he arrives in the land of the wild things. But when the rumpus starts and when Max returns home, the moon is full. Sendak said, "I love full moons. . . . My books are full of discrepancies. Full moons go to three-quarters even halves without reason. But the moon appears in my books for graphic, not astronomical reasons—I simply must have that shape on the page" (Lanes 1980, 93).
- Maurice Sendak won seven Caldecott Honors, more than any other illustrator: *A Very Special House* (1954), *What Do You Say, Dear?* (1959), *The Moon Jumpers* (1960), *Little Bear's Visit* (1962), *Mr. Rabbit and the Lovely Present* (1963), *In the Night Kitchen* (1971), and *Outside Over There* (1982).

## ILLUSTRATOR NOTE

In 1955, Sendak created a dummy of a book he entitled *Where the Wild Horses Are*. He put it away to think about it and didn't return to it until 1963. He tried writing every few days, and with each rewriting the book became longer. Sendak wanted to abandon the project, but his editor Ursula Nordstrom encouraged him to continue. He tried a new title: *Where the Wild Things Are*. "Things" allowed him more freedom of imagination. The book was always going to be a fantasy, but the story evolved from a quest to find mysterious wild horses to Max sailing to the land of the wild things. Sendak didn't think he drew horses very well, anyway (Marcus 2008).

## SOURCES CONSULTED

Carle, Eric, Patricia Lee Gauch, David Briggs, Courtenay Palmer, Kiffin Steurer, and Semander Megged. 2007. *Artist to Artist: 23 Major Illustrators Talk to Children about Their Art.* New York: Philomel.

Lanes, Selma G. 1980. *The Art of Maurice Sendak.* New York: Abrams.

Marcus, Leonard S. 2008. *A Caldecott Celebration: Seven Artists and Their Paths to the Caldecott Medal.* New York: Walker.

Salisbury, Martin, and Morag Styles. 2012. *Children's Picturebooks: The Art of Storytelling.* London: Laurence King.

Sendak, Maurice. 1988. *Caldecott & Co.: Notes on Books and Pictures*. New York: Farrar, Straus and Giroux.

# Why Mosquitoes Buzz in People's Ears: A West African Tale

## 1976 Caldecott Medal

The illustrations are magnificent[:] stylized and patterned pictures of animals, strongly-composed double-page spreads with plenty of white to set off the distinct forms and separate their parts, [and] bold colors used with restraint and nuance.—Zena Sutherland (Sutherland 1975, 37)

*Author:* Verna Aardema
*Illustrator:* Leo and Diane Dillon
*Style:* Folk art
*Media:* India ink, watercolor, pastels, airbrush with vellum and frisket masks

### ANALYSIS

An iguana puts two sticks in his ears after hearing mosquito's ridiculous story and unwittingly sets off a series of misunderstandings among the forest animals. Upon the unintended death of an owlet, darkness reigns as the bereaved mother owl loses her desire to summon the sun in the morning. Leo and Diane Dillon's visual storytelling technique and use of dynamic colors and patterns enrich Verna Aardema's adaptation of this traditional West African pourquoi tale.

In the second opening, the solid horizontal line of the brown earth is flanked by the strong vertical lines of the python and tree, framing the illustration. The action moves forward as the iguana enters the scene and ends with the rabbit racing out of its home in a dramatic diagonal line, leading to

the page turn. In a cinematic approach, the Dillons present a sequence of events in one double-page spread. Except for the clueless iguana, two views of the other animals are shown. Most interesting is the python, whose body morphs into another version of itself. The curve of the snake's body is mirrored by the looping underground action on the recto. In this and all the initial daytime scenes, the sun observes from the sky.

The nighttime scenes that follow the owlet's death depict the animals gathered in a meeting called by King Lion to determine the true account of how the trouble unfolded. The stark white backgrounds are now black, except for the areas of muted blues or purples where the retold story is shown. In the seventh opening, the mass of animals on the verso is balanced by the bold silhouettes of the trees on the recto. The curve of the giraffe's neck encircles King Lion's round mane and embraces most of the animals at the council while Mother Owl stands alone, grieving. Crow points to the rabbit "running for her life" in his interpretation of the events he witnessed. The red bird observes Crow's version of the story.

The animals display a range of emotions as misconceptions abound. The artists "wanted to indicate human emotions that children could identify with yet retain each animal's distinct features. This was challenge enough, but the most difficult part was trying to put expressions onto a mosquito's face" (Dillon and Dillon 1986, 172).

In a folk-art style that "reflects the aesthetic values of the culture from which it comes" (Horning 2010, 111), the Dillons base their illustrations on African batik (Preiss 1981). They replicate the style with watercolor applied with an airbrush. A frisket, a form of stencil, creates the distinctive outlines. The copyright page notes how "the cut-out effect was achieved by actually cutting the shapes out of vellum and frisket masks at several different stages." The artists further explain that "one area is done and then masked out, or covered, and the next area is done. The black areas are painted in last, then glazed with blue or purple" (Dillon and Dillon 1986, 173). In the nighttime scenes, the outlines are in subtle cool tones, further darkening the illustrations.

The lavish color palette includes rich earth tones, bright greens, and brilliant oranges and reds. Patterns fill the spreads, from the overlapping ovals of the mother owl's feathers, to the confident lines in the lion's mane, to the striking markings of the python's body. The airbrush technique allows for variation in values, giving some depth to the full-bleed illustrations.

Leo and Diane Dillon's skilled use of airbrush and frisket masks meets the Caldecott criterion of "excellence of execution in the artistic technique employed." By portraying multiple scenes in one spread, the artists demonstrate "excellence of pictorial interpretation of story, theme, or concept." The colorful images and expressive characters show "excellence of presentation in recognition of a child audience."

FOR FURTHER CONSIDERATION

- Showing "the same animal doing more than one thing on a page" in the first half of the book is the Dillon's response to the "filmlike quality of the story," as well as an effective use of space. "So much happens within the space of two or three paragraphs, we felt that to leave any of the scenes out of the pictures would create a jumpy effect. We wanted the pictures to flow the way the story flowed" (Dillon and Dillon 1986, 172).
- The "little red bird" appears on every spread, although she is never mentioned in the text. The Dillons recall, "We put her in one spread and became rather fond of her. We began to think of her as the observer or reader and added her to the other spreads. Thus . . . you will find her watching, witnessing the events as they unfold. . . . For us she is like the storyteller, gathering information, then passing it on to the next generation" (Dillon and Dillon 1986, 171–72).
- The artists expand the role of the antelope, mentioned just twice in the story. "We decided he really wanted a more important part—he wanted to be a star. So he began trying to get attention, peering out and grinning, hamming it up, until finally on one spread he is seen up front in the center, with a great toothy smile" (Dillon and Dillon 1986, 171).
- With this book, Leo Dillon was the first African American to receive the Caldecott Medal. In addition, the Dillons were the first illustrators to win Caldecott Medals in two consecutive years. They received their second in 1977 for *Ashanti to Zulu: African Traditions*, by Margaret Musgrove.

ILLUSTRATOR NOTE

Leo and Diane Dillon work closely together when illustrating children's books, from concept to drawing to finished art. They exchange work between themselves, describing their joint efforts as the work of the "third artist." They explain, "The third artist is the collaborative artist; it is a combination of the both of us. The work we do together is different than what we do separately. We have learned to 'let it go' and let the art develop as it changes hands. We have learned to accept the unexpected and build on that" (Harcourt Trade Publishers 2004). The artists maintain that "after a work is finished, not even we can be certain who did what" (Kumar 2009, 44).

SOURCES CONSULTED

Dillon, Leo, and Diane Dillon. 1986. "Caldecott Medal Acceptance." In *Newbery and Caldecott Medal Books: 1976–1985*, edited by Lee Kingman, 170–74. Boston: Horn Book.
Harcourt Trade Publishers. 2004. "Interview with Leo and Diane Dillon, Between Heaven and Earth." http://www.harcourtbooks.com/authorinterviews/bookinterview_Dillon.asp.

Horning, Kathleen T. 2010. *From Cover to Cover: Evaluating and Reviewing Children's Books*. Rev. ed. New York: Collins.

Kumar, Lisa, ed. 2009. "Diane Dillon (1933–)." In *Something about the Author*, vol. 194, 42–50. Detroit: Gale.

Preiss, Byron, ed. 1981. *The Art of Leo & Diane Dillon*. New York: Ballantine.

Sutherland, Zena. 1975. Review of *Why Mosquitoes Buzz in People's Ears: A West African Tale*, by Verna Aardema. *Bulletin of the Center for Children's Books* 29 (3): 37.

# Appendix A

## *Selected Sources about Picture Book Art*

### BOOKS

Association for Library Service to Children. 2013. *The Newbery & Caldecott Awards: A Guide to the Medal and Honor Books*. Chicago: American Library Association.

Bang, Molly. 2000. *Picture This: How Pictures Work*. New York: SeaStar.

Evans, Dilys. 2008. *Show & Tell: Exploring the Fine Art of Children's Book Illustration*. San Francisco: Chronicle.

Frohardt, Darcie Clark. 1999. *Teaching Art with Books Kids Love: Teaching Art Appreciation, Elements of Art, and Principles of Design with Award-Winning Children's Books*. Golden, CO: Fulcrum Resources.

Horning, Kathleen T. 2010. *From Cover to Cover: Evaluating and Reviewing Children's Books*. New York: HarperCollins.

Lacy, Lyn Ellen. 1986. *Art and Design in Children's Picture Books: An Analysis of Caldecott Award-Winning Illustrations*. Chicago: American Library Association.

Marcus, Leonard S. 2008. *A Caldecott Celebration: Seven Artists and Their Paths to the Caldecott Medal*. New York: Walker.

———. 2013. *Show Me a Story! Why Picture Books Matter: Conversations with 21 of the World's Most Celebrated Illustrators*. Somerville, MA: Candlewick.

Matulka, Denise I. 2008. *Picture Book Primer: Understanding and Using Picture Books*. Westport, CT: Libraries Unlimited.

Salisbury, Martin. 2004. *Illustrating Children's Books: Creating Pictures for Publication*. Hauppage, NY: Barron's.

Shulevitz, Uri. 1985. *Writing with Pictures: How to Write and Illustrate Children's Books*. New York: Watson-Guptill.

Sipe, Lawrence R. 2011. "The Art of the Picturebook." In *Handbook of Research on Children's and Young Adult Literature*, edited by Shelby A. Wolf, Karen Coats, Patricia Enciso, and Christine Jenkins, 238–52. New York: Routledge.

# ARTICLES

Colburn, Nell. 2010. "Caldecott Confidential: What's Next Year's Best Picture Book for Kids? Please, Don't Ask." *School Library Journal* 56 (2): 38–40.

Erbach, Mary M. 2007. "Illustration as Art—Color." *Book Links* 16 (3): 33–35.

———. 2007. "Illustration as Art—Composition." *Book Links* 16 (11): 41–44.

———. 2007. "Illustration as Art—Line." *Book Links* 16 (5): 29–32.

———. 2007. "Illustration as Art—Shape." *Book Links* 16 (7): 33–36,

———. 2007. "Illustration as Art—Technique." *Book Links* 16 (9): 37–40.

Giorgis, Cyndi. 2012. "Caldecott in the Classroom: The Art of Picture Books." *Book Links* 21 (3): 4–9.

Horning, Kathleen, T. 2013."*Arrow to the Sun* and Critical Controversies." *Horn Book Magazine* 89 (5): 35–41.

———. 2013."*Drummer Hoff* and 'Didactic Intent.'" *Horn Book Magazine* 89 (4): 91–97.

———. 2013."*Hey, Al* and the Quirky Choice." *Horn Book Magazine* 89 (6): 33–39.

———. 2013. "*Madeline's Rescue* and the Question of Audience." *Horn Book Magazine* 89 (3): 35–41.

———. 2013. "*Mei Li* and the Making of a Picture Book." *Horn Book Magazine* 89 (1): 35–40.

———. 2013."*Prayer for a Child* and the Test of Time." *Horn Book Magazine* 89 (2): 73–78.

Lukehart, Wendy. 2010. "Art in Theory and Practice." *School Library Journal* 56 (1): 18–19.

———. 2010. "Art in Theory and Practice, II." *School Library Journal* 56 (2): 20–21.

Saylor, David. 2000. "Look Again: Art Design of Children's Books." *School Library Journal* 46 (1): 37–38.

Sipe, Lawrence R. 2001. "Picturebooks as Aesthetic Objects." *Literacy Teaching and Learning* 6 (1): 23–42.

Sutton, Roger, ed. 2014. "Special Issue: Illustration." *Horn Book Magazine* 90 (2).

# WEBSITES

Association for Library Service to Children. 2014. *Welcome to the Caldecott Medal Home Page!* http://www.ala.org/alsc/awardsgrants/bookmedia/caldecottmedal/caldecottmedal.

Danielson, Julie. 2014. *Seven Impossible Things before Breakfast.* http://blaine.org/sevenimpossiblethings/.

Matulka, Denise I. 2014. *Picturing Books.* http://www.picturingbooks.com/.

Robinson, Lolly, Robin Smith, and Martha Parravano. 2014. "Calling Caldecott." *Horn Book Magazine.* http://www.hbook.com/category/blogs/calling-caldecott/.

Sutton, Roger, ed. 1998. "Classic Horn Book: Special Issue: Picture Books." *Horn Book Magazine.* http://www.hbook.com/tag/hbmmar98/.

# Appendix B

## Randolph Caldecott Medal
## Terms, Definitions, and Criteria

### TERMS

1. The Medal shall be awarded annually to the artist of the most distinguished American picture book for children published by an American publisher in the United States in English during the preceding year. There are no limitations as to the character of the picture book except that the illustrations be original work. Honor books may be named. These shall be books that are also truly distinguished.
2. The award is restricted to artists who are citizens or residents of the United States. Books published in a U.S. territory or U.S. commonwealth are eligible.
3. The committee in its deliberations is to consider only books eligible for the award, as specified in the terms.

### DEFINITIONS

1. A "picture book for children," as distinguished from other books with illustrations, is one that essentially provides the child with a visual experience. A picture book has a collective unity of storyline, theme, or concept, developed through the series of pictures of which the book is comprised.
2. A "picture book for children" is one for which children are an intended potential audience. The book displays respect for children's

understandings, abilities, and appreciations. Children are defined as persons of ages up to and including fourteen and picture books for this entire age range are to be considered.

3.  "Distinguished" is defined as:

    *   Marked by eminence and distinction; noted for significant achievement.
    *   Marked by excellence in quality.
    *   Marked by conspicuous excellence or eminence.
    *   Individually distinct.

4.  The artist is the illustrator or co-illustrator. The artist may be awarded the medal posthumously.

5.  The term "original work" may have several meanings. For purposes of these awards, it is defined as follows:

    *   "Original work" means that the illustrations were created by this artist and no one else.
    *   Further, "original work" means that the illustrations are presented here for the first time and have not been previously published elsewhere in this or any other form. Illustrations reprinted or compiled from other sources are not eligible.

6.  "American picture book in the United States" means that books first published in previous years in other countries are not eligible. Books published simultaneously in the U.S. and another country may be eligible. Books published in a U.S. territory or U.S. commonwealth are eligible.

7.  "In English" means that the committee considers only books written and published in English. This requirement DOES NOT limit the use of words or phrases in another language where appropriate in context.

8.  "Published . . . in the preceding year" means that the book has a publication date in that year, was available for purchase in that year, and has a copyright date no later than that year. A book might have a copyright date prior to the year under consideration but, for various reasons, was not published until the year under consideration. If a book is published prior to its year of copyright as stated in the book, it shall be considered in its year of copyright as stated in the book. The intent of the definition is that every book be eligible for consideration, but that no book be considered in more than one year.

9.  "Resident" specifies that the illustrator has established and maintains a residence in the United States, U.S. territory, or U.S. commonwealth as distinct from being a casual or occasional visitor.

10. The term, "only the books eligible for the award," specifies that the committee is not to consider the entire body of the work by an artist or whether the artist has previously won the award. The committee's decision is to be made following deliberation about books of the specified calendar year.

## CRITERIA

1. In identifying a "distinguished American picture book for children," defined as illustration, committee members need to consider:

   - Excellence of execution in the artistic technique employed;
   - Excellence of pictorial interpretation of story, theme, or concept;
   - Appropriateness of style of illustration to the story, theme, or concept;
   - Delineation of plot, theme, characters, setting, mood or information through the pictures;
   - Excellence of presentation in recognition of a child audience.

2. The only limitation to graphic form is that the form must be one which may be used in a picture book. The book must be a self-contained entity, not dependent on other media (i.e., sound, film, or computer program) for its enjoyment.
3. Each book is to be considered as a picture book. The committee is to make its decision primarily on the illustration, but other components of a book are to be considered especially when they make a book less effective as a children's picture book. Such other components might include the written text, the overall design of the book, etc.

*Note:* The committee should keep in mind that the award is for distinguished illustrations in a picture book and for excellence of pictorial presentation for children. The award is not for didactic intent or for popularity.

[Adopted by the ALSC board, January 1978. Revised, Midwinter 1987. Revised, Annual 2008.]

*Source:* Association for Library Service to Children (ALSC). 2009. *Randolph Caldecott Medal Committee Manual.* http://www.ala.org/alsc/sites/ala.org.alsc/files/content/caldecott_manual_9Oct2009.pdf.

# Appendix C

## *Bibliography of Caldecott Entries*

Aardema, Verna. 1975. *Why Mosquitoes Buzz in People's Ears: A West African Tale.* Illustrated by Leo and Diane Dillon. New York: Dial.

Barnett, Mac. 2012. *Extra Yarn.* Illustrated by Jon Klassen. New York: Balzer + Bray.

Becker, Aaron. 2013. *Journey.* Illustrated by the author. Somerville, MA: Candlewick.

Bemelmans, Ludwig. 1939. *Madeline.* Illustrated by the author. New York: Viking.

Buzzeo, Toni. 2012. *One Cool Friend.* Illustrated by David Small. New York: Dial Books for Young Readers.

Crews, Donald. 1978. *Freight Train.* Illustrated by the author. New York: Greenwillow.

Cronin, Doreen. 2000. *Click, Clack, Moo: Cows That Type.* Illustrated by Betsy Lewin. New York: Simon & Schuster Books for Young Readers.

Falconer, Ian. 2000. *Olivia.* Illustrated by the author. New York: Atheneum Books for Young Readers.

Fleming, Denise. 1993. *In the Small, Small Pond.* Illustrated by the author. New York: Henry Holt.

Floca, Brian. 2013. *Locomotive.* Illustrated by the author. New York: Atheneum Books for Young Readers.

Gerstein, Mordicai. 2003. *The Man Who Walked Between the Towers.* Illustrated by the author. Brookfield, CT: Roaring Brook.

Henkes, Kevin. 2004. *Kitten's First Full Moon.* Illustrated by the author. New York: Greenwillow.

Hill, Laban Carrick. 2010. *Dave the Potter: Artist, Poet, Slave.* Illustrated by Bryan Collier. New York: Little, Brown Books for Young Readers.

Ho, Minfong. 1996. *HUSH! A Thai Lullaby.* Illustrated by Holly Meade. New York: Orchard.

Idle, Molly. 2013. *Flora and the Flamingo.* Illustrated by the author. San Francisco, CA: Chronicle.

Jenkins, Steve, and Robin Page. 2003. *What Do You Do with a Tail Like This?* Illustrated by Steve Jenkins. Boston: Houghton Mifflin.

Juster, Norton. 2005. *The Hello, Goodbye Window.* Illustrated by Chris Raschka. New York: Hyperion Books for Children.

Keats, Ezra Jack. 1962. *The Snowy Day.* Illustrated by the author. New York: Viking.

Klassen, Jon. 2012. *This Is Not My Hat.* Illustrated by the author. Somerville, MA: Candlewick.

Levine, Ellen. 2007. *Henry's Freedom Box: A True Story from the Underground Railroad.* Illustrated by Kadir Nelson. New York: Scholastic.

Lobel, Arnold. 1970. *Frog and Toad Are Friends*. Illustrated by the author. New York: Harper and Row.

Logue, Mary. 2012. *Sleep Like a Tiger*. Illustrated by Pamela Zagarenski. Boston: Houghton Mifflin.

Martin, Jacqueline Briggs. 1998. *Snowflake Bentley*. Illustrated by Mary Azarian. Boston: Houghton Mifflin.

McCloskey, Robert. 1941. *Make Way for Ducklings*. Illustrated by the author. New York: Viking.

McDonnell, Patrick. 2011. *Me . . . Jane*. Illustrated by the author. New York: Little, Brown.

Pinkney, Jerry. 2009. *The Lion & the Mouse*. Illustrated by the author. New York: Little, Brown.

Raschka, Chris. 2011. *A Ball for Daisy*. Illustrated by the author. New York: Schwartz & Wade.

Rathmann, Peggy. 1995. *Officer Buckle and Gloria*. Illustrated by the author. New York: Putnam.

Reynolds, Aaron. 2012. *Creepy Carrots!* Illustrated by the author. New York: Simon and Schuster Books for Young Readers.

Rocco, John. 2011. *Blackout*. Illustrated by the author. New York: Disney/Hyperion.

Rohmann, Eric. 2002. *My Friend Rabbit*. Illustrated by the author. Brookfield, CT: Roaring Brook.

Say, Allen. 1993. *Grandfather's Journey*. Illustrated by the author. Boston, MA: Houghton Mifflin.

Scanlon, Liz Garton. 2009. *All the World*. Illustrated by Marla Frazee. New York: Beach Lane.

Scieszka, Jon. 1992. *The Stinky Cheese Man and Other Fairly Stupid Tales*. Illustrated by Lane Smith. New York: Viking.

Seeger, Laura Vaccaro. 2012. *Green*. Illustrated by the author. New York: Roaring Brook.

Selznick, Brian. 2007. *The Invention of Hugo Cabret*. Illustrated by the author. New York: Scholastic.

Sendak, Maurice. 1963. *Where the Wild Things Are*. Illustrated by the author. New York: Harper and Row.

Shannon, David. 1998. *No, David!* Illustrated by the author. New York: Blue Sky.

Sidman, Joyce. 2009. *Red Sings from Treetops: A Year in Colors*. Illustrated by Pamela Zagarenski. Boston: Houghton Mifflin.

Smith, Lane. 2011. *Grandpa Green*. Illustrated by the author. New York: Roaring Brook.

Stead, Philip. 2010. *A Sick Day for Amos McGee*. Illustrated by Erin E. Stead. New York: Roaring Brook.

Steig, William. 1969. *Sylvester and the Magic Pebble*. Illustrated by the author. New York: Windmill.

Stein, David Ezra. 2010. *Interrupting Chicken*. Illustrated by the author. Somerville, MA: Candlewick.

Swanson, Susan Marie. 2008. *The House in the Night*. Illustrated by Beth Krommes. Boston, MA: Houghton Mifflin Harcourt.

Taback, Simms. 1999. *Joseph Had a Little Overcoat*. Illustrated by the author. New York: Viking.

Van Allsburg, Chris. 1981. *Jumanji*. Illustrated by the author. Boston: Houghton Mifflin.

———. 1985. *The Polar Express*. Illustrated by the author. Boston: Houghton Mifflin.

Wiesner, David. 1991. *Tuesday*. Illustrated by the author. New York: Clarion.

———. 2001. *The Three Pigs*. Illustrated by the author. New York: Clarion.

———. 2013. *Mr. Wuffles!* Illustrated by the author. New York: Clarion, Houghton Mifflin.

Willems, Mo. 2003. *Don't Let the Pigeon Drive the Bus!* Illustrated by the author. New York: Hyperion Books for Children.

———. 2004. *Knuffle Bunny: A Cautionary Tale*. Illustrated by the author. New York: Hyperion Books for Children.

Wood, Audrey. 1985. *King Bidgood's in the Bathtub*. Illustrated by Don Wood. San Diego: Harcourt Brace Jovanovich.

Yolen, Jane. 1987. *Owl Moon*. Illustrated by John Schoenherr. New York: Philomel.

Young, Ed. 1989. *Lon Po Po: A Red-Riding Hood Story from China.* Illustrated by the author. New York: Philomel.

Zelinksy, Paul O. 1997. *Rapunzel.* Illustrated by the author. New York: Dutton Children's Books.

# Appendix D

*Caldecott Medal Winners, 1938–2014*

2014: *Locomotive*, by Brian Floca

2013: *This Is Not My Hat*, by Jon Klassen

2012: *A Ball for Daisy*, by Chris Raschka

2011: *A Sick Day for Amos McGee*, illustrated by Erin E. Stead and written by Philip C. Stead

2010: *The Lion & the Mouse*, by Jerry Pinkney

2009: *The House in the Night*, illustrated by Beth Krommes and written by Susan Marie Swanson

2008: *The Invention of Hugo Cabret*, by Brian Selznick

2007: *Flotsam*, by David Wiesner

2006: *The Hello, Goodbye Window*, illustrated by Chris Raschka and written by Norton Juster

2005: *Kitten's First Full Moon*, by Kevin Henkes

2004: *The Man Who Walked Between the Towers*, by Mordicai Gerstein

2003: *My Friend Rabbit*, by Eric Rohmann

2002: *The Three Pigs*, by David Wiesner

2001: *So You Want to Be President?*, illustrated by David Small and written by Judith St. George

2000: *Joseph Had a Little Overcoat*, by Simms Taback

1999: *Snowflake Bentley*, illustrated by Mary Azarian and written by Jacqueline Briggs Martin

1998: *Rapunzel*, by Paul O. Zelinsky

1997: *Golem*, by David Wisniewski

1996: *Officer Buckle and Gloria*, by Peggy Rathmann

1995: *Smoky Night*, illustrated by David Diaz and written by Eve Bunting

1994: *Grandfather's Journey*, by Allen Say

1993: *Mirette on the High Wire*, by Emily Arnold McCully

1992: *Tuesday*, by David Wiesner

1991: *Black and White*, by David Macaulay

1990: *Lon Po Po: A Red-Riding Hood Story from China*, by Ed Young

1989: *Song and Dance Man*, illustrated by Stephen Gammell and written by Karen Ackerman

1988: *Owl Moon*, illustrated by John Schoenherr and written by Jane Yolen

1987: *Hey, Al*, illustrated by Richard Egielski and written by Arthur Yorinks

1986: *The Polar Express*, by Chris Van Allsburg

1985: *Saint George and the Dragon*, illustrated by Trina Schart Hyman and retold by Margaret Hodges

1984: *The Glorious Flight: Across the Channel with Louis Bleriot*, by Alice and Martin Provensen

1983: *Shadow*, illustrated and translated by Marcia Brown

1982: *Jumanji*, by Chris Van Allsburg

1981: *Fables*, by Arnold Lobel

1980: *Ox-Cart Man*, illustrated by Barbara Cooney and written by Donald Hall

1979: *The Girl Who Loved Wild Horses*, by Paul Goble

1978: *Noah's Ark*, by Peter Spier

1977: *Ashanti to Zulu: African Traditions*, illustrated by Leo and Diane Dillon and written by Margaret Musgrove

1976: *Why Mosquitoes Buzz in People's Ears: A West African Tale*, illustrated by Leo and Diane Dillon and retold by Verna Aardema

1975: *Arrow to the Sun*, by Gerald McDermott

1974: *Duffy and the Devil*, illustrated by Margot Zemach and retold by Harve Zemach

1973: *The Funny Little Woman*, illustrated by Blair Lent and retold by Arlene Mosel

1972: *One Fine Day*, illustrated and retold by Nonny Hogrogian

1971: *A Story A Story*, illustrated and retold by Gail E. Haley

1970: *Sylvester and the Magic Pebble*, by William Steig

1969: *The Fool of the World and the Flying Ship*, illustrated by Uri Shulevitz and retold by Arthur Ransome

1968: *Drummer Hoff*, illustrated by Ed Emberley and adapted by Barbara Emberley

1967: *Sam, Bangs & Moonshine*, by Evaline Ness

1966: *Always Room for One More*, illustrated by Nonny Hogrogian and written by Sorche Nic Leodhas, pseud. (Leclair Alger)

1965: *May I Bring a Friend?*, illustrated by Beni Montresor and written by Beatrice Schenk de Regniers

1964: *Where the Wild Things Are*, by Maurice Sendak

1963: *The Snowy Day*, by Ezra Jack Keats

1962: *Once a Mouse*, illustrated and retold by Marcia Brown

1961: *Baboushka and the Three Kings*, illustrated by Nicolas Sidjakov and written by Ruth Robbins

1960: *Nine Days to Christmas*, illustrated by Marie Hall Ets and written by Marie Hall Ets and Aurora Labastida

1959: *Chanticleer and the Fox*, illustrated and adapted by Barbara Cooney from Chaucer's *Canterbury Tales*

1958: *Time of Wonder*, by Robert McCloskey

1957: *A Tree Is Nice*, illustrated by Marc Simont and written by Janice Udry

1956: *Frog Went A-Courtin'*, illustrated by Feodor Rojankovsky and re-told by John Langstaff

1955: *Cinderella, or the Little Glass Slipper*, illustrated and translated by Marcia Brown

1954: *Madeline's Rescue*, by Ludwig Bemelmans

1953: *The Biggest Bear*, by Lynd Ward

1952: *Finders Keepers*, illustrated by Nicolas, pseud. (Nicholas Mordvinoff) and written by Will, pseud. (William Lipkind)

1951: *The Egg Tree*, by Katherine Milhous

1950: *Song of the Swallows*, by Leo Politi

1949: *The Big Snow*, by Berta and Elmer Hader

1948: *White Snow, Bright Snow*, illustrated by Roger Duvoisin and written by Alvin Tresselt

1947: *The Little Island*, illustrated by Leonard Weisgard and written by Golden MacDonald, pseud. (Margaret Wise Brown)

1946: *The Rooster Crows*, by Maud and Miska Petersham

1945: *Prayer for a Child*, illustrated by Elizabeth Orton Jones and written by Rachel Field

1944: *Many Moons*, illustrated by Louis Slobodkin and written by James Thurber

1943: *The Little House*, by Virginia Lee Burton

1942: *Make Way for Ducklings*, by Robert McCloskey

1941: *They Were Strong and Good*, by Robert Lawson

1940: *Abraham Lincoln*, by Ingri and Edgar Parin d'Aulaire

1939: *Mei Li*, by Thomas Handforth

1938: *Animals of the Bible: A Picture Book*, illustrated by Dorothy P. Lathrop and text selected by Helen Dean Fish

# Glossary

**abstract:** A style of art that simplifies, exaggerates, or distorts reality; expresses the essence of the subject rather than its direct representation

**achromatic:** Literally "without color"; white, black, or shades of gray

**acrylic:** Fast-drying, water-soluble paint with a synthetic base that adheres to most surfaces; similar to oil, but does not crack; can be thinned to appear like watercolor

**airbrush:** A precision air-operated spray gun with which paints, dyes, or inks can be applied in even gradations

**asymmetry:** Visual elements of unequal weight on opposites sides of a perceived midline; intentional unevenness that may achieve either balance or disharmony

**batik:** A technique for hand-dyeing cloth using removable wax to repel dyes and then boiling the cloth to dissolve the wax and reveal undyed areas

**bleed:** Side of an illustration that extends beyond the edge of the page but is trimmed to size without any border

**book jacket:** Paper folded over the hard cover of a book; also referred to as a dust jacket

**cartoon art:** A style of art reminiscent of comics; may employ comics conventions such as speech balloons and panels, but not always

**charcoal pencil:** Charcoal particles mixed with clays and encased in wood; more convenient to use than traditional charcoal

**chiaroscuro:** Contrasting light and dark; light brightening one side of an object while the other side is darkened

**china marker:** A grease pencil with a broad tip that is moisture resistant; also known as a wax pencil

**Chinese ink:** Black ink in solid form, mixed with a binding agent and molded into cakes or sticks

**chroma:** Brightness or intensity of a hue or color

**collage:** A variety of materials such as paper, fabric, wood, or objects adhered to a flat surface

**color:** The term that encompasses hue, value, and chroma

**color separation:** The process of separating individual color components (cyan, magenta, yellow, and black) in artwork for printing; a plate or film for each color prepared and printed separately, one on top of the other, allowing for the production of a wide spectrum of colors on a printed page; also called pre-separated art

**composition:** The arrangement of elements in a drawing or painting to achieve unity or a specific effect

**conté pencil:** A hard pencil made of graphite and clay; sometimes referred to as a conté crayon

**copyright page:** The page that includes ISBN, publisher, copyright date, and often a brief summary of the story; found at the beginning or end of a book

**cotton rag fiber:** Cotton rag that is beaten to a fine pulp and suspended in water; used in papermaking

**cover:** The hinged front and back boards under the dust jacket, including the spine; sometimes called the binding

**craft knife:** A small-scale precision cutting tool with removable blades

**crosshatching:** Criss-crossed parallel lines used to increase value or produce shading

**deckle:** In papermaking, an open frame that sits on top of the mold (screen) to hold the pulp in place

**dedication page:** The page that includes a note by the author and sometimes the illustrator as a tribute to one or more persons

**die-cuts:** Shapes cut into paper or cardboard with sharp steel knives or a metal form

**digital art:** Art that is created, enhanced, or manipulated with the use of a computer

**double-page spread:** An illustration that extends across two facing pages of the book

**dummy:** A mock-up of a book that includes proposed sketches and text in the order in which they would appear

**dust jacket:** Paper folded over the hard cover of a book, also referred to as a book jacket

**endpapers:** Paper glued flat to the inside front and back hard covers of a book

**expressionistic:** A style of art that emphasizes an emotional response to the subject through color and distorted and exaggerated lines and shapes

**flat:** Color with no variation of value, no contrast between lightness and darkness

**flyleaf:** The unpasted page of the endpaper

**focal point:** The place in a composition that draws the viewer's interest or attention

**folding bone:** Smooth-edged tool typically used for creasing paper, embossing, burnishing, and scratching

**folk art:** An art style reflective of a particular culture that may incorporate stylized patterns, simple shapes, and lack of perspective and proportion

**frisket:** A masking material, often a paper or film, that acts as a form of stencil to protect areas of an airbrushed painting from spray

**full-bleed:** An illustration in which all four sides extend to the edge of the page without a border

**gatefold:** A spread in which one or both pages fold into the gutter

**gestural art:** Lines that look quickly and loosely drawn to capture a moment, a movement, or an expression

**gouache:** Opaque watercolor paint that dries to a flat, even color

**gutter:** The crease where two pages meet at the binding

**half-title:** The first page of the book that usually contains only the title but may include the publisher

**hatched:** Parallel lines used to increase value or produce shading depending on how closely the lines are spaced

**hue:** The name of a color; its exact shade or tint

**impressionistic:** An artistic style that focuses on reflected or broken light and conveys more of the feeling of the object rather than its actual shape

**India ink:** Black ink made from carbon

**line:** A mark made on a surface, a place where different colors meet, or the direction of action in a composition; can be straight or curved and can move in three directions: horizontal, vertical, or diagonal

**lithograph:** A print made from an image drawn with a grease pencil on a special plate or stone over which ink is rolled; the ink adheres to the grease, and the image is transferred to paper pressed over the stone

**marbling:** In papermaking, the art of applying swirled patterns to the surface by floating color in water and transferring it to paper

**minimalist art:** An art style that reduces objects to their simplest forms

**minimal realism:** A style of art in which subjects are simplified to their basic components with the fewest possible visual elements; associated with artist Charley Harper

**mixed media:** Use of more than one medium in a composition

**mold:** In papermaking, the lower screen that holds the pulp

**monochromatic:** Tints or shades of a single color

**motif:** A recurring element such as a figure or a design

**naïve:** An art style that may appear awkward; colors are flat and objects or characters may be depicted in detail but often in stiff, unrealistic poses

**negative space:** Unfilled, empty space

**nib:** A pen point through which ink flows; attached to a holder for writing or drawing

**oil paint:** A slow-drying paint created by mixing colored pigments with oil, traditionally linseed oil

**oil pastel:** A colored stick combining the qualities of an oily, waxy crayon with chalk

**opening:** Two facing pages, also called a spread; the first opening is the spread after the title page where the story begins or continues

**painterly style:** A painting technique that shows texture by allowing brushstrokes to be visible

**palette:** The range of colors an illustrator uses within a book

**panels:** Sequential images that may or may not be separated by lines

**pastels:** Gum, water, and pigment combined and pressed into a stick; two kinds of pastels are oil pastels and chalk pastels, and both can be smudged and blended

**perspective:** Point of view; angle at which illustration is viewed

**pigment:** Finely powdered synthetic or natural color material that can be mixed with a fluid or pressed into wax to create a medium such as paint or colored pencil

**postmodern:** An art movement that is more like a contradictory attitude of resistance to hierarchical and unified expressions; elements of postmodernism include playfulness, nonlinearity, self-referential or anti-authoritarian text, sarcasm, irony, and co-authoring

**pre-separated art:** The process of separating individual color components (cyan, magenta, yellow, and black) in artwork for printing; a plate or film for each color prepared and printed separately, one on top of the other, allowing for the production of a wide spectrum of colors on a printed page; also called color separation

**pressboard:** A stiff, dense board, typically created from wood, tactile pulp, or laminated wastepaper

**primary colors:** Red, blue, and yellow hues

**pulp:** A fibrous material made out of wood, fiber crops such as cotton, or waste paper that is broken down for use in papermaking

**realistic:** A style of art in which subjects are depicted accurately with recognizable details

**recto:** The right page of a spread or opening

**reductive:** A subject reduced to its most basic form but still recognizable and reflecting its essence

**relief print:** A printing method in which the surface of a block of wood, linoleum, or other material is carved; raised areas are inked and printed on paper, leaving an image

**retro:** A style that is inspired by and imitative of trends or fashions from the recent past, generally at least fifteen or twenty years

**sans serif:** A clean style of typeface without serifs or lines that project from the main strokes of a letter; literally "without serif"

**scratchboard:** A process of scratching an illustration on a white or colored surface that has been coated, often in black or in the color of the desired outlines, revealing the image beneath

**secondary colors:** Violet, green, and orange hues; created by mixing together two primary colors (red, blue, or yellow)

**sepia:** Reddish-brown hue, frequently seen in photographs of the nineteenth and early twentieth centuries

**serif:** A typeface with lines that project from the main strokes of a letter

**shade:** A hue made darker by adding black

**single page:** one of the two facing pages of a spread or opening

**speech balloon:** A balloon-like graphic in which a character's speech is enclosed

**spot art:** Small artwork often isolated in the front or back matter

**spread:** Two facing pages of a book; also called an opening

**stencil:** A thin sheet of material with a design cut into it; ink or paint can be applied through the opening onto a flat surface beneath it

**stippling:** Making dots to create shading or simulate texture; may be done with a brush of even bristles or other tools

**storyboard:** Thumbnail sketches outlining the plot or plan for the book

**surrealistic:** A style of art in which unrealistic, bizarre, or extraordinary objects, settings, or characters are juxtaposed with the ordinary, creating incongruity

**symmetry:** Formal balance with an agreement of parts on opposite sides of a perceived midline

**tempera:** A fast-drying paint of water and pigment mixed with a binding agent such as egg yolk; may crack when dry

**thumbnail sketches:** Very small rough sketches an illustrator uses to determine the layout of the book pages

**tissue parchment:** Commercial-quality tissue paper

**title page:** Page that includes the title of the book and the names of the author, illustrator, and publisher

**tone:** A hue to which gray has been added

**value:** Lightness or darkness of a color

**vantage point:** The point of reference from which a viewer relates to a composition

**vellum:** Fine parchment characterized by a smooth, velvety texture, originally made from calfskin

**verso:** The left page of a spread or opening

**vignette:** Small illustration; sometimes called spot illustration

**wash:** Ink or paint, usually watercolor, diluted with water and applied to a surface

**watercolor:** Transparent paint of pigment mixed with water

**woodblock print:** Image created by carving away portions of a drawing on a wood block, leaving raised areas that are inked before the block is pressed to paper

# Author-Illustrator-Title Index

# Media Index

# Style Index

# About the Authors

**Heidi Hammond**, PhD, has twenty-three years' experience as a school librarian at the elementary-, middle-, and high-school levels. She holds a Minnesota teaching license in school library media, English, speech, and reading. She coordinates the school library media specialist portion of the MLIS program at St. Catherine University in St. Paul, Minnesota.

Heidi served on the 2011 Randolph Caldecott Award Committee (Association for Library Service to Children) that selected *A Sick Day for Amos McGee*. She was a member of the 2013 Margaret A. Edwards Award Committee (Young Adult Library Services Association) that selected Tamora Pierce. She has also served on the editorial board of *SLR-School Library Research* (American Association of School Librarians).

**Gail Nordstrom**, MLIS, rediscovered the power and delight of children's books as a youth services librarian for Stillwater (Minnesota) Public Library, where she worked with children, teens, and caregivers for nineteen years. She is currently the public library consultant for Viking Library System in west-central Minnesota. She continues to share her enthusiasm for children's literature in workshops and conferences in the state.

Gail had the honor of serving on the 2011 Randolph Caldecott Award Committee (Association for Library Service to Children) that selected *A Sick Day for Amos McGee*. She was also a member of the 2002 John Newbery Award Committee (ALSC) that selected *A Single Shard*. She has organized local Newbery and Caldecott mock discussions for librarians and teachers since 1997. Gail has served as judge for the Minnesota Book Awards and is a member of the Maud Hart Lovelace Book Award Selection Committee.